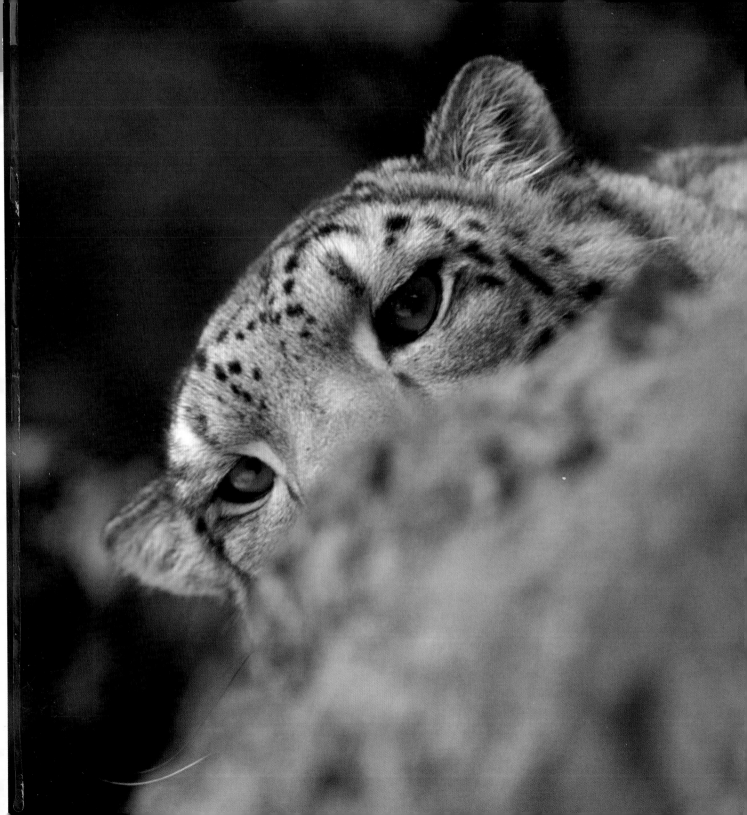

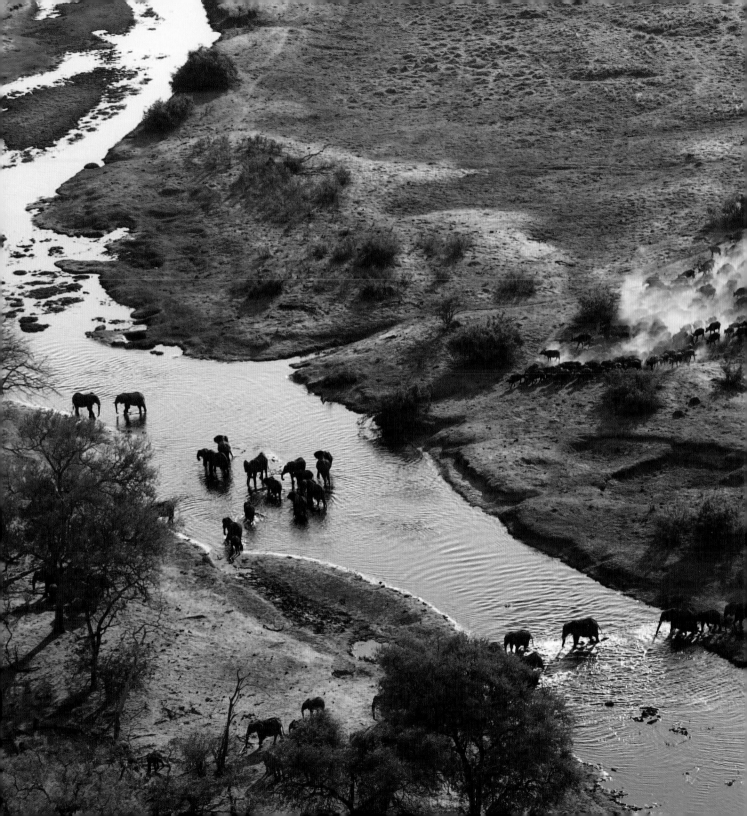

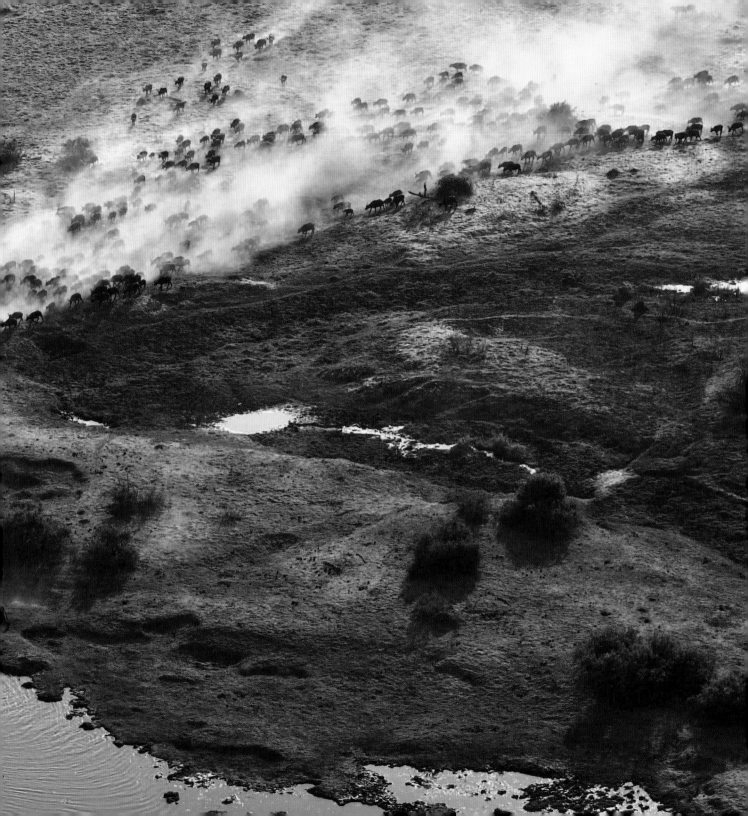

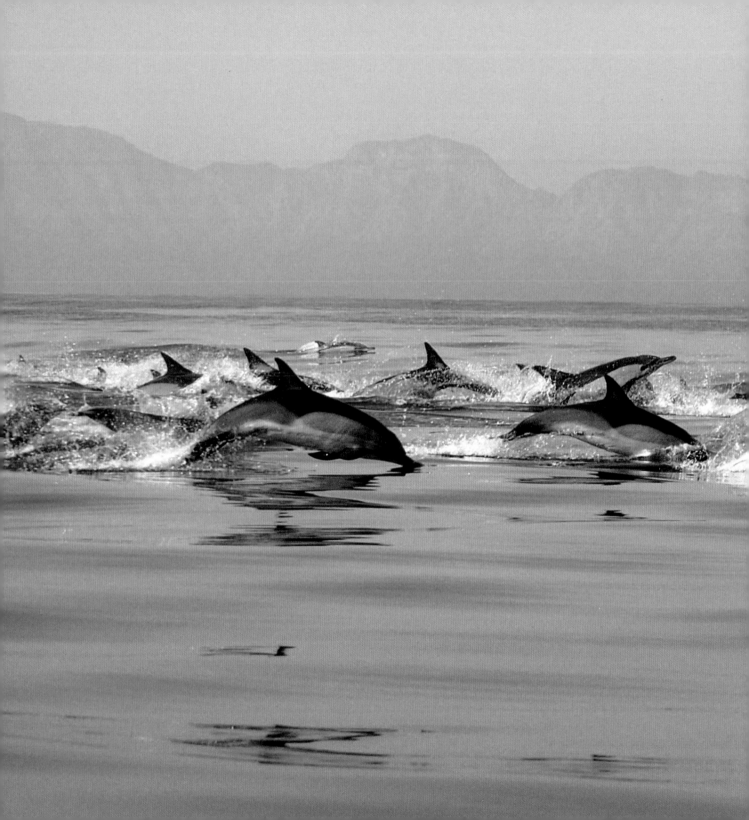

# planet earth

## the photographs

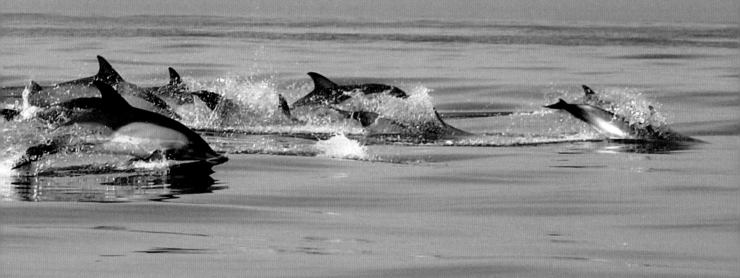

# ALASTAIR FOTHERGILL

BOOKS

# CONTENTS

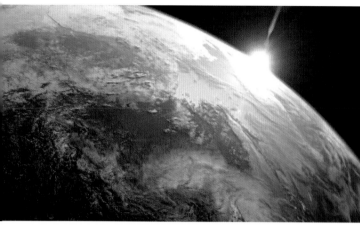

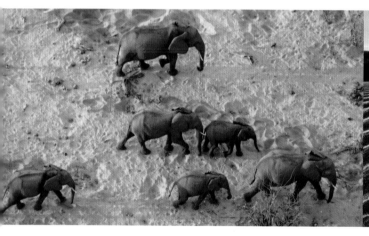

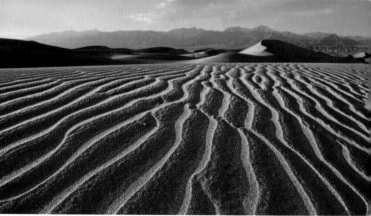

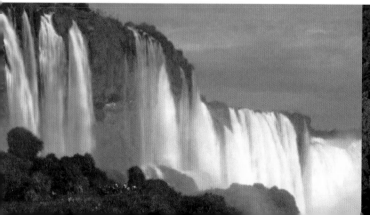

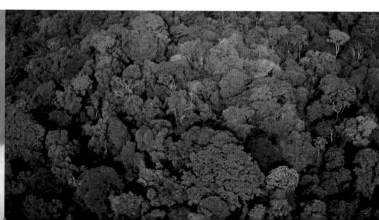

## FROZEN POLES 16

## THE GREAT FORESTS 46

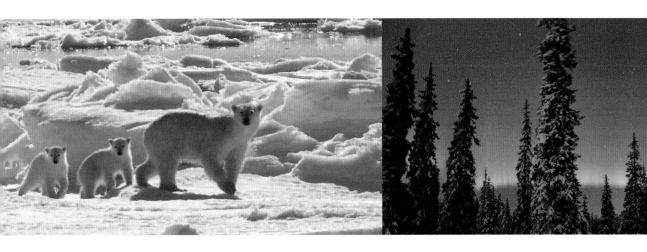

## MOUNTAIN HEIGHTS 124

## THE UNDERWORLD 146

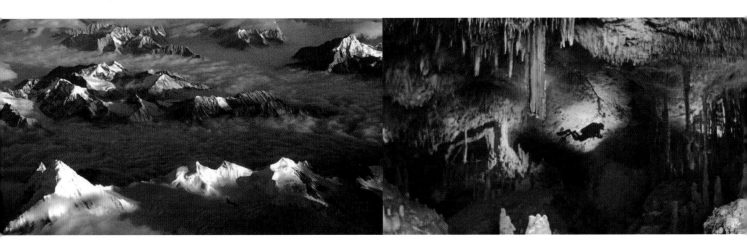

## SHALLOW SEAS 216

## OPEN OCEAN DEPTHS 248

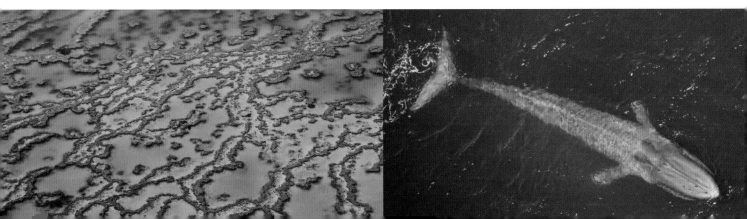

When we started work on the *Planet Earth* series back in 2002, our aim was to film the planet as it had never been seen before – easy to say, but hard to deliver. From the very start it was clear that the key was going to be the aerial view. Only from the air can you really appreciate the true scale of the taiga forest – a seemingly endless ocean of conifer trees. The huge herds of wildebeest are impressive enough from the ground, but from above you can see the clear line of the fresh green on one side and parched brown on the other that marks the before-and-after effect of so many hungry mouths. Keeping up with African hunting dogs from a Land Rover is impossible, but with the help of a helicopter, you can follow a pack's every intriguing move.

Filming aerials, though, has always been a challenge for wildlife film-makers. Small planes are difficult to manoeuvre, and helicopters are just too noisy – flying low enough to film even half-decent close-ups risks disturbing the animals.

For *Planet Earth,* this was all to change when we spotted a small advert in the trade press. A company in Los Angeles had developed a new system that could stabilize lenses attached on the outside of helicopters and linked to high-definition cameras. It had been used to film car chases, and Hollywood was planning to use it to film aerials for movies such as *Pirates of the Caribbean.* This was to be the answer to our prayers. We gave the system the name heligimbal (*heli* for helicopter and *gimbal* for the gimbals or giros used to stabilize the lens and remove the vibrations from the helicopter) and took an early prototype to Hawaii for a test run. Our aim was to film the humpback whales that gather off the islands each year to breed. There are strict rules about how low you can fly above this marine sanctuary, and so filming close-up aerials would be a true test. But there were a host of early problems. In particular, the original design made filming into the sun really difficult – a disaster when animals are calling the shots.

Much of what we filmed in Hawaii was unusable, but there were a few images that really inspired us. The highly stabilized but powerful zoom lens captured shots that made you feel as if you were flying just a few metres above a whale mother and her calf, travelling with the whales as they forged their way through a rough tropical sea. It was a fresh perspective on a familiar story, and we knew immediately we had a tool in our hands that could revolutionize wildlife film-making.

**RIGHT** THE GREAT BREAKTHROUGH
A humpback mother and calf in Hawaii – the first subjects to be filmed using the revolutionary heligimbal system, which allowed close-ups from high above.

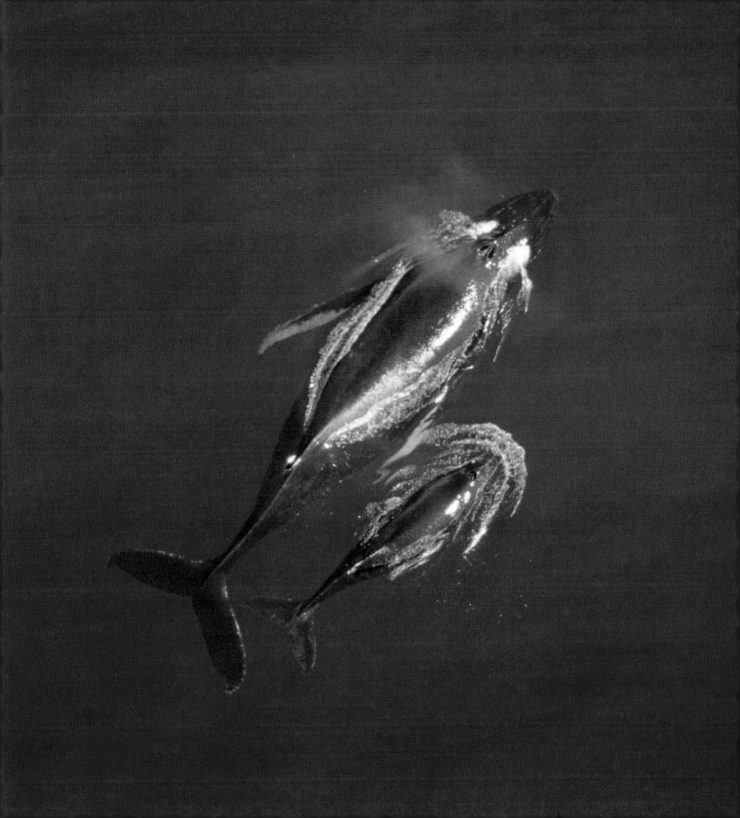

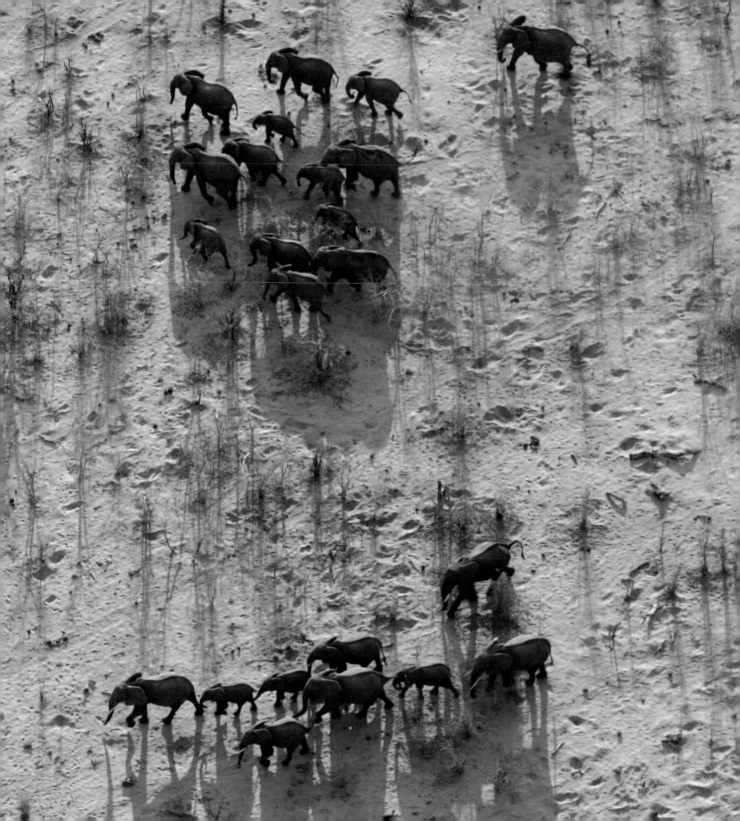

The talented team of engineers that had designed the heligimbal set about solving some of the teething problems, and a couple of months later we were up in Arctic Canada trying to film wolves hunting caribou calves. The tundra landscape is so immense that even keeping up with the enormous caribou herds, often 50,000 strong, is a challenge. Canadian cameraman Jeff Turner had spent much of the previous two years in the area trying to film wolf hunts, using a float plane to find and keep up with constantly moving herds but having to land every time he wanted to film. Through enormous persistence, he had managed to film exciting hunting moments, but he had never captured a complete wolf hunt.

Using Jeff's experience and knowledge, and guided by GPS data from radio-collared caribou, the helicopter kept up with the herds, and in just a few days we were filming remarkable action.

We could film four or five times higher than normal and follow the wolves' every move without them even seeming to notice. The hunt would start with the pack running at the caribou herd from all directions to create panic. Once a calf became separated from its mother, a wolf would concentrate on running it down. Using the powerful zoom lens, we were able to film rock-steady close-ups of the pursuits, often over miles, the helicopter keeping up with every twist and turn from start to nail-biting finish.

We went on to take the heligimbal to almost every corner of the planet. Among the beautiful sand dunes of Namibia, we followed desert elephants as they trekked in a constant search for food. Pulling back from a close-up of the elephants to reveal an endless expanse of rolling dunes, you could really appreciate the challenges faced by the world's largest herbivore surviving in a land seemingly devoid of vegetation. Off the coast of California, our helicopter was able to keep up with pods of hundreds of hunting dolphins, the dark blue water igniting like a firework display as groups exploded at high speed out of the waves. In Antarctica, the Lynx helicopters from HMS *Endurance*, the British Navy ice-breaker, enabled us to hover over humpback whales as they encircled swarms of krill with their nets of bubbles. I had filmed this behaviour at water-level the previous summer, but only from the air could I clearly see the wonderfully synchronized ballet that created the circle of entrapping bubbles.

All our heligimbal filming trips delivered exciting new images, but the most

LEFT THE GREAT WALK
Elephants walking across the dry plains of Botswana in search of waterholes that the matriarchs remember from droughts past.

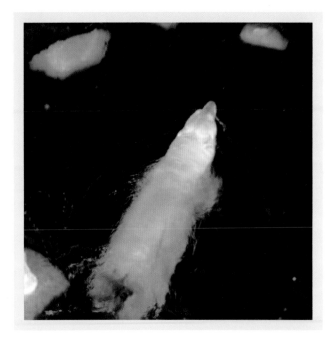 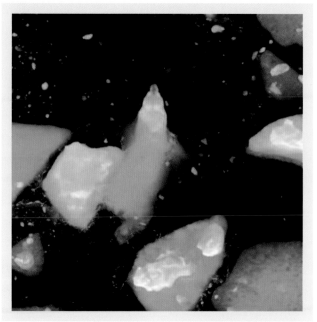

ABOVE THE GREAT MELT
Stills from the *Planet Earth*
recording of the lone polar bear,
swimming out to sea in an
immense world of melting sea ice.
The pictures, shot from a helicopter
high above, were made possible
only by the use of the heligimbal.

memorable for me was the last trip of the whole series. In March 2005, one of our land-based teams had been allowed to visit the remote island of Kong Karls Land in Norway's Svalbard archipelago, which had been closed to visitors for the past 25 years to safeguard a dense population of polar bears. Here they filmed newborn polar bear cubs emerging for the first time from their natal den under the snow and then leaving the nursery slopes to follow their hungry mother out onto the sea ice where she could hunt for seals.

By the end of May, the sea ice breaks up, and it becomes increasingly difficult for the bears to catch seals. This world of drifting ice floes is also inaccessible to film-makers – any ice-breaker capable of handling these conditions would disturb the polar bears. But by using the heligimbal and borrowing a helicopter stationed at a remote Svalbard mine, we attempted to film for the first time polar bears in their shifting world of ice.

For ten days we had vicious summer storms, but then the sun broke through the thick layers of cloud, and we took off over the scattered sea ice. Just as the pilot started worrying about running out of fuel, we found our bear. A big male was walking slowly along the shore in low evening light, totally relaxed as we hovered

high above. Then, to my joy, he decided to swim out into the fjord. The water was the deepest dark blue, patterned with broken sea ice. With the powerful zoom lens, we were able to fill the frame with the bear's massive head, and as he ducked and dived between the floes, we could follow his every sinuous move. The water was gin clear, and the warm yellow evening light dappled his elegant body.

With the fuel rapidly running out, we frantically filmed. Only later when we reviewed what we had shot could we appreciate the beauty of the pictures. They remain my favourite of all the thousands of hours we recorded for *Planet Earth*, and they seem to have struck a chord with the many people who watched the series. Not only was the sequence a fresh perspective on the lives of polar bears, but it was also a powerful reminder of the ever-increasing challenges these beautiful animals face in a rapidly changing world. Millions of words have been written and spoken about global warming, but for me, the image of the polar bear with its world literally melting beneath its feet carries the most powerful message. I hope that some of the photographs in this book will prove as moving for you.

*Alan Phyllt*

**OVERLEAF** THE GREAT FEAST Humpbacks cooperatively feeding using the bubble-net technique – encircling the fish with bubbles and then rising up through the net to take huge mouthfuls, the pleats of their great gullets expanding to accommodate the feast.

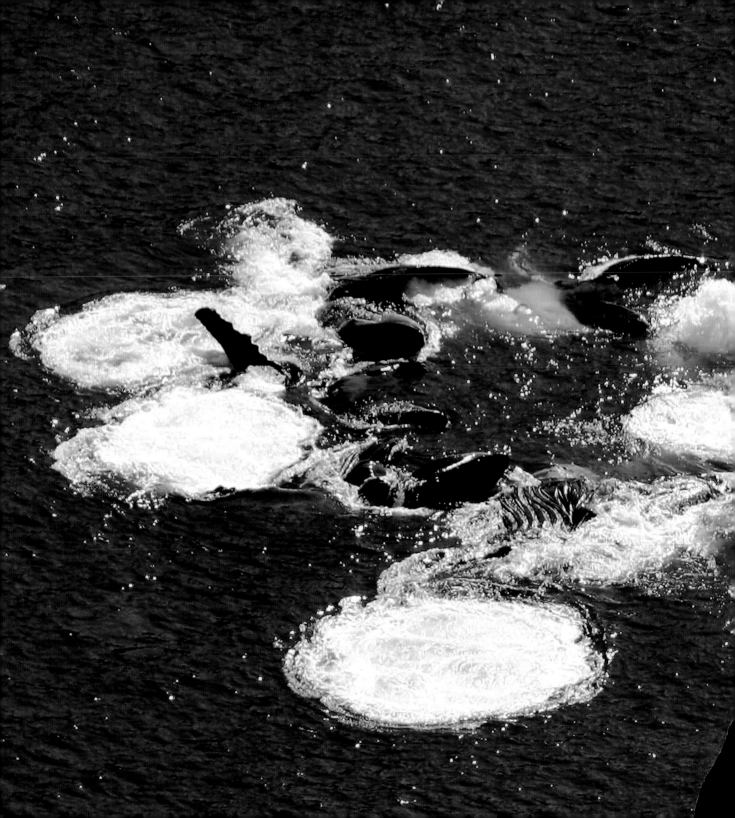

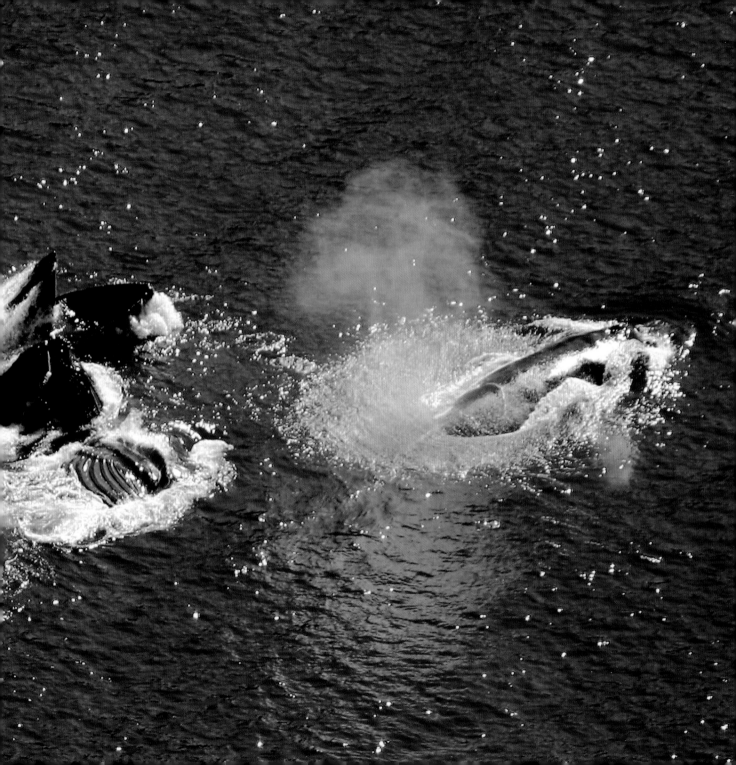

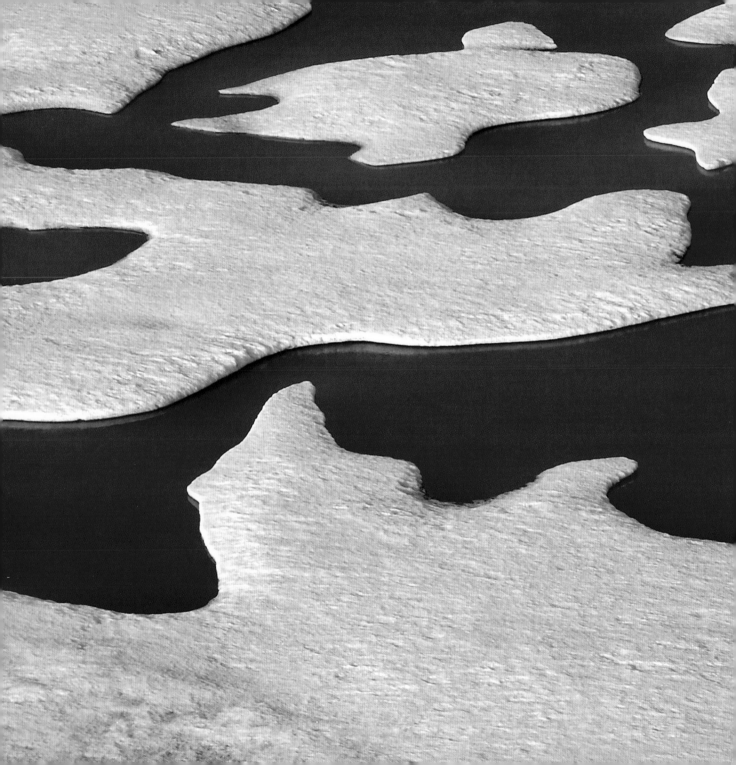

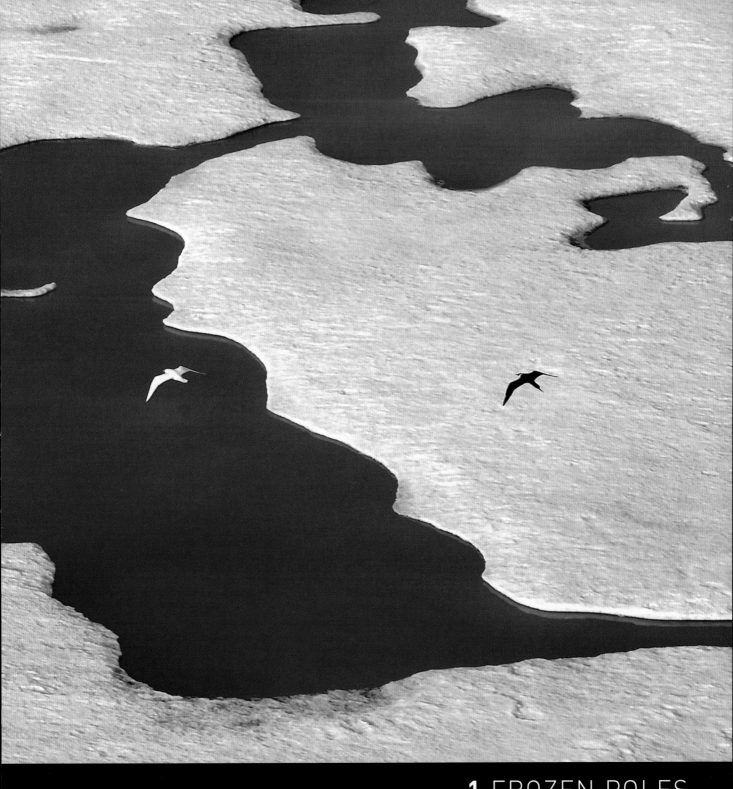

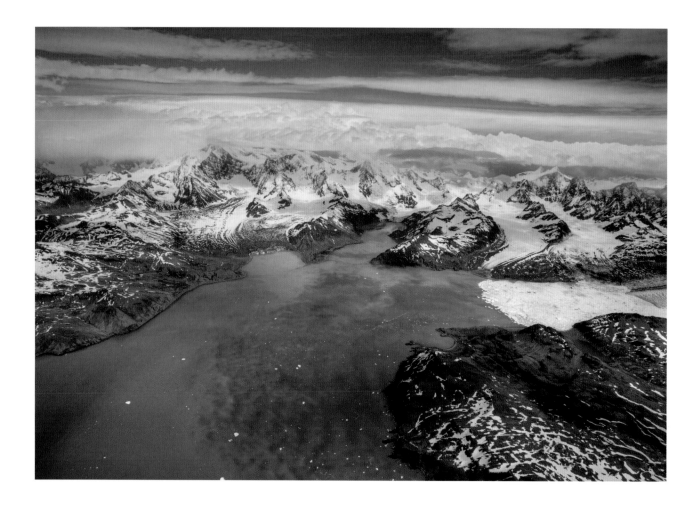

ANTARCTIC OASIS South Georgia in summer. Even in the depths of the polar winter, this subantarctic island remains beyond the grip of the sea ice, making it a haven for a rich variety of animals, all of which need year-round feeding access to the ocean.

'One of the wonderful things about Antarctica is the silence. You also feel terribly small – the scale of everything, and the ability of the weather to change so dramatically in one day. It put me and, in a sense, it puts humans very much back in place.'

ALASTAIR FOTHERGILL

# UNDER SOME PROJECTIONS, ALMOST THE WHOLE ARCTIC ICE CAP COULD DISAPPEAR BY

# 2050

RIGHT: THE GREAT ARCTIC MELT Summer sea ice in the Arctic. The rate at which the ice is thinning and contracting will have a major effect on the climate, through an increase in the volume of meltwater in the ocean (also raising the sea level) and a reduction in solar radiation reflected by the ice.

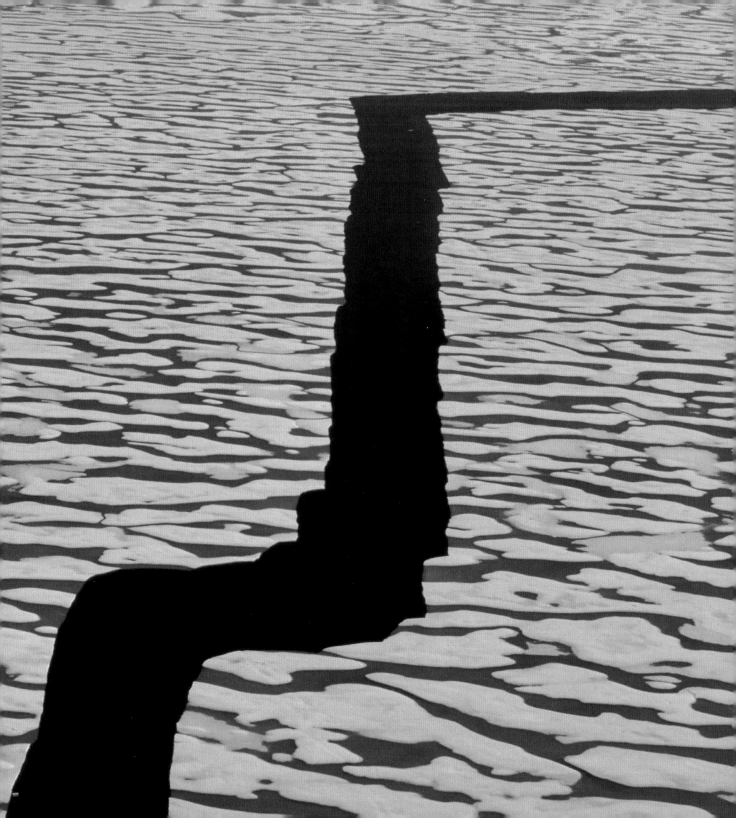

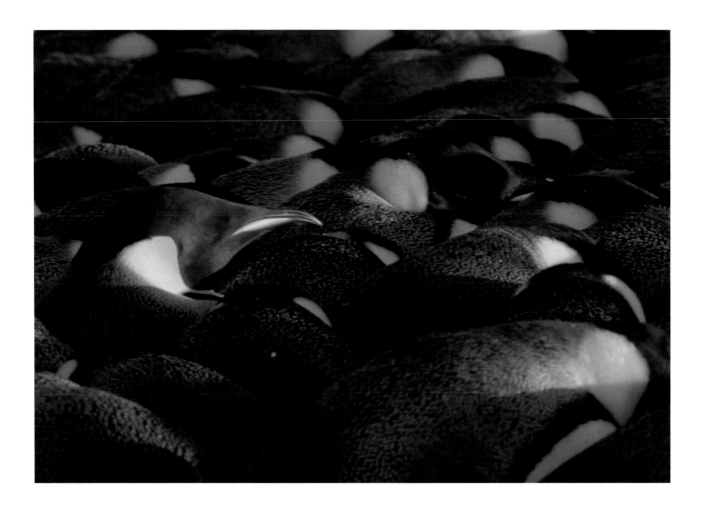

**ABOVE** EMPEROR HUDDLE Shafts of spring sunlight touch a huddle of emperor penguins. Male emperors survive up to four months of winter by huddling – shuffling position so everyone gets a turn in the middle. The *Planet Earth* team overwintered with them to get shots of their ordeal.

**RIGHT** SOUTHERN LIGHTS, MIDWINTER Male emperors huddle beneath a shimmering curtain of light. The aurora australis is caused by electrons from the sun breaking through the Earth's magnetic field, which is weak at the poles, and clashing with atoms in the upper atmosphere.

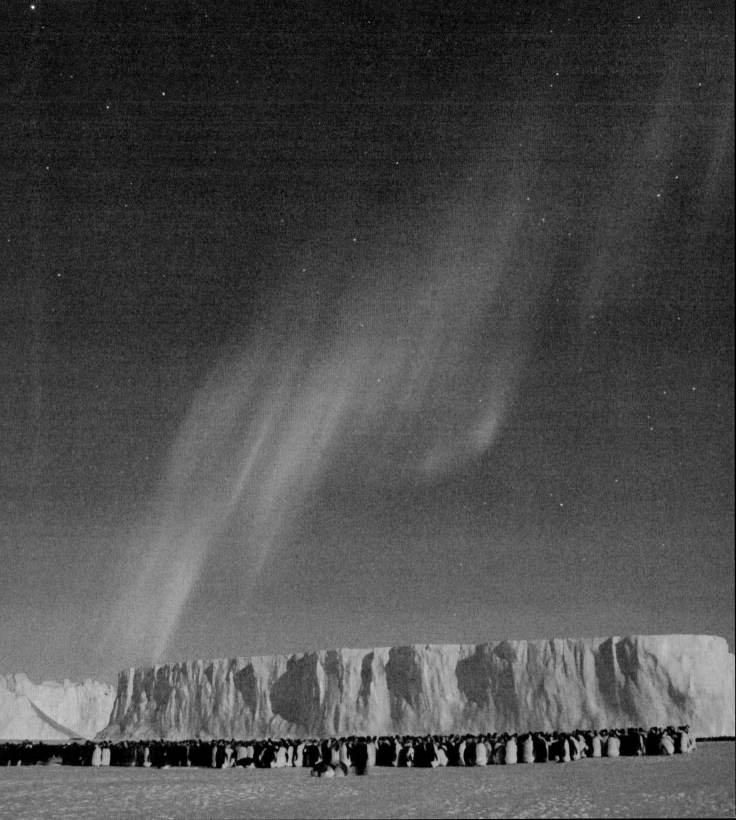

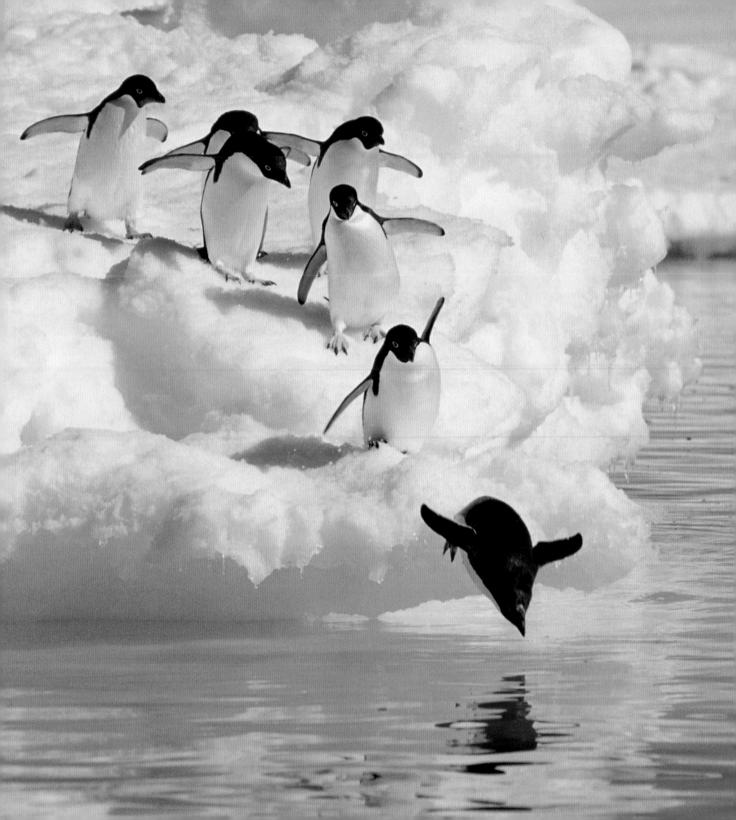

'It's got much milder in the Antarctic peninsula. Glaciers have retreated, it's greener, and some of the penguins are changing their behaviour.'

# ALASTAIR FOTHERGILL

**LEFT** ADÉLIE TAKE-OFF Adélies gather at the ice edge before taking the plunge, aware that a leopard seal may lurk below. One of only four species of penguin that regularly breed on the Antarctic continent, it depends on the abundance of the shrimp-like krill, as do so many other Antarctic animals.

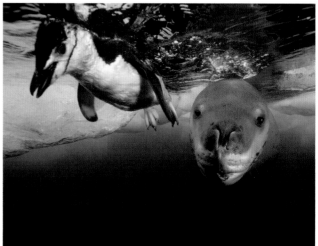

LEOPARD SEAL MOUTHFUL A chinstrap falls prey to the formidable leopard seal. Most penguin colonies have at least one resident leopard seal patrolling close to shore, waiting to pick off penguins as they leave and return to the colony. All Antarctic penguins, even emperors, may fall prey.

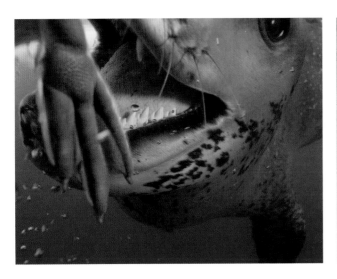

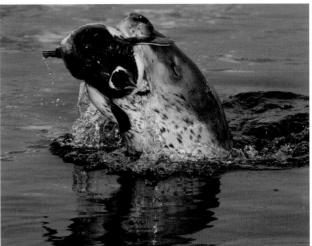

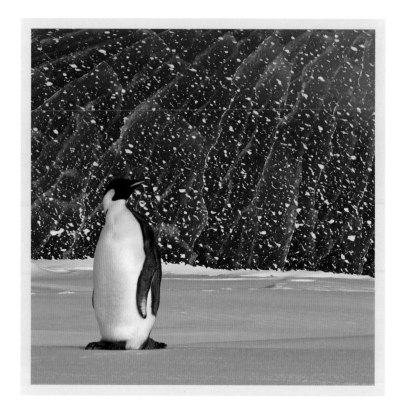

**ABOVE** EMPEROR AT THE ICE EDGE A 'jade' iceberg provides a backdrop for an emperor. Green ice originates from the base of icebergs, where enormous pressure over time forces out the air bubbles (which make ice appear white) and turn it a vibrant green.

**RIGHT** SYNCHRONIZED SWIMMERS Forty-ton humpback whales perform a dance of extraordinary precision as they create a net of bubbles, blasted from their blowholes, around a swarm of Antarctic krill. Mouths open, they then swallow the concentrated krill as they surface.

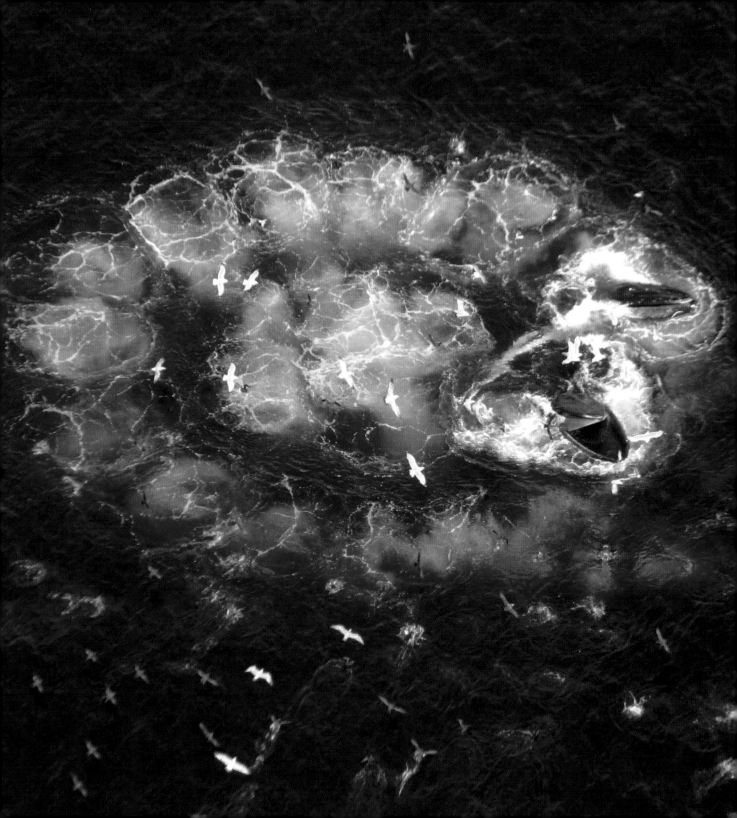

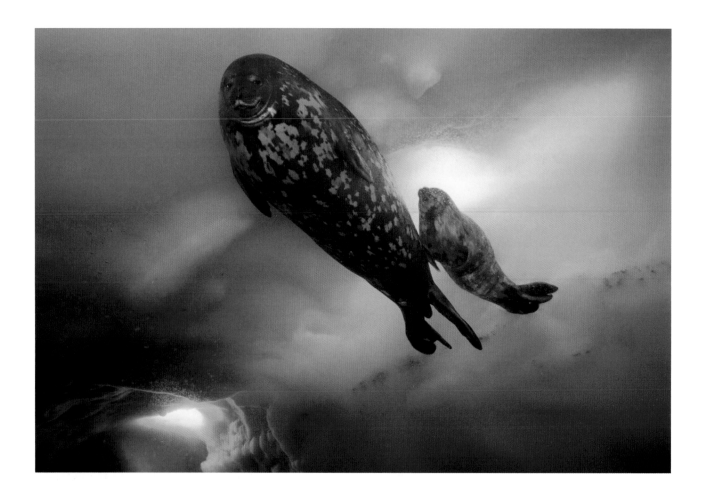

THE ICE GRINDERS Weddell seals – the only mammals to overwinter in the Antarctic. They maintain breathing holes by constantly grinding away at the ice edges, a survival tactic that leaves them with worn teeth and consequently the shortest lifespan of any Antarctic seal.

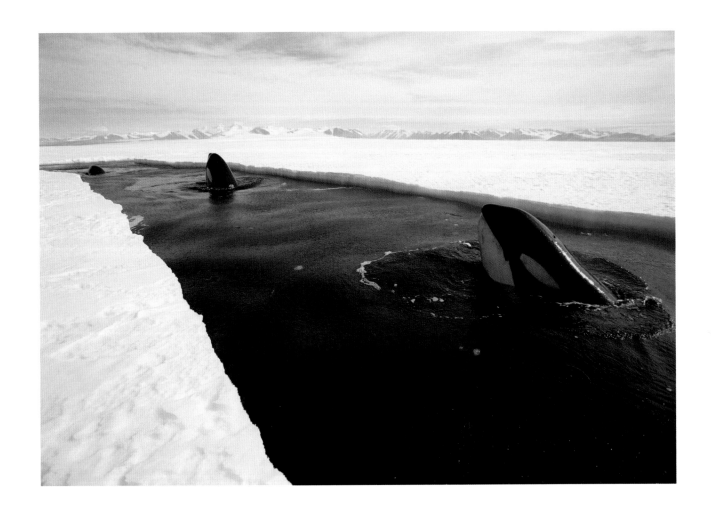

SPYHOPPING FOR ADÉLIES A pod of killer whales stealing into the centre of the ice as the Antarctic sea ice cracks in summer. Here they can ambush Adélies and other penguins, and by spyhopping, they can spot where the penguins are congregating.

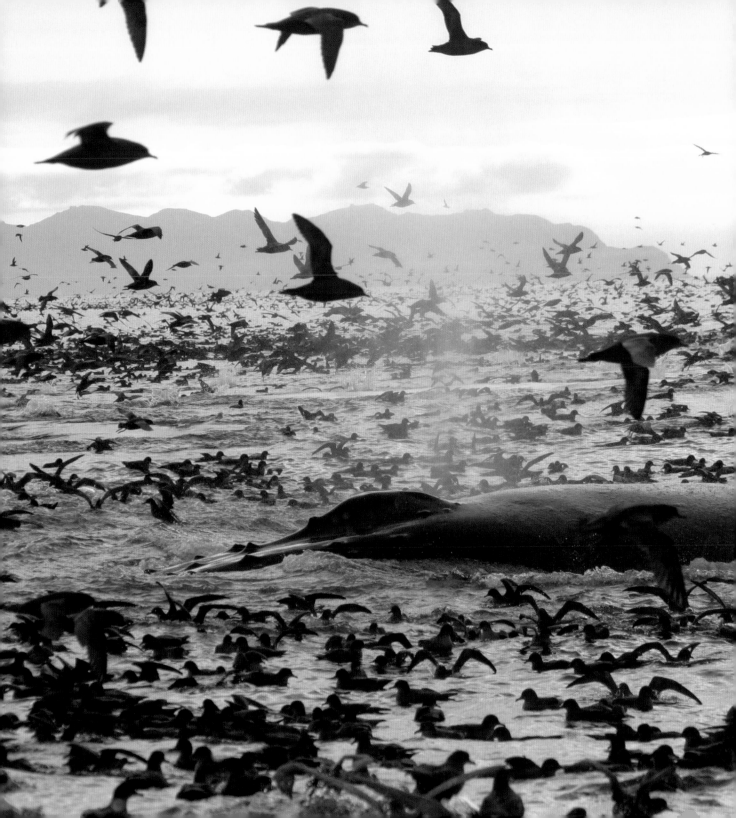

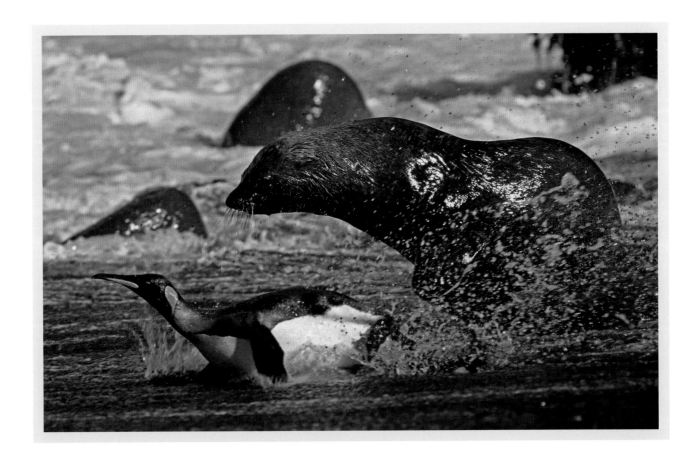

**LEFT** FEEDING BONANZA Humpback whales feeding off the Arctic Aleutian Islands are joined by thousands of sooty shearwaters, which have migrated from the other end of the planet after fish.

**ABOVE** DEATH OF A KING A bull fur seal chases down a king penguin. Only on the remote subantarctic island of Marion have fur seals learnt to prey on king penguins by ambushing them in the surf.

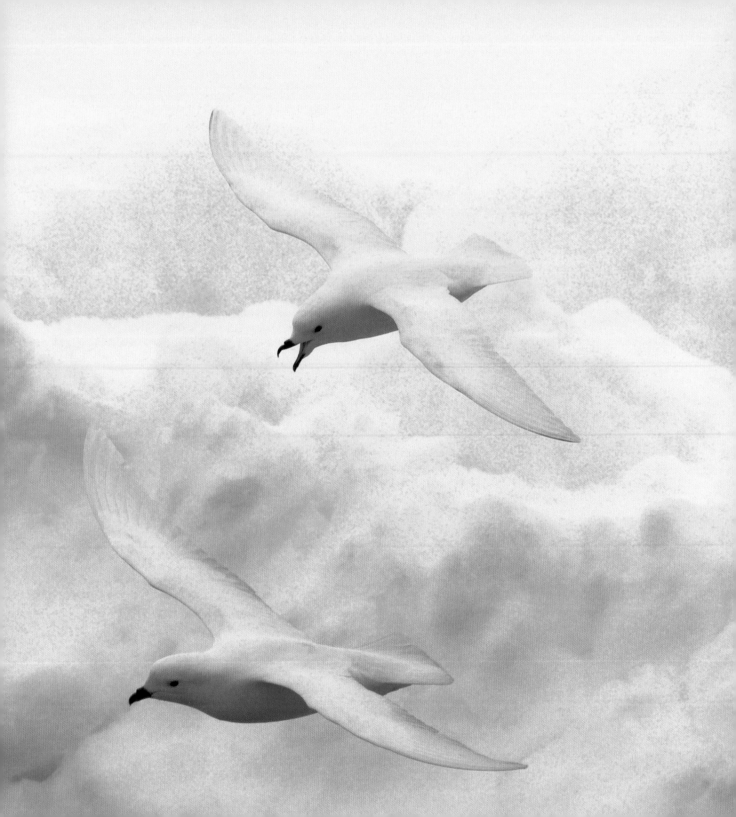

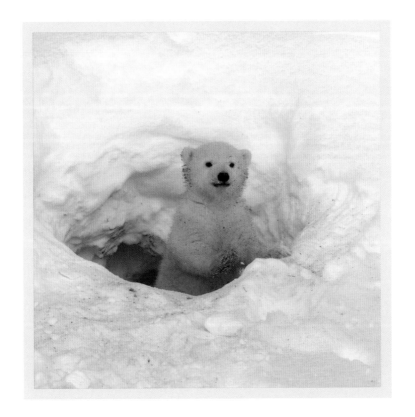

**LEFT** SNOW PETRELS — THE ANTARCTIC ICE BIRDS
Snow petrels fly hundreds of miles inland in spring into the heart of the continent in search of bare rock on which to breed. They nest further south than any other bird on the planet.

**ABOVE** BRAVE NEW WORLD After a cramped two months spent in its snowbound maternal den, a polar bear cub emerges for the first time. The *Planet Earth* team spent a cramped six weeks in a hut on the remote island of Kong Karls Land, Svalbard, to film the emergence of cubs.

'We know that polar bears are under stress, and there seems very little doubt that if climate change proceeds and the ice retreats significantly, more polar bears will not be able to survive.'

## DAVID ATTENBOROUGH

**RIGHT: LEARNING TO HUNT** Young polar bears follow their mother onto the breaking sea ice as she hunts for seals after a winter of starvation. Life is tough for young bears at the best of times, and even with skills learnt from their mother, one of these cubs may not survive its first year.

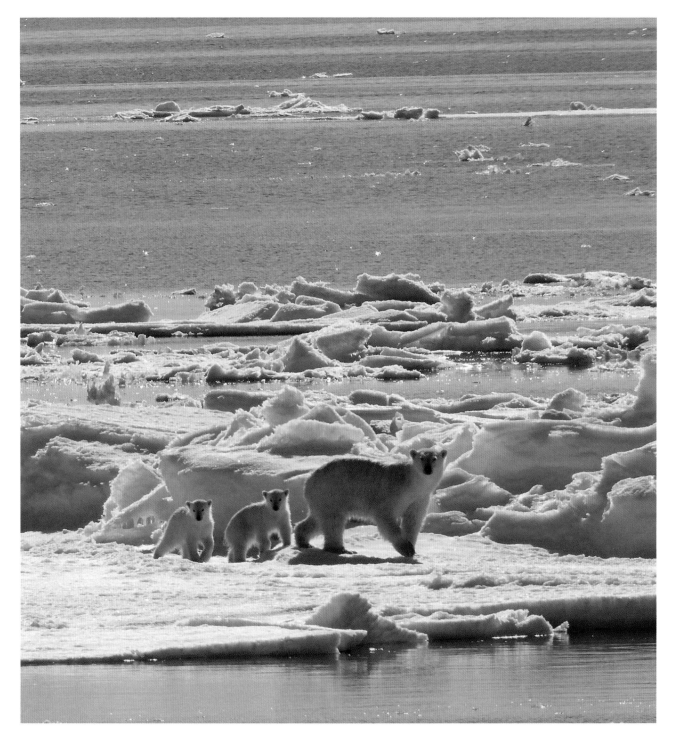

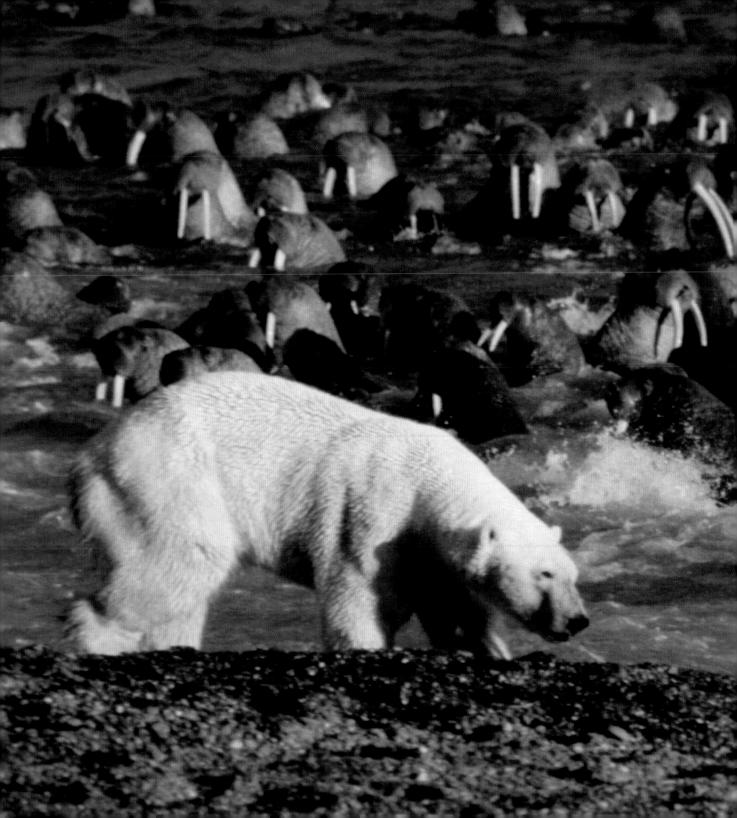

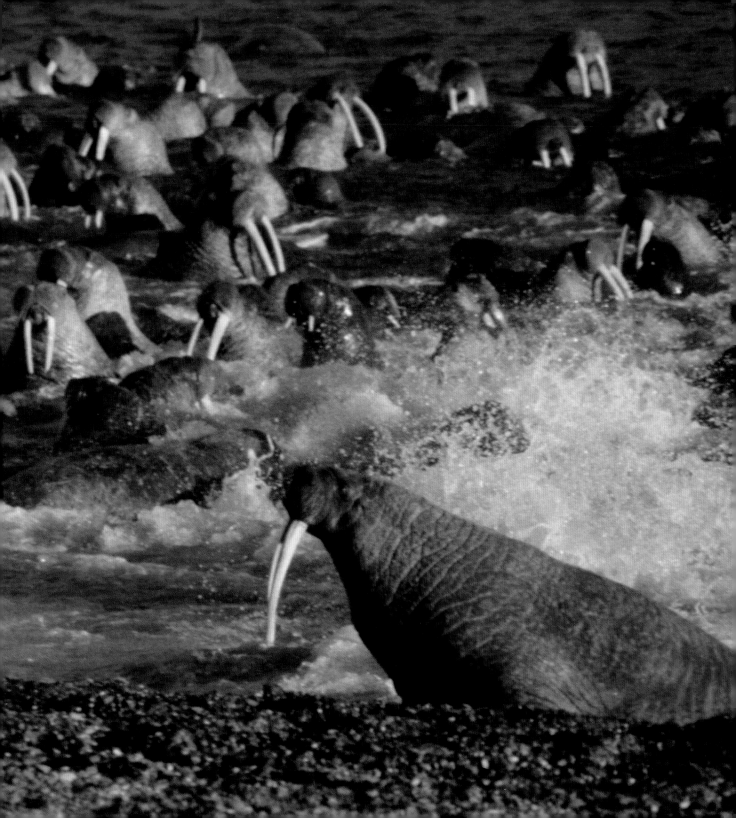

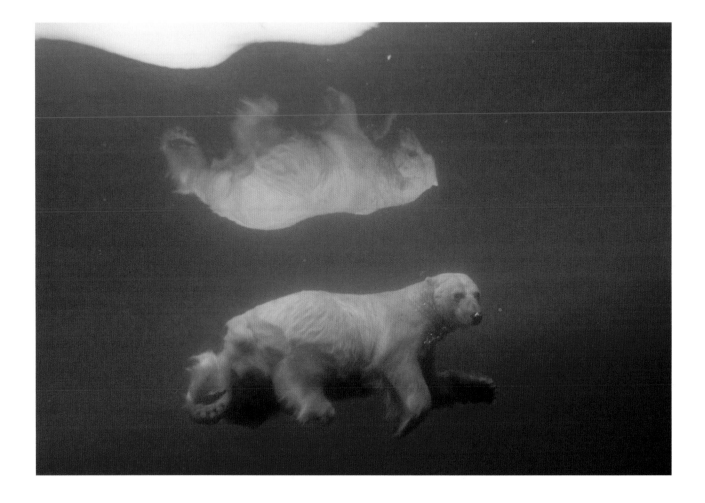

**PREVIOUS SPREAD** TITANIC STRUGGLE A desperate polar bear sizes up a walrus as the rest of the colony retreats to the sea. Disappearing ice at at the end of summer means there are no more ringed seals to hunt, and so starving bears will resort to hunting such large, dangerous prey.

**ABOVE** AQUA-BEAR The graceful motion of this polar bear belies the danger of this scene. Swimming bears are far too unpredictable to dive with, so the *Planet Earth* team used cameras on poles and the quietest-possible engines on their boats to capture moments like this.

'Over the next 50 years, we might lose 35 per cent of polar bears. And as their population continues to decline and their prey species move further out to sea, it's going to be a very tough adaptation.'

JEFF MCNEELY, CHIEF SCIENTIST, IUCN —

THE WORLD CONSERVATION UNION

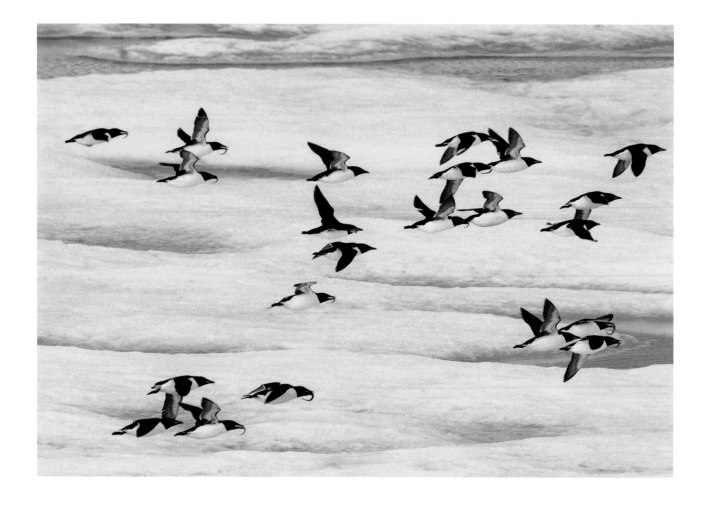

**ABOVE** ARCTIC RUSH HOUR Summer-breeding Brunnich's guillemots make the most of the rich Arctic fishing, shuttling back and forth to their nests with food for their chicks.

**RIGHT** BREATHING SPACE Favourite prey of polar bears, a ringed seal surfaces at its breathing hole with caution. The hole also serves as an emergency exit when the seal is feeding its pup on the ice.

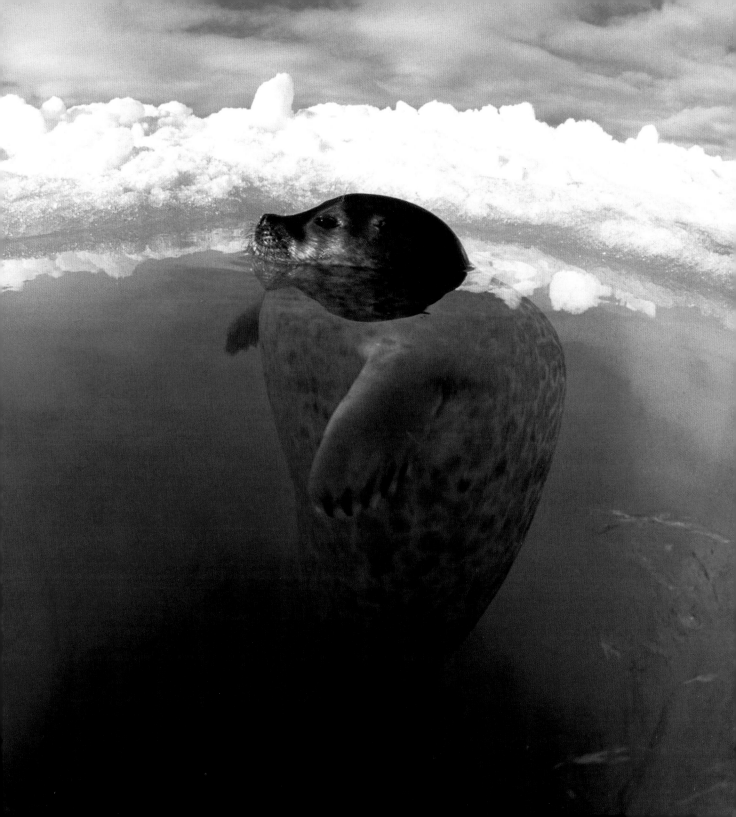

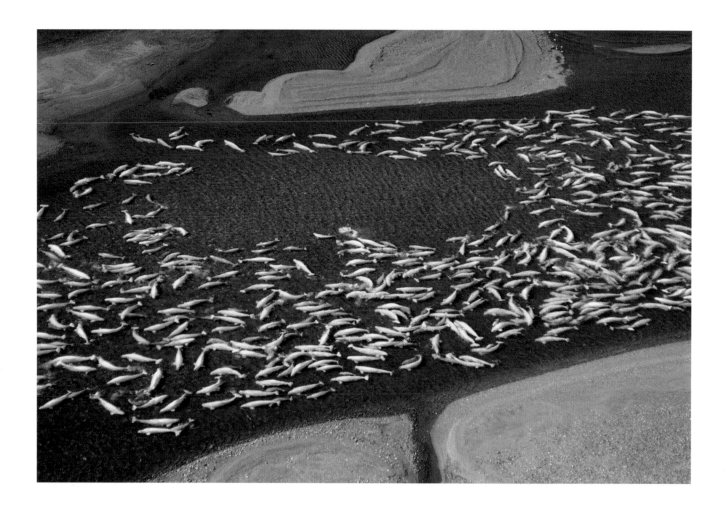

**ABOVE** SUMMER MOULT Beluga whales sloughing off their winter skin on shingle in shallow water, as they do every summer. While doing so, the whales gain some protection by gathering in such large numbers.

**RIGHT** URCHIN JUGGLING A young male eider duck juggles a sea urchin, positioning it to be swallowed whole. *Planet Earth* filmed the ducks in winter diving for urchins in ice-free areas in Hudson Bay.

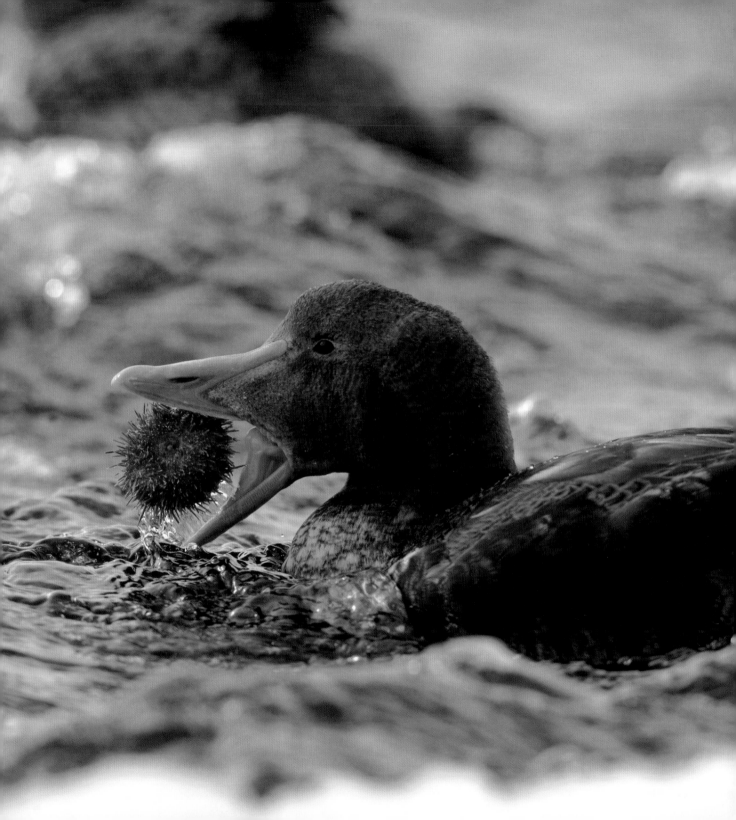

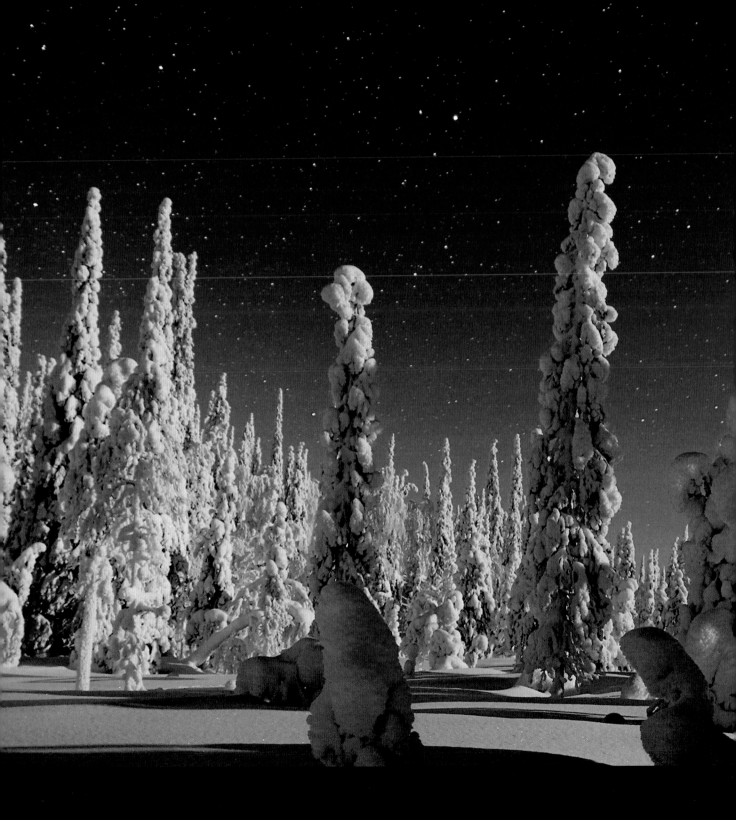

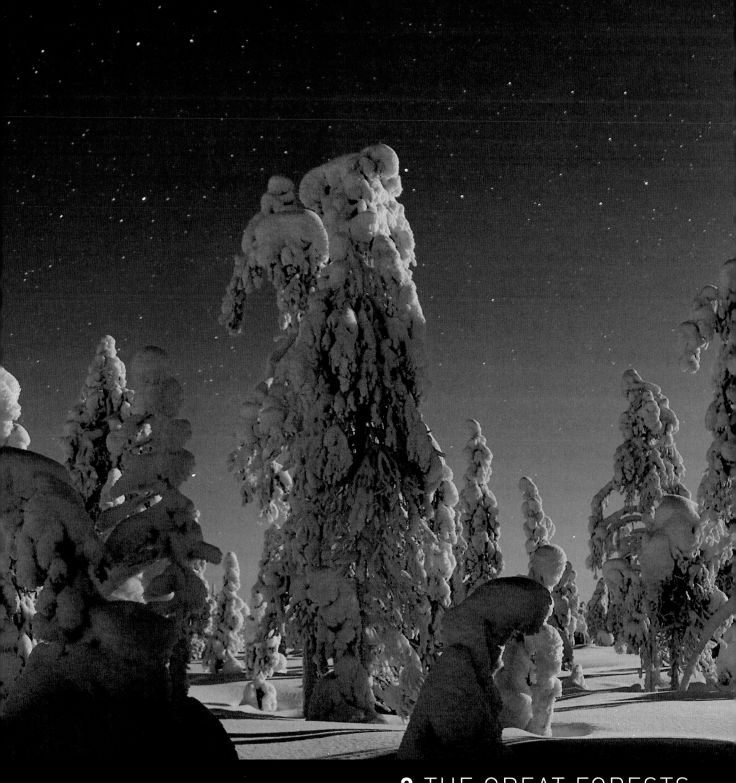

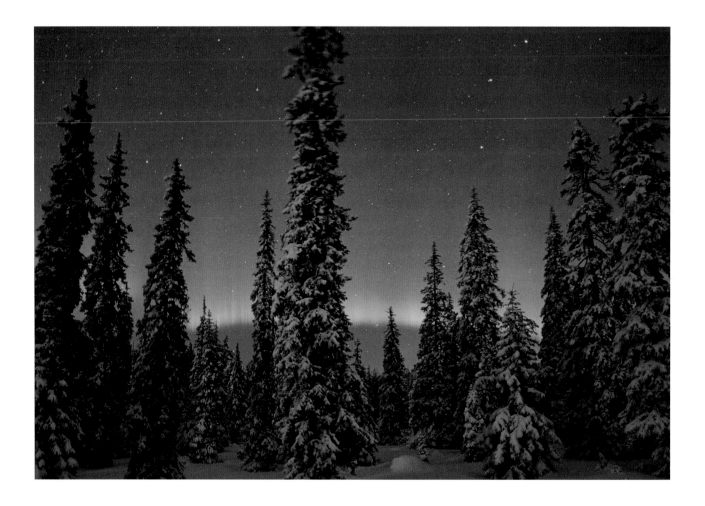

FOREST EDGE, NORTHERN LIGHTS Conifers surviving close to the
Arctic tree line. They reign supreme in the freezing conditions between
latitudes 70 and 55, their ice-resistant needles and flexible branches
enabling them to withstand extreme frosts and heavy snow.

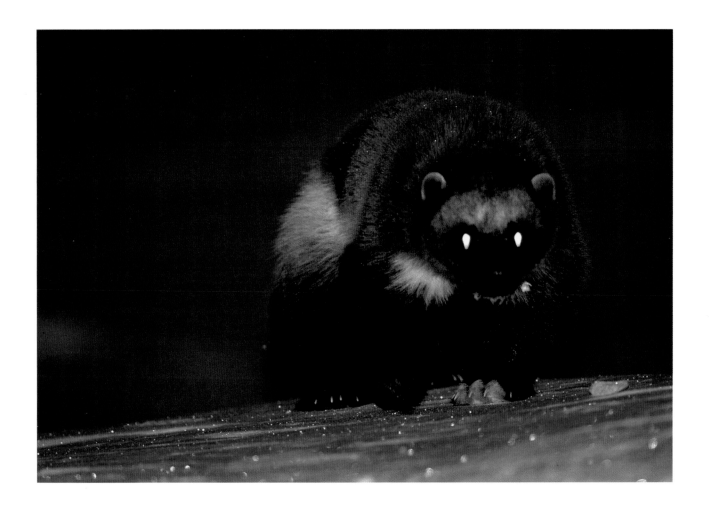

NIGHT SCAVENGER A wolverine on the hunt. Meals in the far north are few and far between, and so the wolverine – the largest member of the badger family – will eat almost anything, dead or alive, large or small. Its ability to eat a huge amount in a sitting has earned it the name glutton.

'As some areas are losing wilderness, other areas are gaining it. The eastern part of the US, for example, was almost totally deforested 200 years ago, and now it's been reforested and repopulated by black bears and moose.'

JEFF MCNEELY, CHIEF SCIENTIST, IUCN —

THE WORLD CONSERVATION UNION

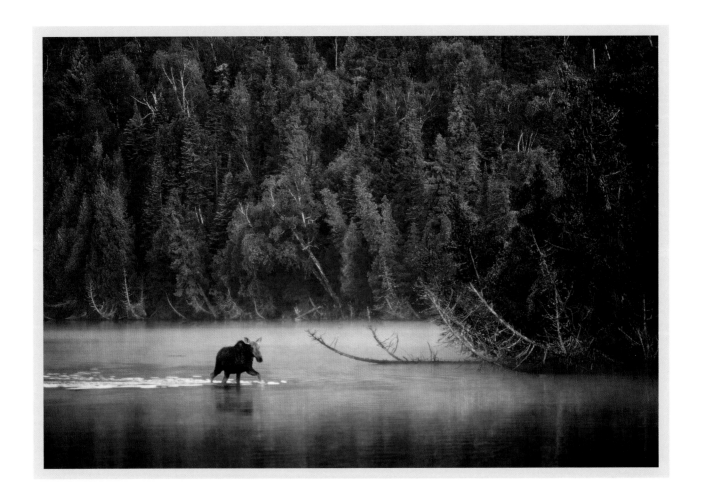

FOREST GIANT A moose – the world's largest deer – feeds on aquatic
plants in an Alaskan river. In the cold conditions of the northern forests,
being larger than more temperate-living relatives, and so having a smaller
surface area, reduces heat loss, and many animals here are giants.

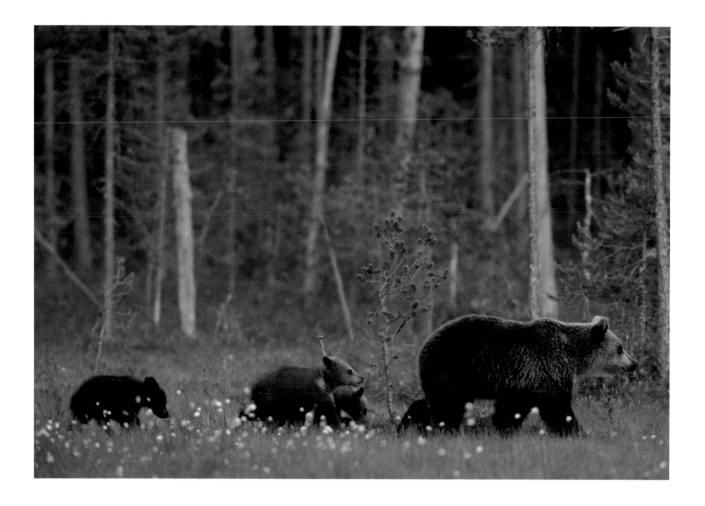

**ABOVE** FOREST FORAGERS Cubs learning from mother what is good to eat in the forest. European brown bears make full use of the forest larder, dining on nuts, berries, tree bark, twigs, leaves, bulbs, herbs and insects, depending on the season, as well as small animals and carrion.

**RIGHT** FOREST HUNTER A goshawk on the lookout. It is a stealth hunter and like all forest birds of prey, it has specially rounded wings, allowing it to dive and turn between the trees in pursuit of mammals, including squirrels, and birds as large as owls and grouse.

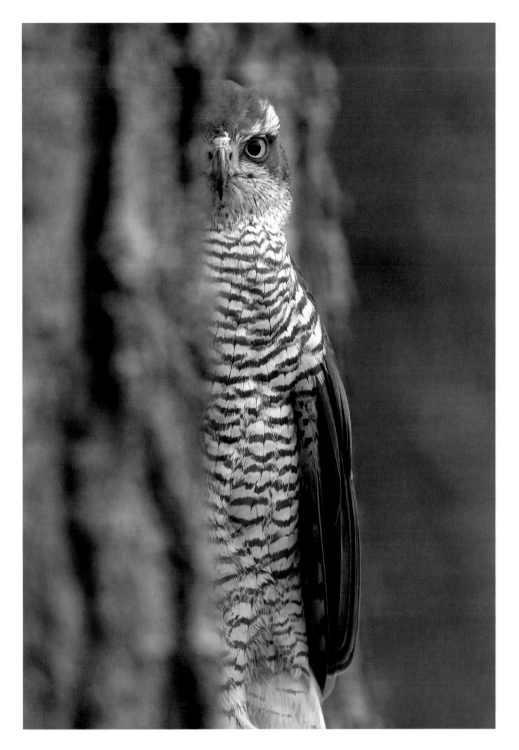

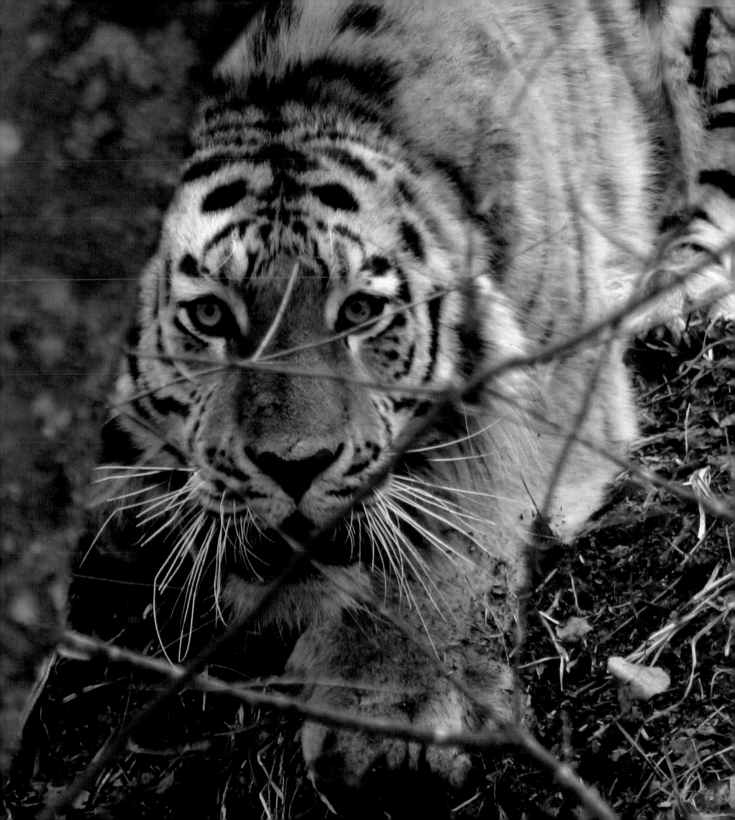

'If we lose these majestic creatures with their sense of power and ancestry, then we as well as the ecosystem are diminished by that. We lose a measure of our own significance or insignificance when some of these astonishing creatures go.'

# RICHARD MABEY

LEFT SIBERIAN GIANT A wild Siberian tiger, the world's biggest cat – highly endangered, rarely seen and seldom photographed in the wild. Such huge predators need large territories and plenty of prey, all of which are under threat from logging and poaching in Siberia's forests.

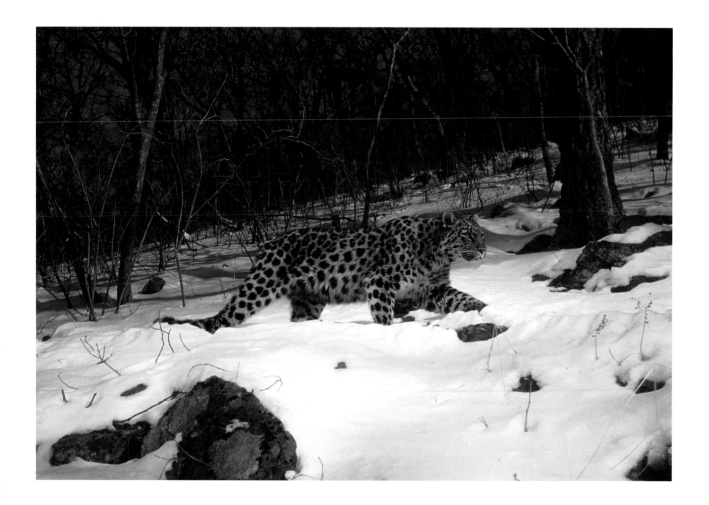

**ABOVE** AMUR LEOPARD One of the last pictures of one of the last wild Amur leopards – the rarest race of leopard, filmed for *Planet Earth*. As few as 40 (possibly fewer than 25) live in the mixed deciduous forest of the remote Amur River valley on the China-Russia border.

**RIGHT** FOREST OF MANY SEASONS The colours of deciduous trees in autumn blend with evergreen conifers in a mixed Japanese woodland on the edge of the boreal forest zone. The deciduous trees will absorb nutrients from their leaves and then drop them in advance of the frosts.

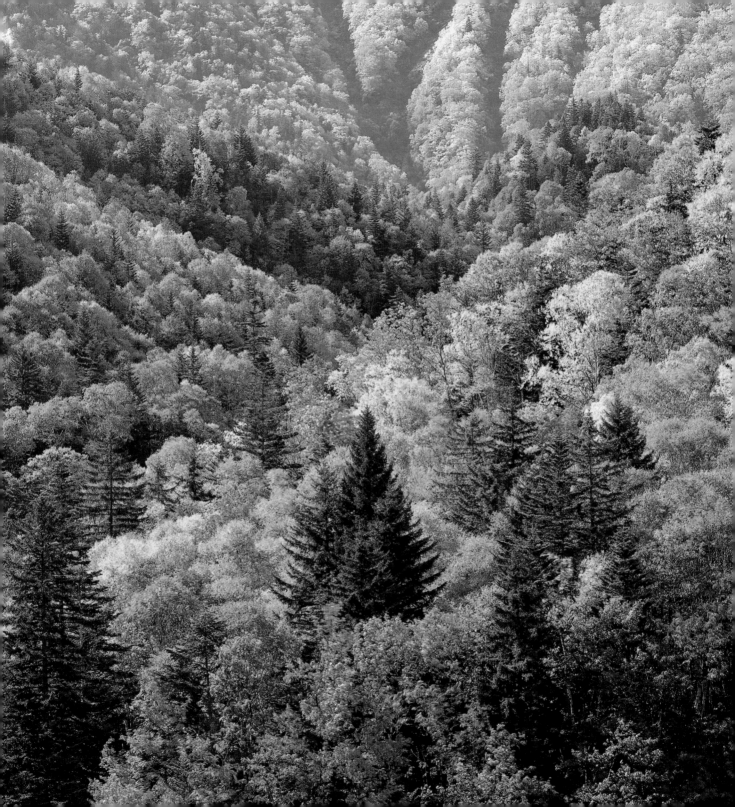

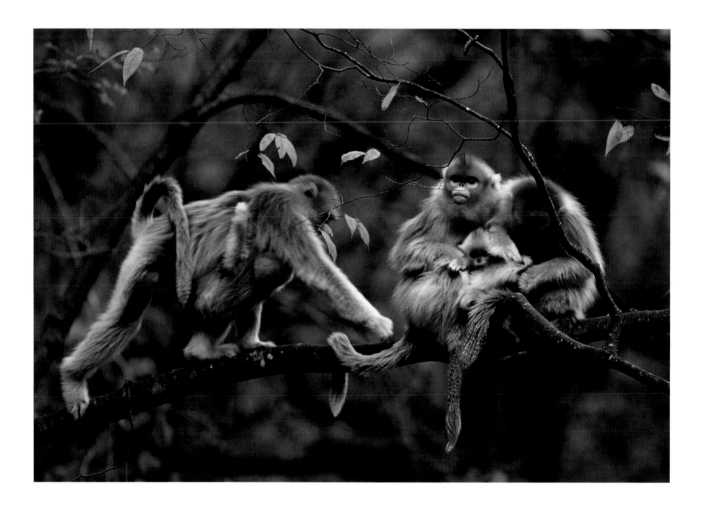

HIGH-LIVING MONKEYS Golden snub-nosed monkeys in
high-altitude forest in southern China. Thick fur and the ability to digest
lichens, conifer needles and even bark allow them to survive in patches of
forest at altitudes of up to 4500 metres (14,760 feet).

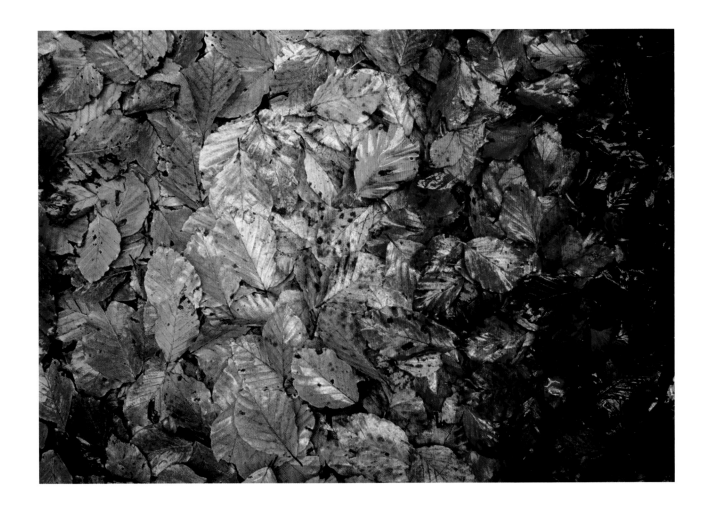

LEAF PALETTE The colours of temperate deciduous forests. The dead leaves – their sugars and chlorophyll reabsorbed by the tree before they were discarded – will be broken down by fungi and other organisms into a mulch and the nutrients recycled into the forest system.

# THE FORESTS ARE THE LUNGS OF THE PLANET, PRODUCING THE OXYGEN WE BREATHE AND REMOVING CO2 FROM THE AIR.

**RIGHT** THE EDIBLE ZONE Autumn birch woodland. Birch and trees such as oak, beech, aspen and maple dominate the northern temperate forests south of 55 degrees. Unlike conifers, their leaves make excellent food for many organisms, fuelling an elaborate web of life and nurturing a rich soil.

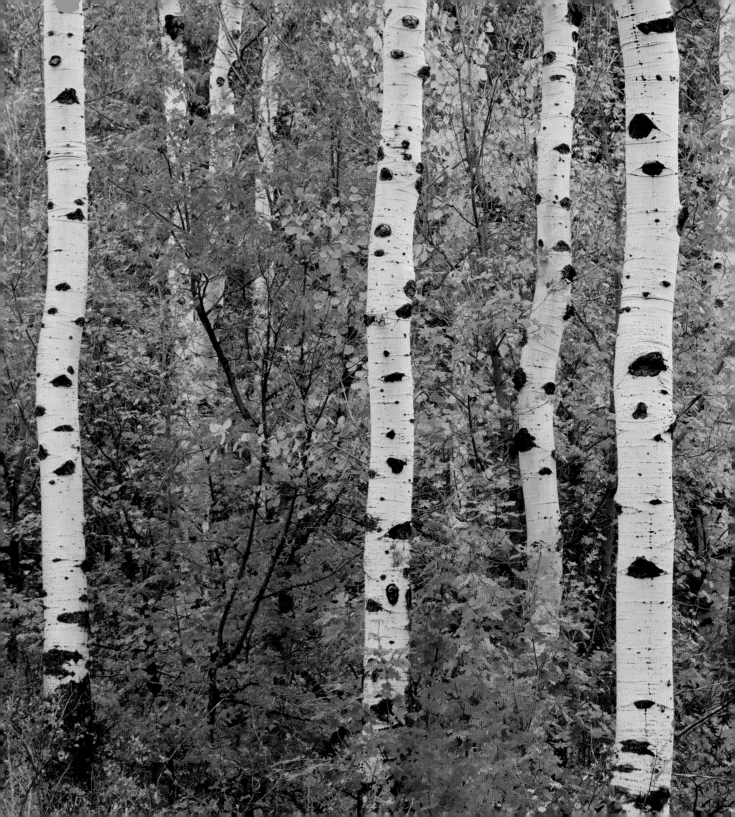

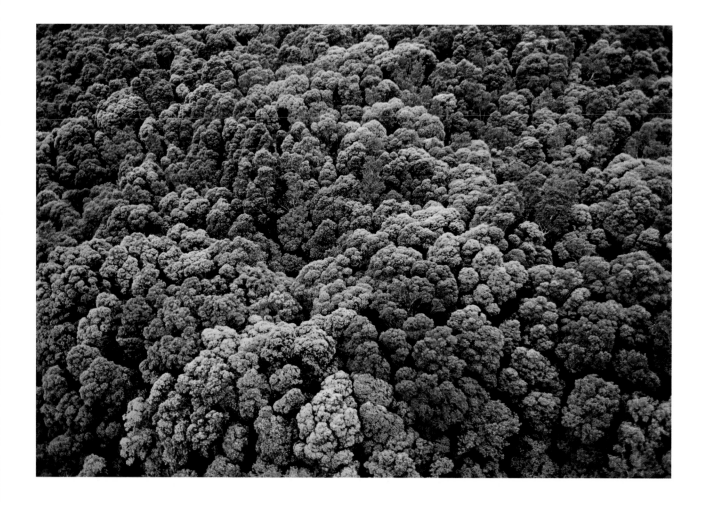

**ABOVE** TEMPERATE RAINFOREST A thick canopy of flowering temperate rainforest in Westland National Park, New Zealand. Though composed of native trees such as tawa, kamahi and rumu, its understorey mirrors that of coastal temperate rainforest in the northern hemisphere.

**RIGHT** THE UNDERSTOREY Old-growth temperate rainforest on the Pacific coast of North America. These trees form a scaffolding on which a community of plants grows in profusion, and they also provide a warm, moist environment for a rich understorey of ferns and other plants.

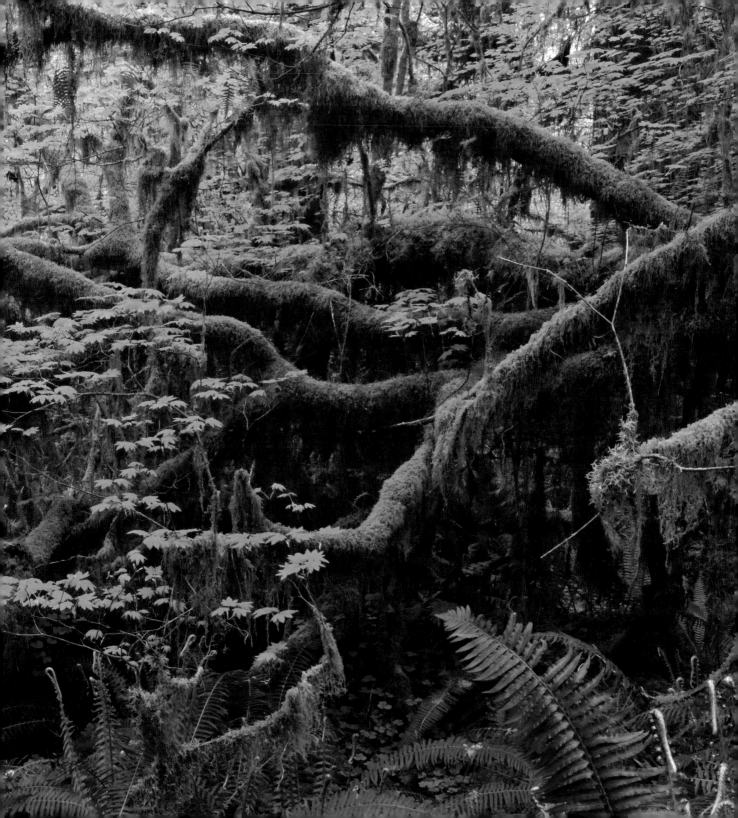

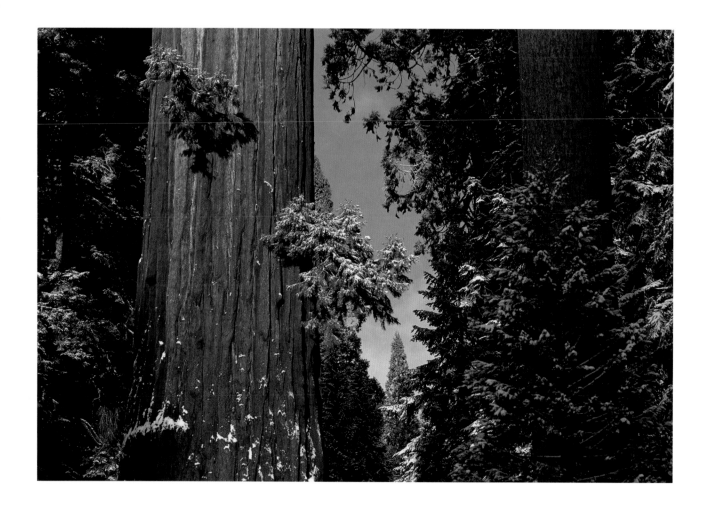

THE LARGEST TREES IN THE WORLD Giant sequoias in California,
some measuring up to 11 metres (36 feet) around the base. These conifers
are able to grow enormous in the warm, wet, light conditions of the
coastal slopes of California's Sierra Nevada.

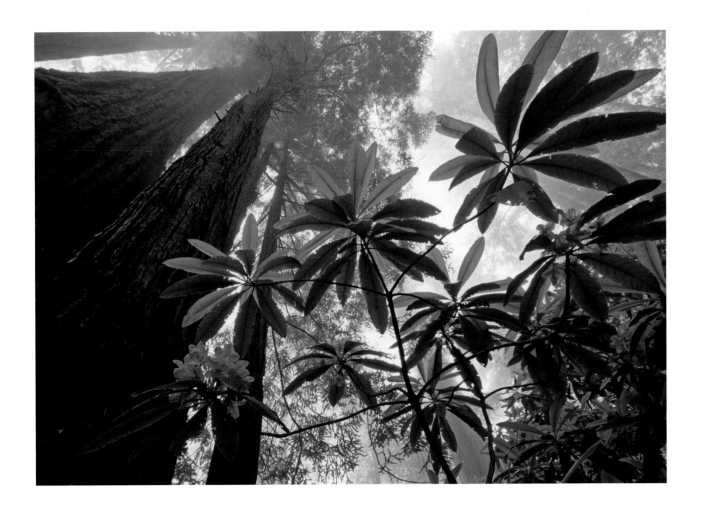

**ABOVE** THE TALLEST TREES IN THE WORLD Enormous coastal redwoods in northern California, the tallest of which, at 115.55 metres (379.1 feet), is the Hyperion. To give an impression of their height, *Planet Earth* rigged a cable system that ran cameras right up to the top of a tree.

**OVERLEAF** HOT-FOREST SHOWTIME An Indian peacock lights up the dry forest floor with a display of colour. Though there are no winter frosts here, the broadleaved trees such as teak still drop their leaves but at the driest time of year, to conserve water.

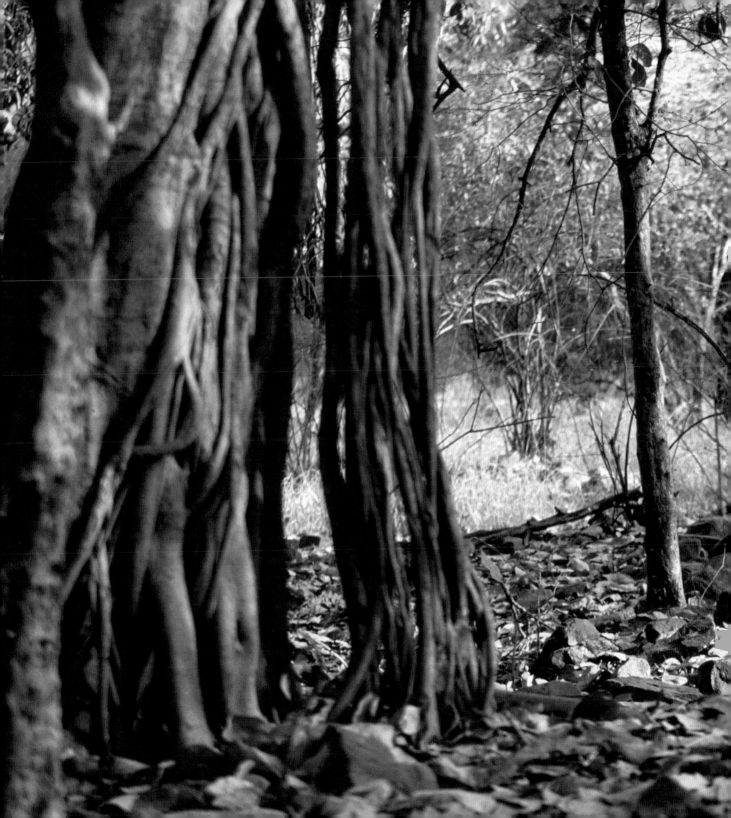

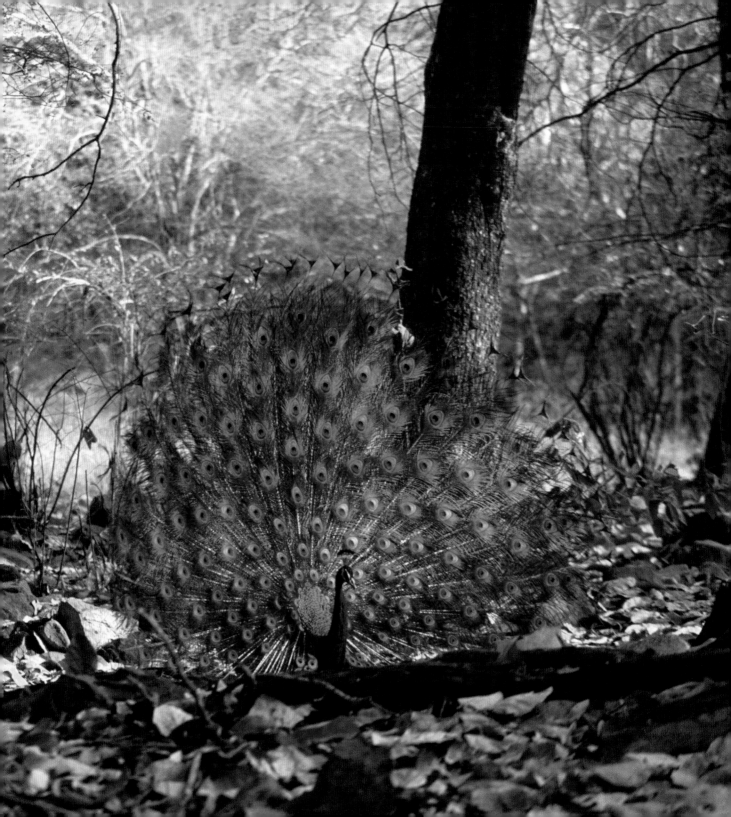

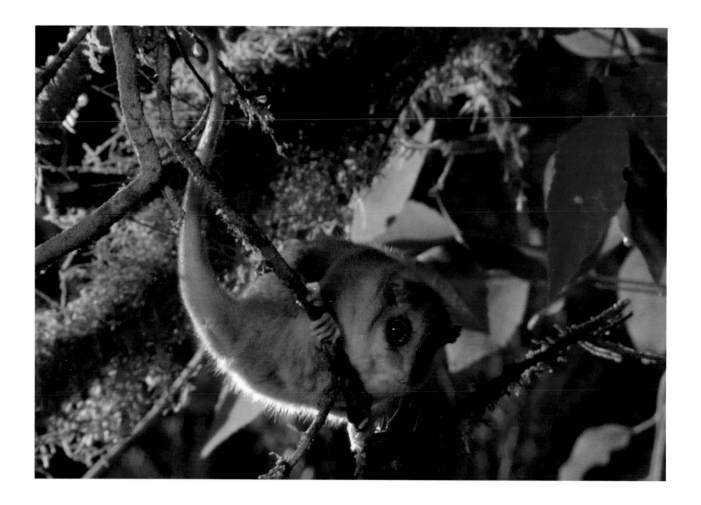

HANGER-ON A film frame of the nocturnal monito del monte of the
coastal rainforest of Chile and Argentina. It has a prehensile tail and
marsupial pouch, and is the only surviving member of an ancient order
from the time when South America was joined to Australia.

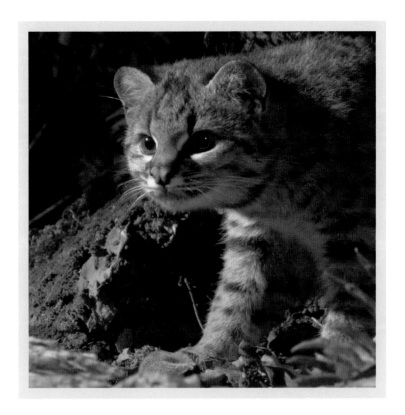

THE SECRETIVE KODKOD The smallest cat in the western hemisphere –
another film frame of a nocturnal inhabitant of the Valdivian temperate
rainforest. It is thought to be highly social, but as with other animals
filmed by *Planet Earth* in this forest, the kodkod has been little studied.

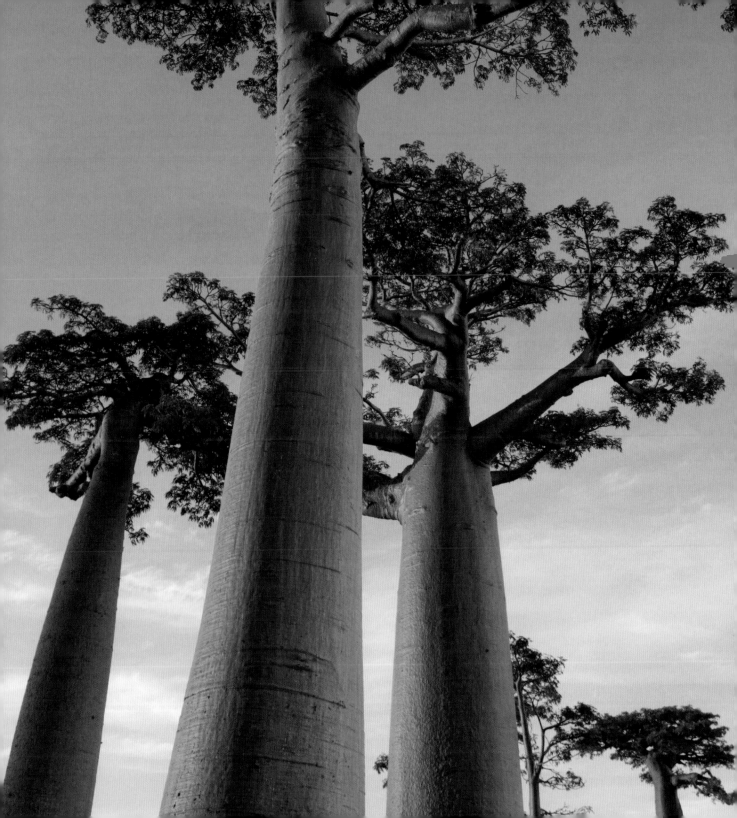

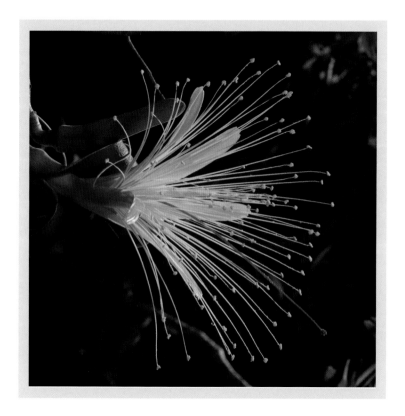

**LEFT** DRY-FOREST GIANTS Mature giant baobabs up to 25 metres (82 feet tall) growing in Madagascar. Called 'mothers of the forest', they are trees of dry deciduous forest, much of which has been cleared. *Planet Earth* used a motorized hot-air balloon to film the tree crowns.

**ABOVE** HIGH-RISE NECTAR A flower of the bottle baobab, found in the dry forests of Madagascar's west coast and pollinated by hawkmoths. It opens just after dusk and takes only a minute or so to reveal its nectar offering. Baobab flowers also provide nectar for lemurs and bats.

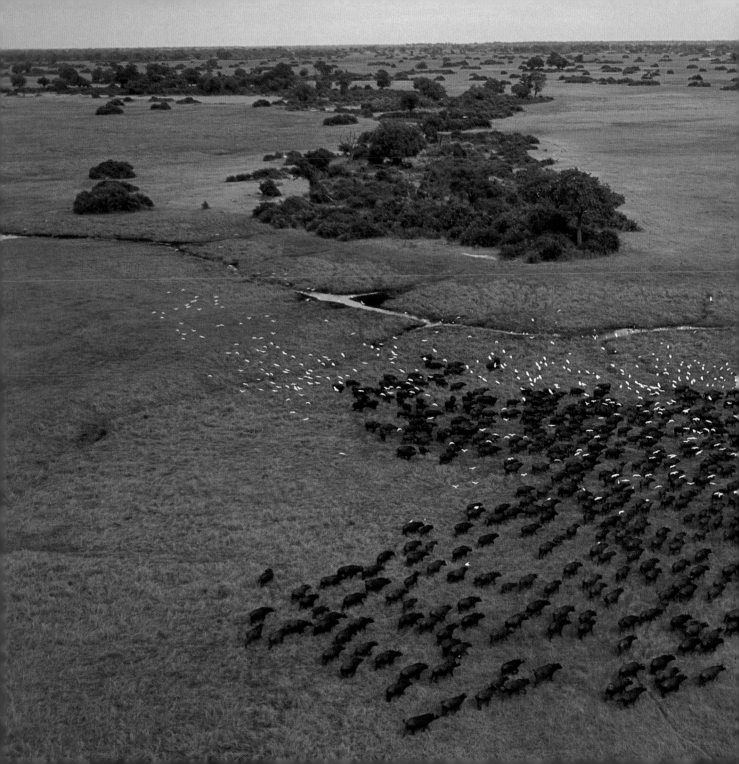

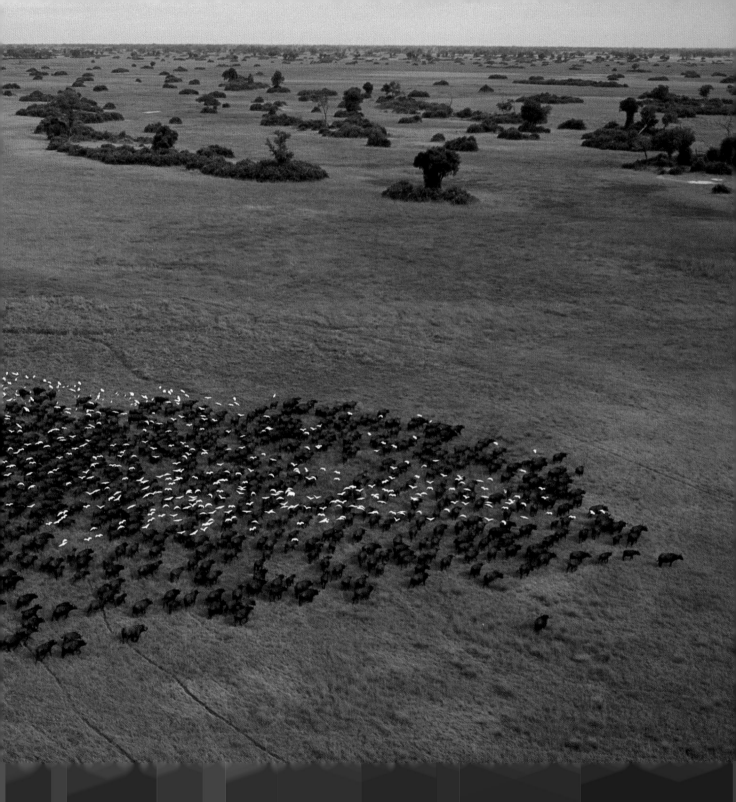

# GRASSES ARE THE MOST WIDESPREAD AND ABUNDANT FLOWERING PLANTS — AND THE TOUGHEST, ABLE TO WITHSTAND BEING BURNT, FROZEN, DROWNED, PARCHED AND GRAZED.

**RIGHT** THE GREAT PLAINS TREK Elephants trekking along ancient routes to distant waterholes and rivers in search of water. In the dry season, Botswana's grasslands become dustbowls, forcing the migration. As many as 100 elephants will travel together, marching up to 80km (50 miles) a day.

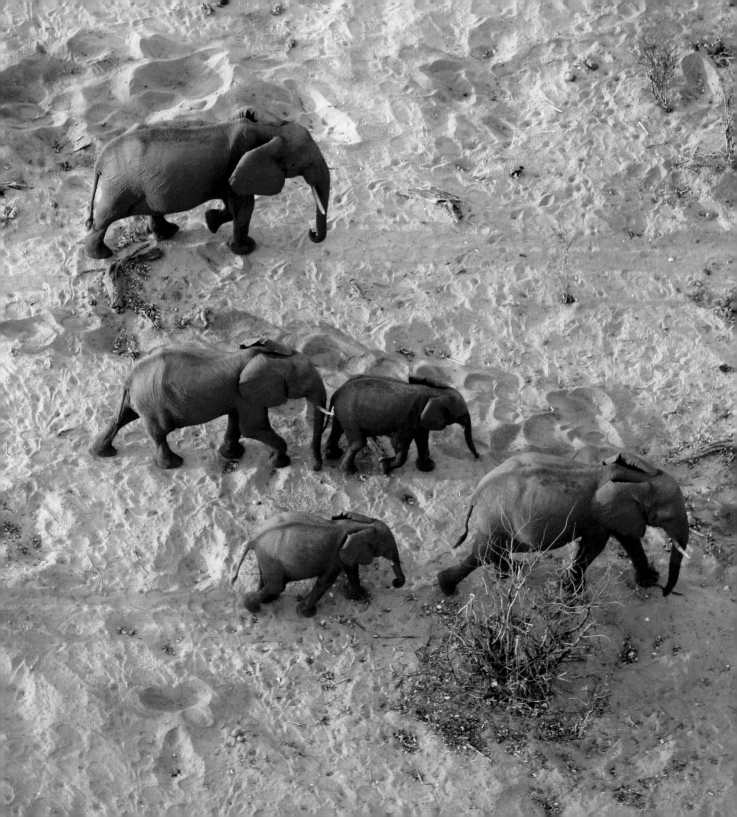

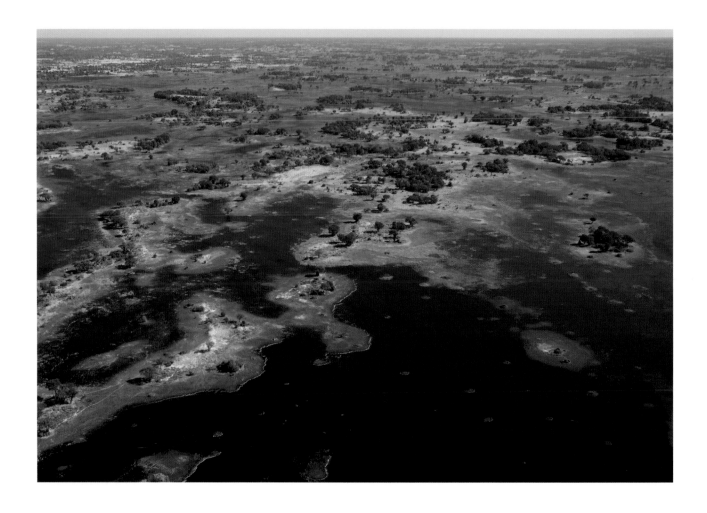

**ABOVE** FROM GRASSLAND TO SWAMPLAND The Okavango inland delta, transformed by the rains. Water originating in the highlands swells the huge river and causes it to spill out across 15,000 square kilometres (5792 square miles) of grassland.

**RIGHT** THE GREAT OKAVANGO One of Africa's most breathtaking views when seen from the air – the Okavango in flood. The dynamic shallow-water savannah system is habitat for several thousand species of plants, 450 birds, 164 mammals, 65 fish and a diversity of insects.

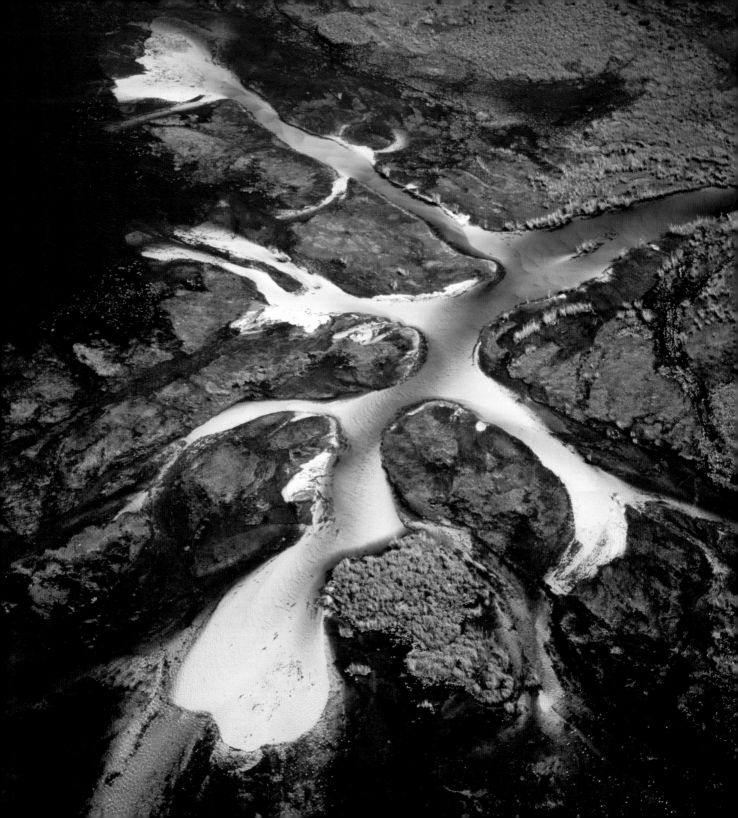

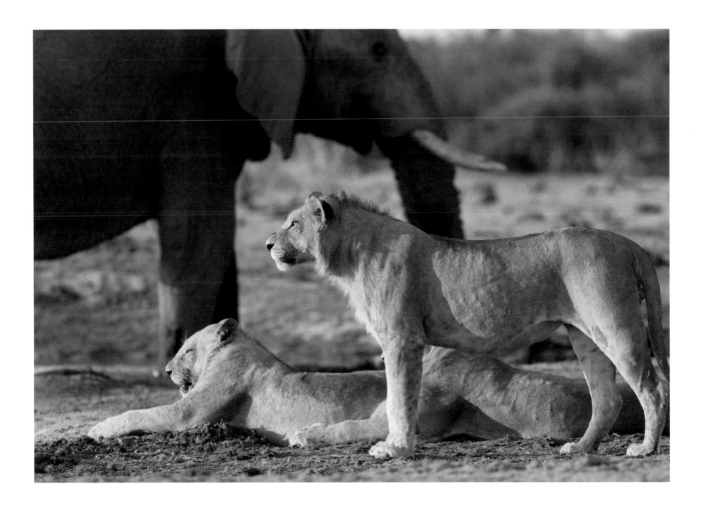

**ABOVE** STAND-OFF Elephants forced to cohabit with lions at a dry-season waterhole in Botswana's Chobe National Park. In the day, elephants rule the waterhole, and lions must creep around them to get a drink, but at night, darkness gives lions the advantage.

**RIGHT** DEATH OF AN ELEPHANT At the same waterhole, a pride of more than 30 lions brings down an adolescent female elephant. In the dry season in Chobe, when prey is scarce, lions may kill 30 to 40 elephants – often adolescents, which are more easily separated from the herds.

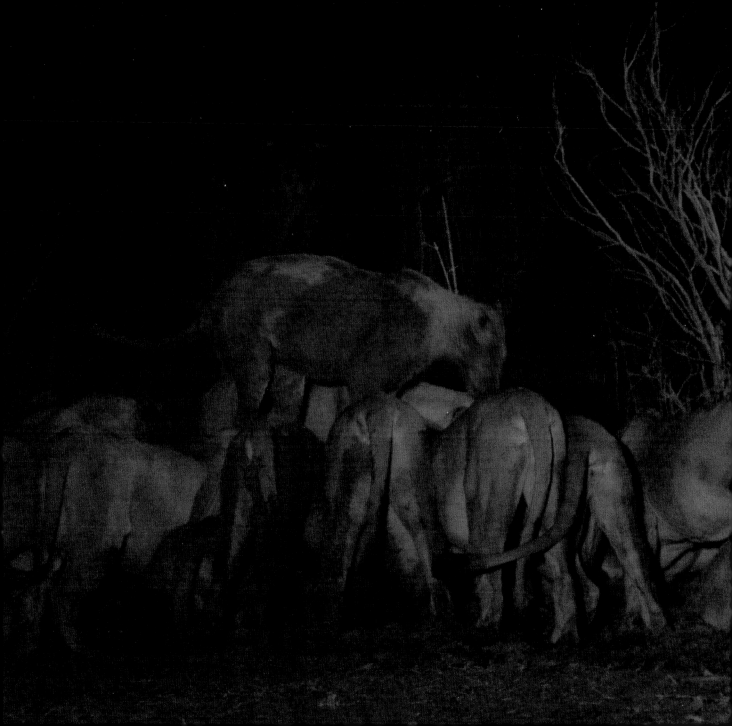

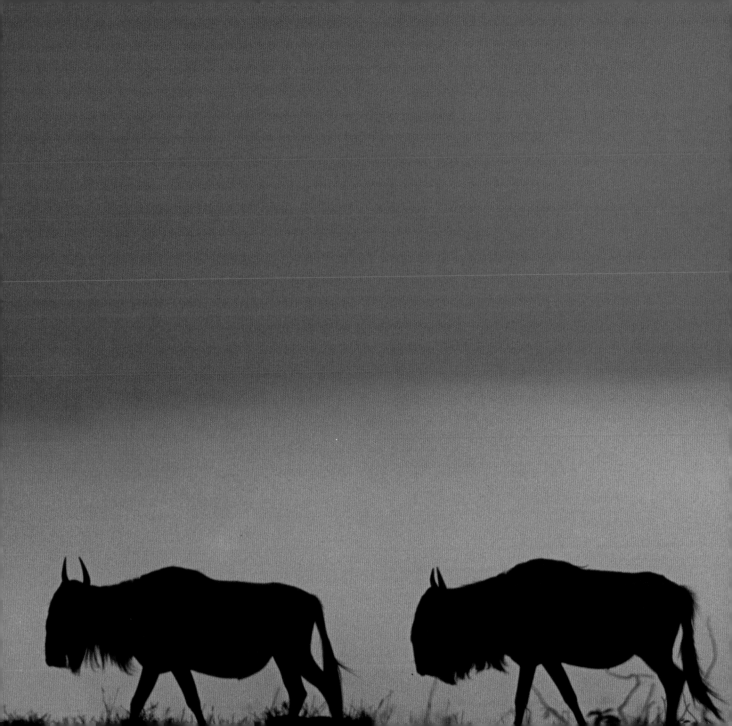

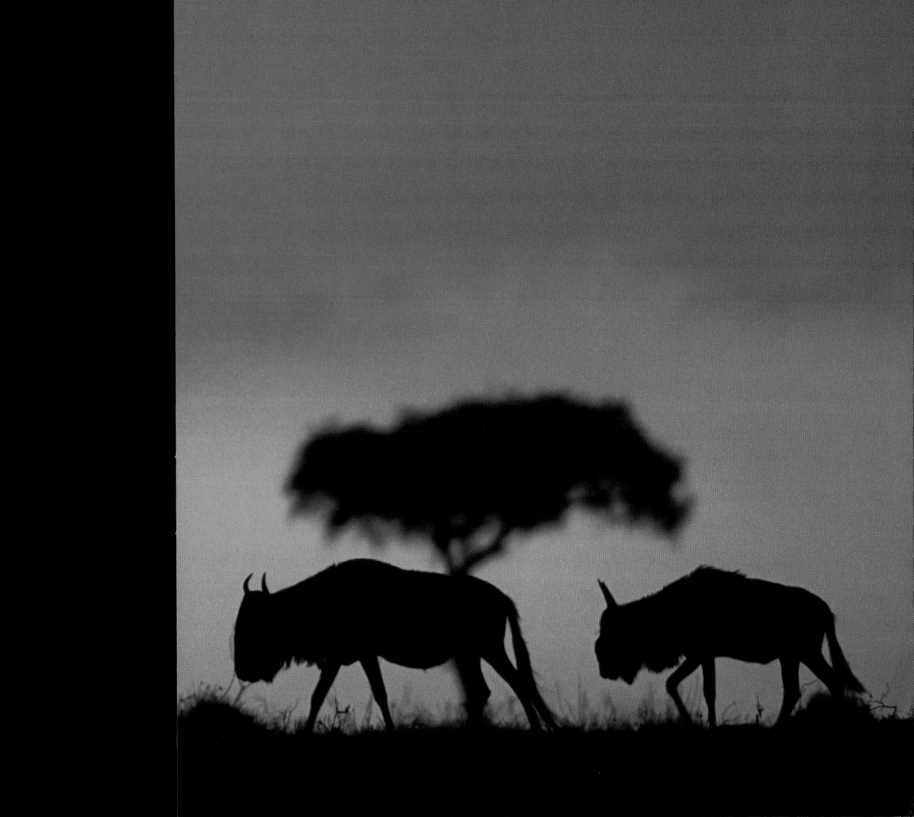

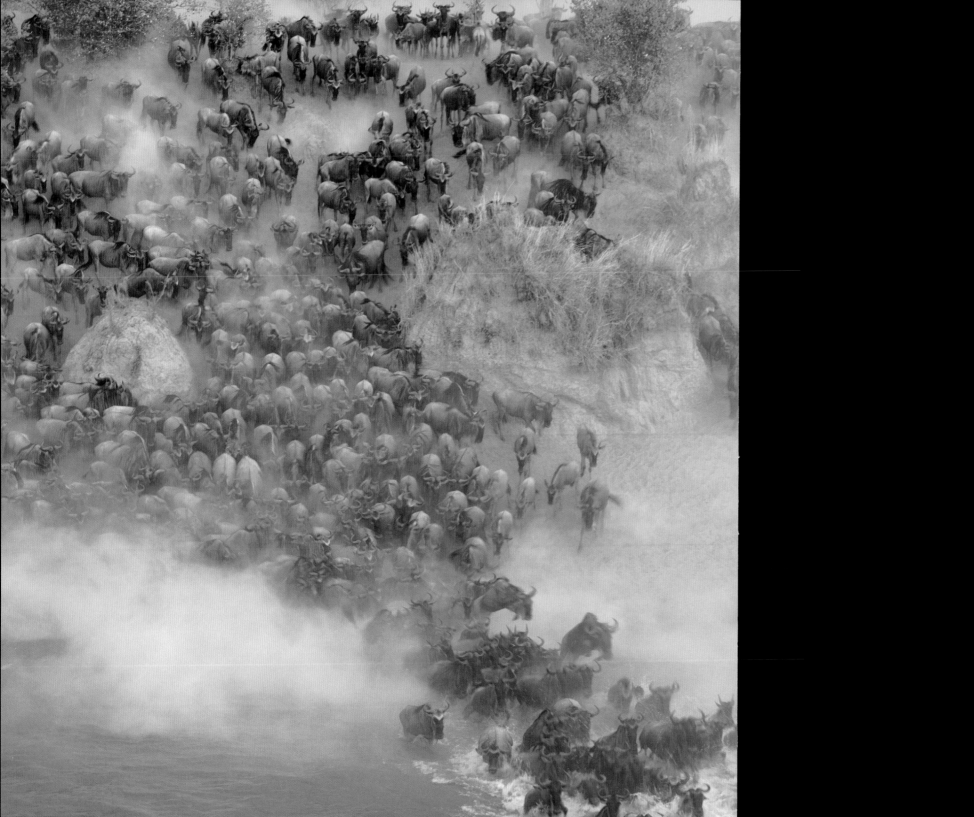

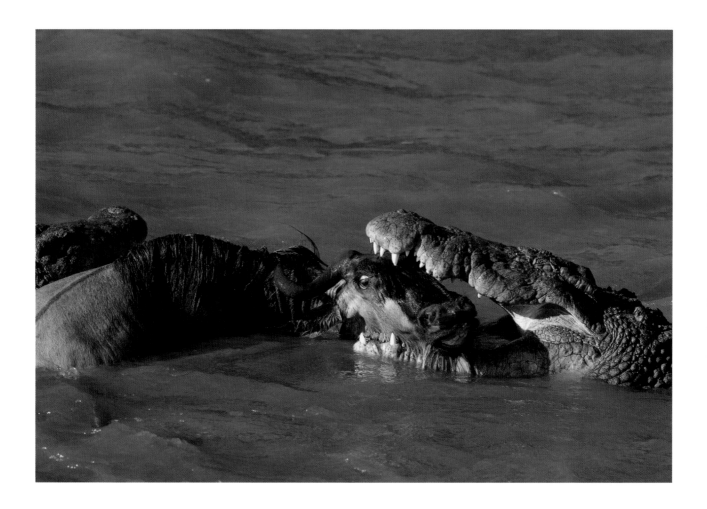

**LEFT & PREVIOUS SPREAD** THE GREAT MIGRATION Wildebeest following the rains – and hence fresh grass – on their annual migration in East Africa. At peak time, nearly 2 million are on the move, and pile-ups occur at river crossings as nervous beasts hesitate to take the plunge.

**ABOVE** ... AND THE ANNUAL FEAST Death in the jaws of an ambushing crocodile. Thousands of migrating wildebeest die in this way. But for the Nile crocodiles, who normally have just fish to feed on, this is their seasonal bonanza of meat.

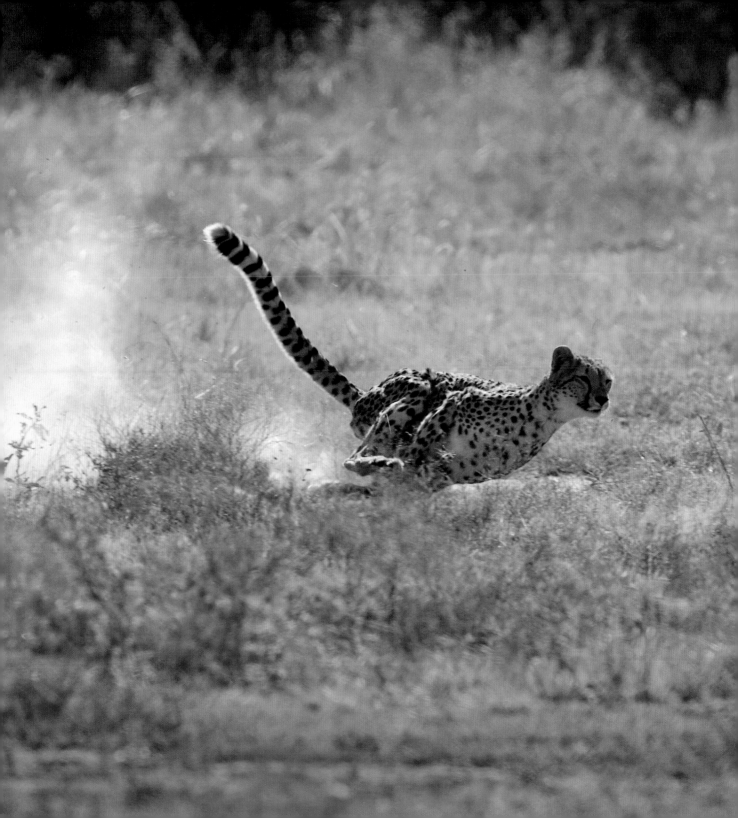

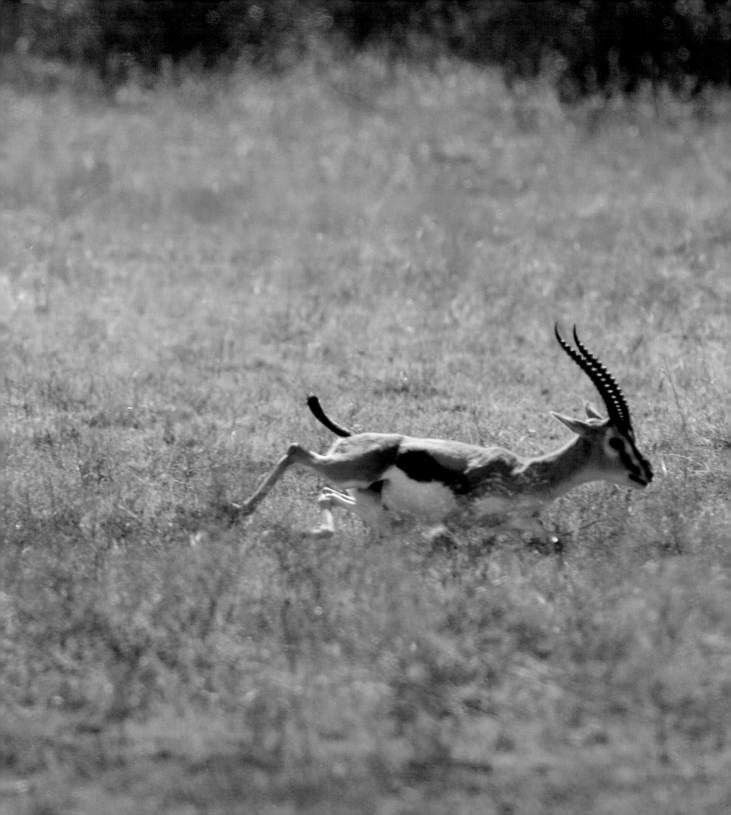

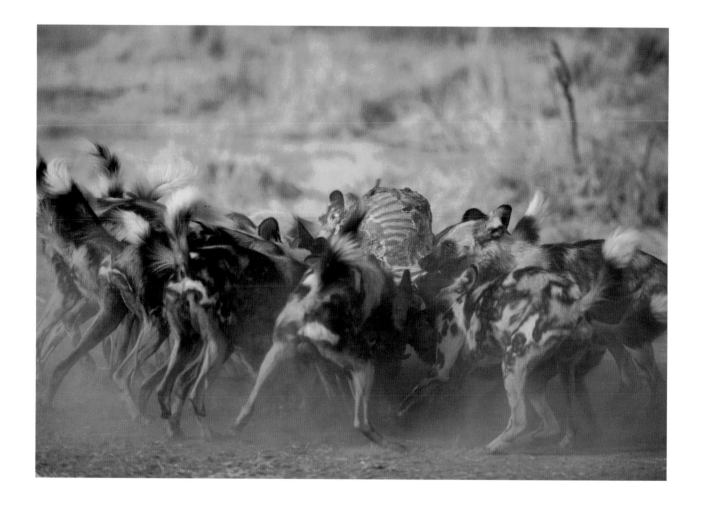

**PREVIOUS SPREAD** RACE FOR LIFE A cheetah on the heels of a Thomson's gazelle. On the open plain, there are no places from where a cheetah can ambush prey and nowhere for prey to hide. So sprinting has become its speciality, moulding it into the fastest creature on land.

**ABOVE** ALL AS ONE A pack of African wild dogs shares a kill in a frenzy of excitement. The way wild dogs catch fast-running prey on the plains is by hunting cooperatively. *Planet Earth's* aerial shots revealed for the first time just how fine-tuned the hunting dog strategy is.

'In the end, the reason why we shouldn't lose any more species is moral. We didn't create life. We've got no means to put it back. Therefore we don't have the right to destroy it.'

**TONY JUNIPER, FRIENDS OF THE EARTH**

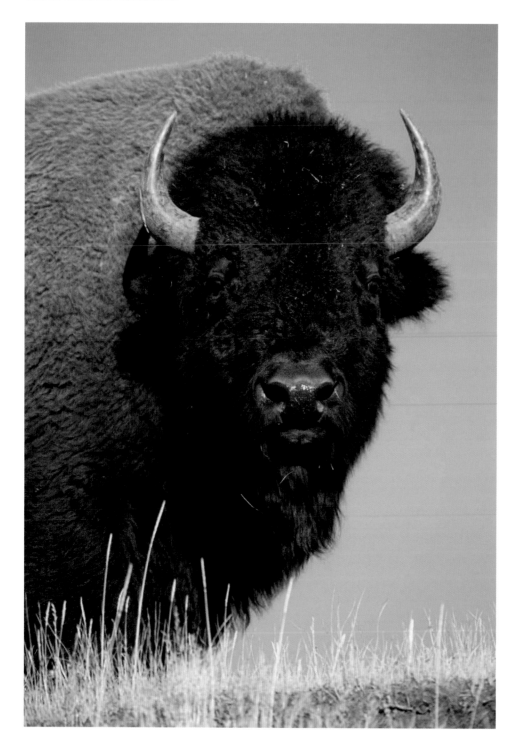

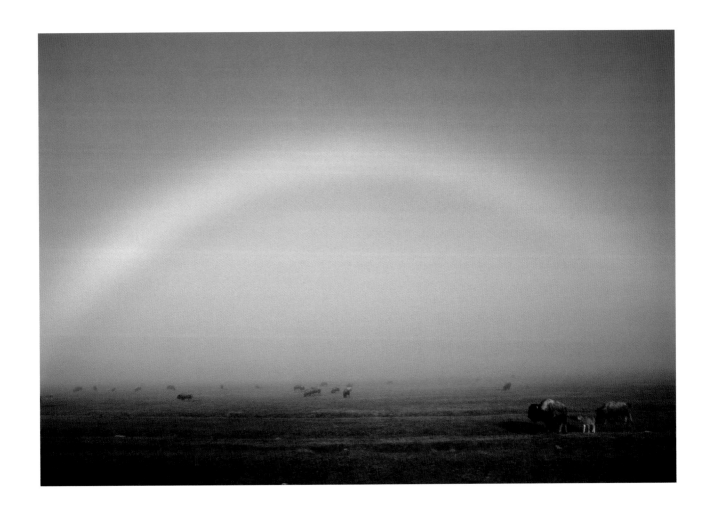

**ABOVE & LEFT** LAST OF THE GREAT HERD A relict herd of the North American plains bison. A century and a half ago, when more than 60 million bison wandered the grasslands, people spoke of enormous herds taking five days to pass by. Today the population numbers 350,000.

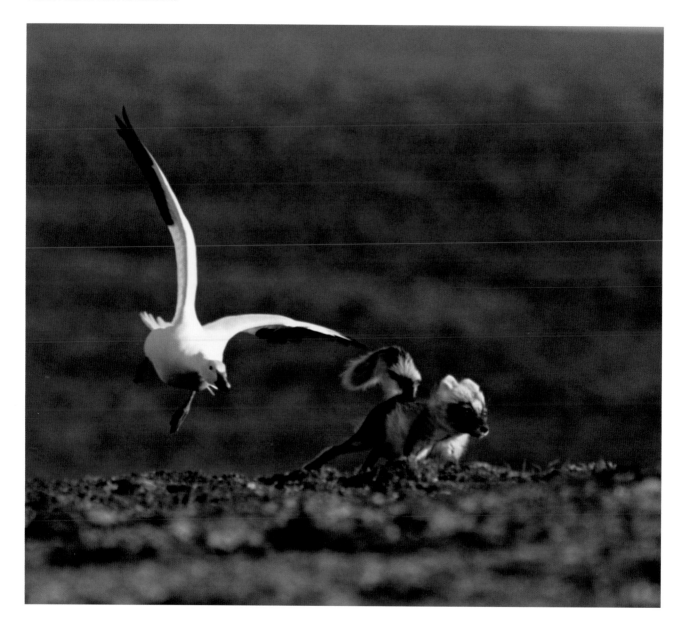

ARCTIC EGG-THIEF Beating wings and sharp beaks drive off a thief.
Safety in numbers also means that the huge colonies of snow geese that
nest on the tundra suffer comparatively low losses, but their eggs still
provide the resident Arctic foxes with an annual feast.

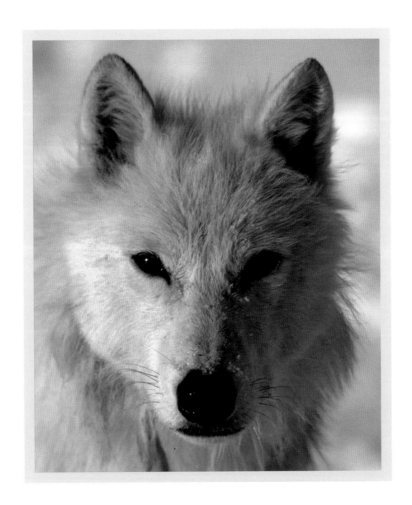

CARIBOU HUNTER Arctic wolf on the lookout. The annual feast for
wolves in the high Arctic comes with the arrival of the caribou. But being
tied to the movement of the herds means they must leave their pups for
days at a time as they trek across the tundra after caribou calves.

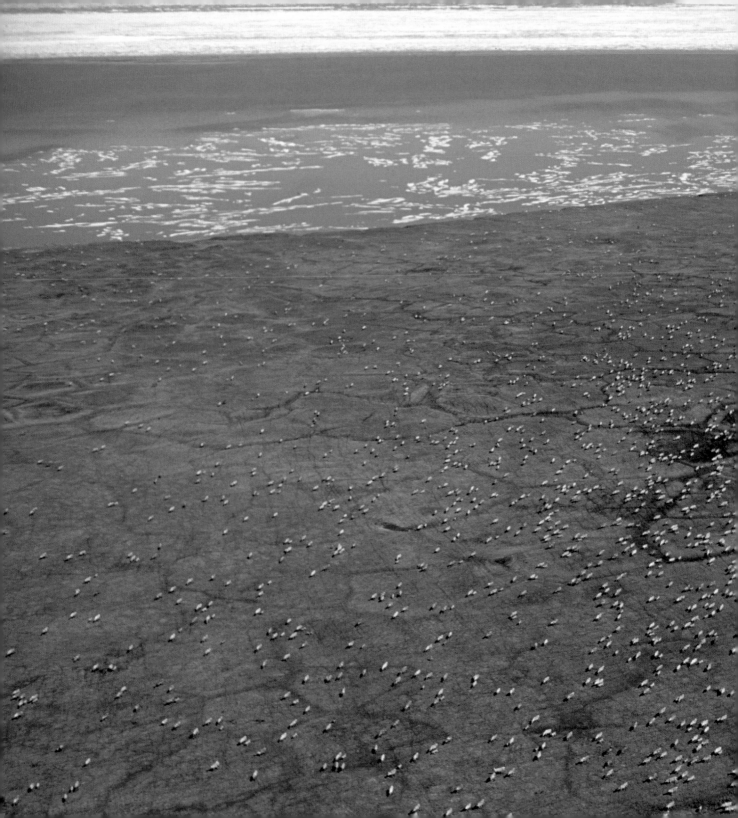

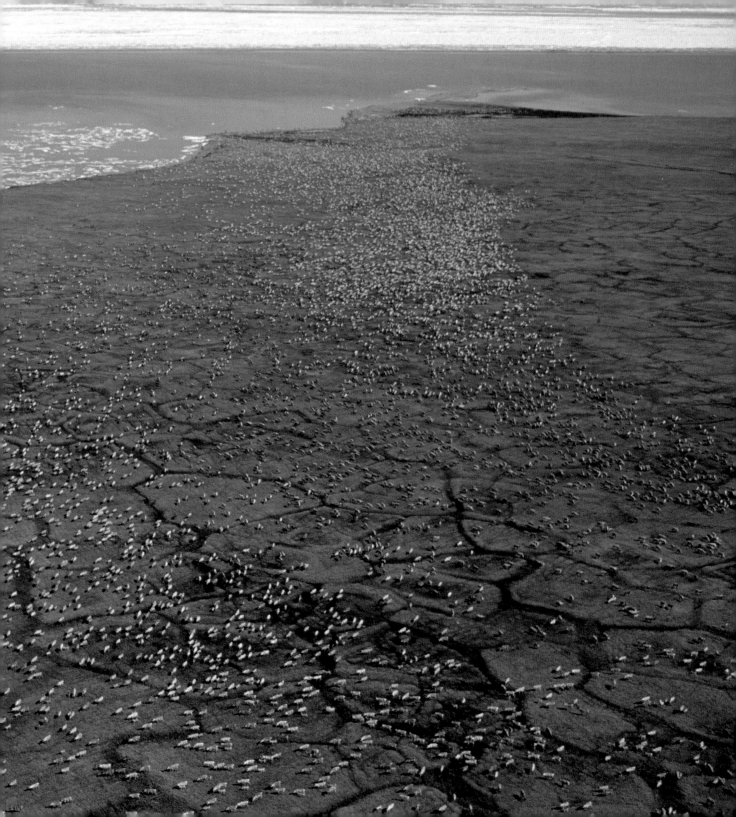

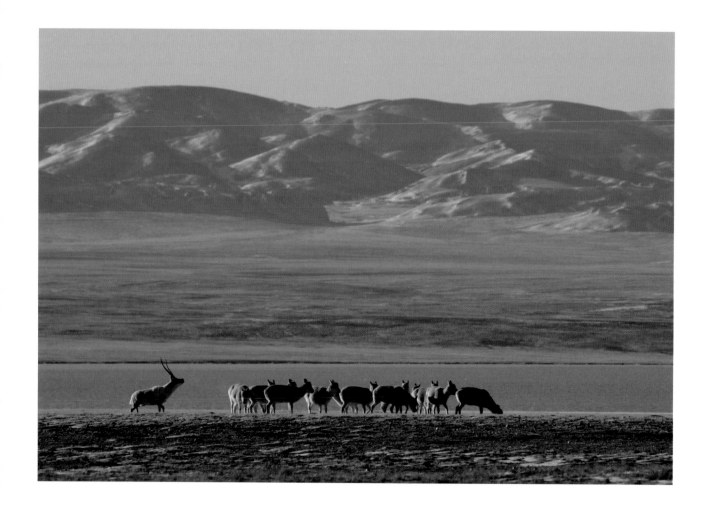

**PREVIOUS SPREAD** THE LONGEST MIGRATION OF ALL
The Porcupine Herd on the move north to its tundra calving grounds.
Every year, 3 million caribou embark on the longest of all land migrations
so they can give birth as far as possible from the majority of predators.

**ABOVE** TIBETAN SURVIVORS A male chiru, or Tibetan antelope,
guards his harem on the Tibetan plains. Poaching for the chiru's fine wool
(shahtoosh) has decimated the population – down from several million
to 75,000 – but herds still migrate annually across the plains.

'Wilderness is more than important, it's vital. The natural ecosystems of the Earth are what keep the climate and the composition of the atmosphere and the oceans just right for life, and it's been happening like that through the great system Gaia for nearly a quarter of the age of the universe.' JAMES LOVELOCK

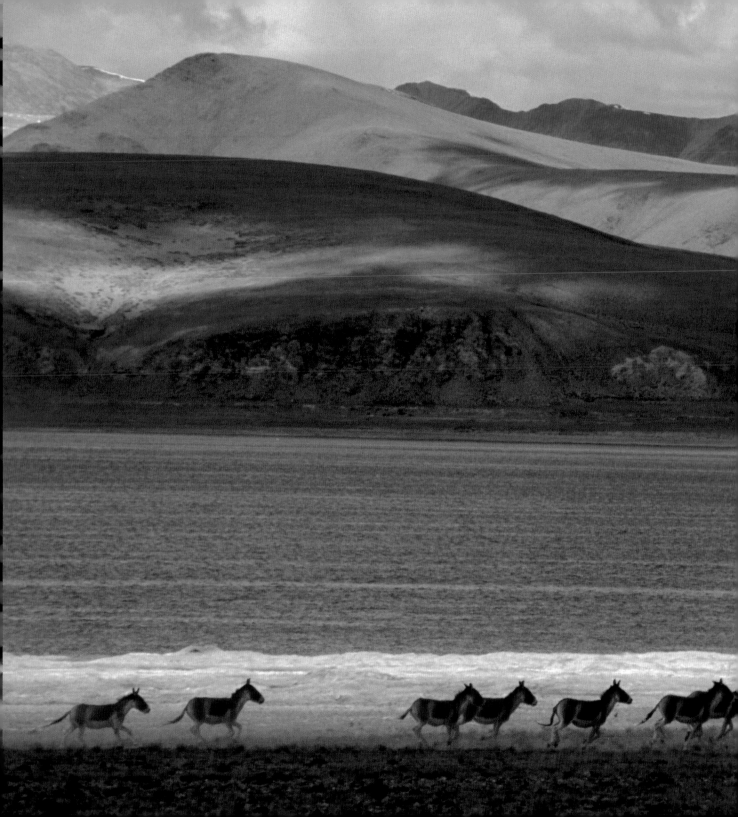

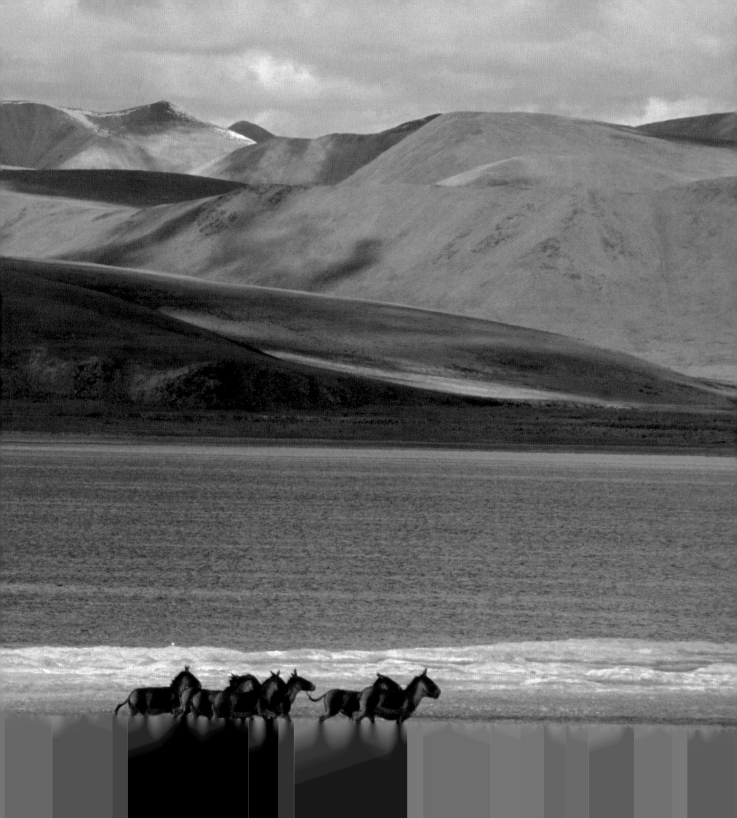

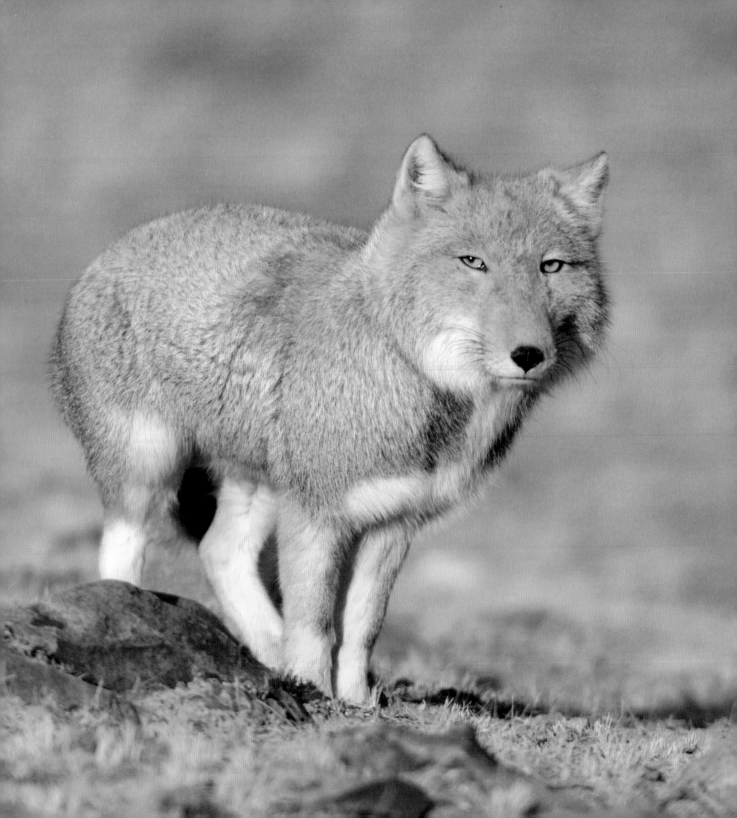

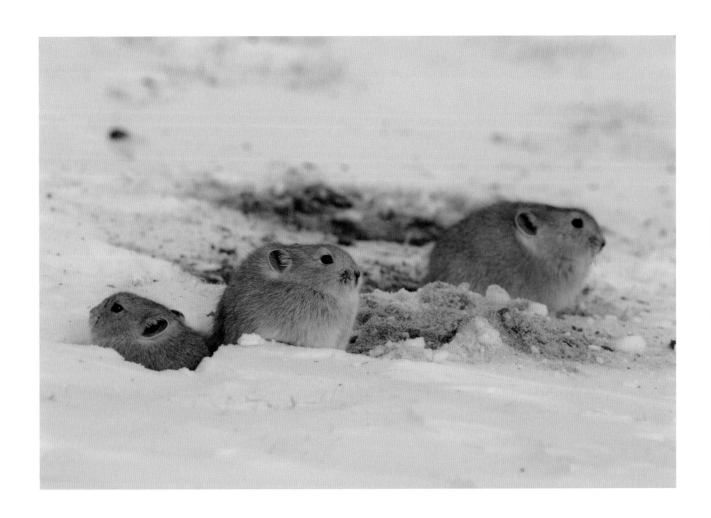

**PREVIOUS SPREAD** PLAINS ASSES Kiangs – largest of the wild asses. They roam in herds across the vast steppes and alpine meadows of the Tibetan Plateau, eating almost exclusively grass.
**LEFT** PIKA PREDATOR The unmistakable Tibetan fox.

**ABOVE** PREY FOR ALL Pikas on watch at the burrow entrance. Being the favourite prey of most of the predators on the Tibetan Plateau gives these rodents a central role in the ecosystem. Their burrows also aerate the soil and provide refuge and nest cover for birds, reptiles and insects.

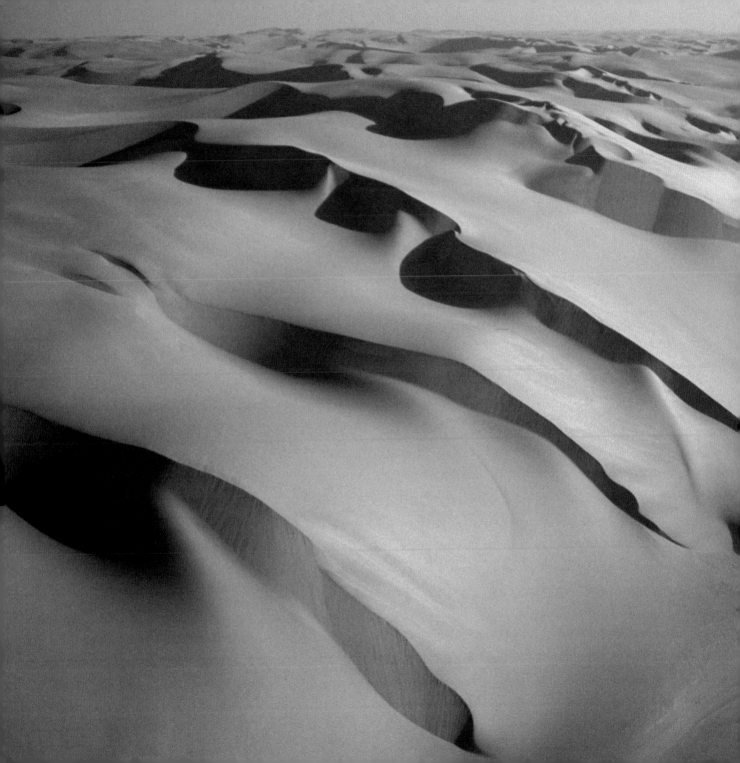

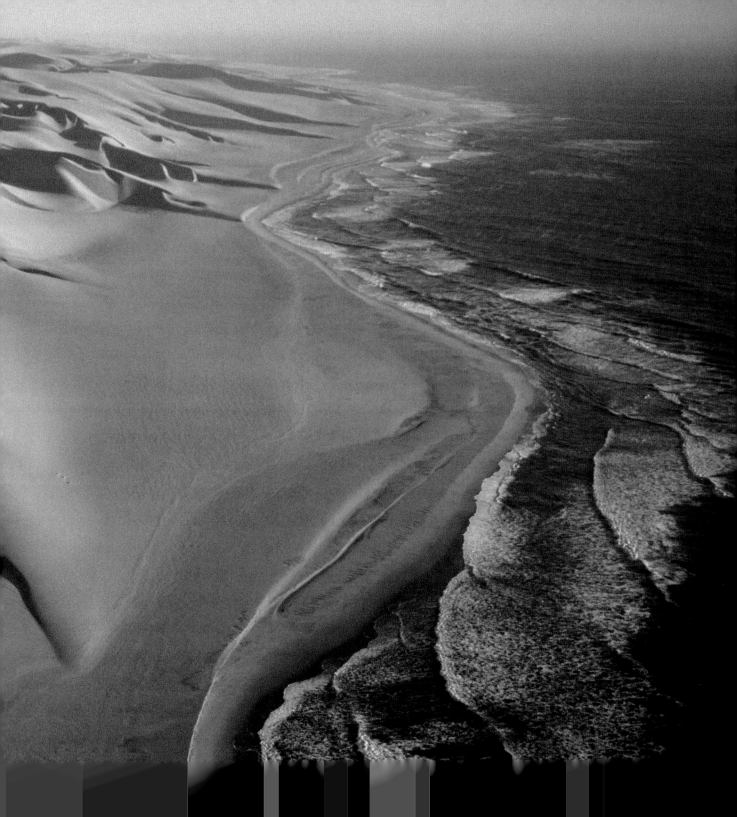

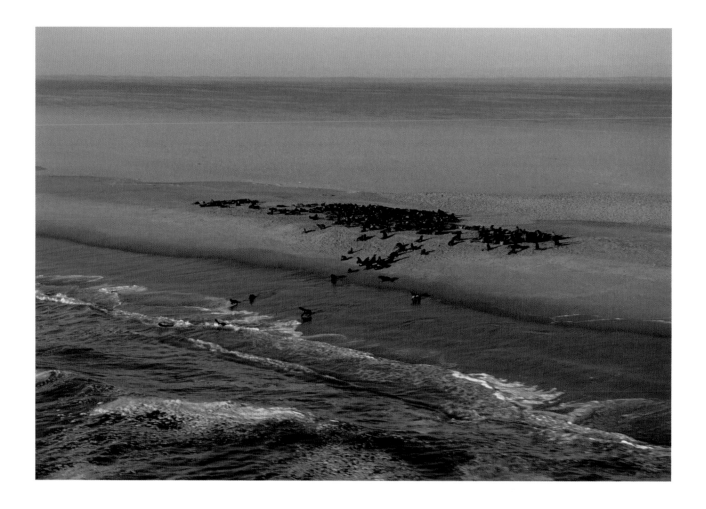

WHERE DESERT MEETS THE SEA The Namib Desert coast is one of
the driest places on Earth, where winds blow from land to sea and cold
currents pull moisture out of the air. This is, though, the perfect location
for a fur seal colony, with plentiful ocean food and few land predators.

DESERTS ARE THE EASIEST REGIONS ON EARTH TO RECOGNIZE FROM SPACE, COVERING A THIRD OF THE LAND AND EXPANDING EVERY YEAR.

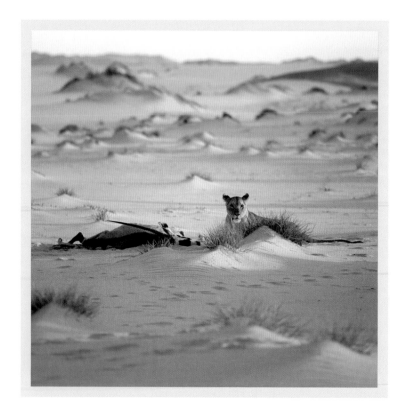

**ABOVE** DESERT LION, DESERT ORYX Namib lion with its staple prey, oryx. These desert lions cope with desert life by searching for prey over huge areas. The oryx survive by eating any vegetation available, including roots and tubers, and trekking long distances to find water.

**RIGHT** DESERT ELEPHANT A Namib elephant in search of water. These elephants have smaller bodies than plains elephants and larger feet for walking on sand, and can go for days without water. They dig for the roots of grass and other plants, to obtain moisture as well as nutrition.

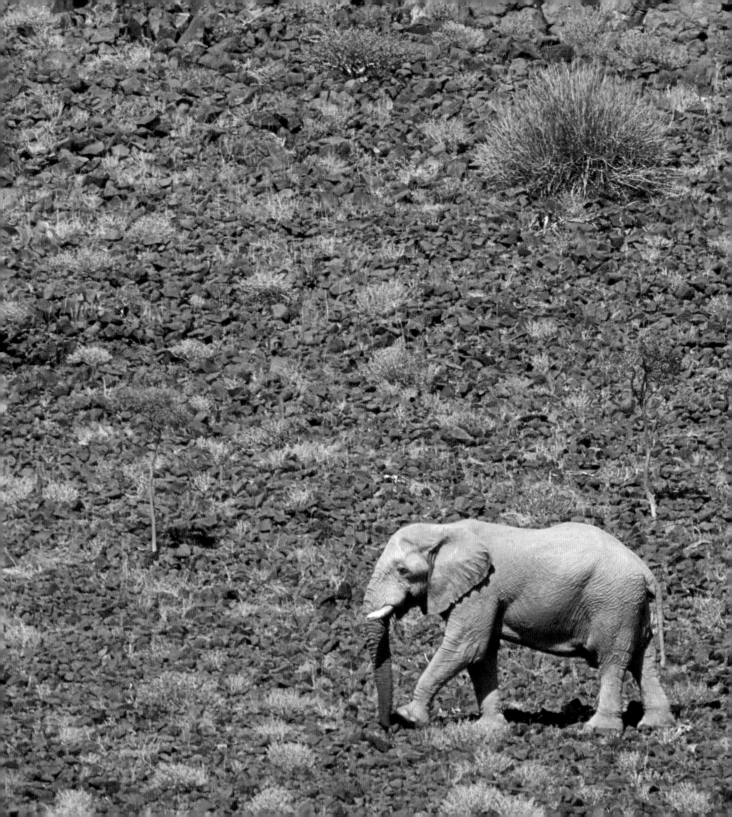

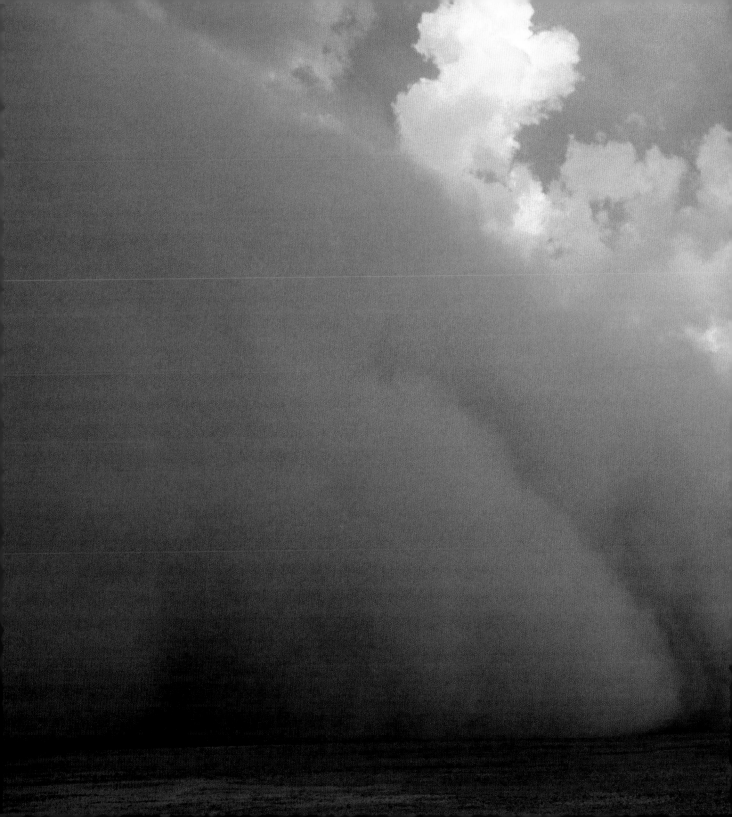

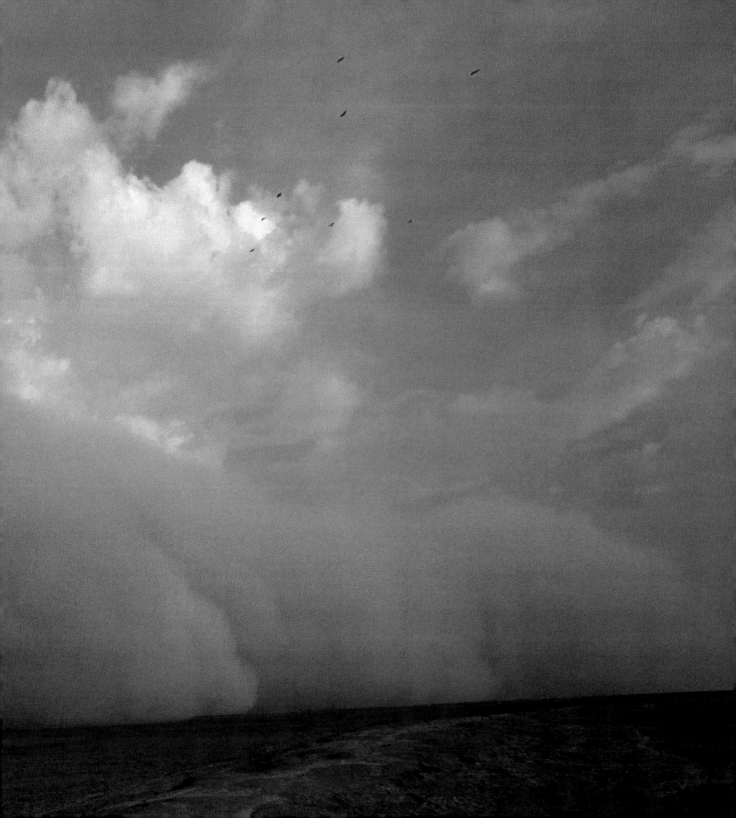

'Beyond the ecosystem services and all the goods that we can get from the natural world, it's really a living library, and it's just ridiculous to burn the books.' THOMAS LOVEJOY, CONSERVATION BIOLOGIST

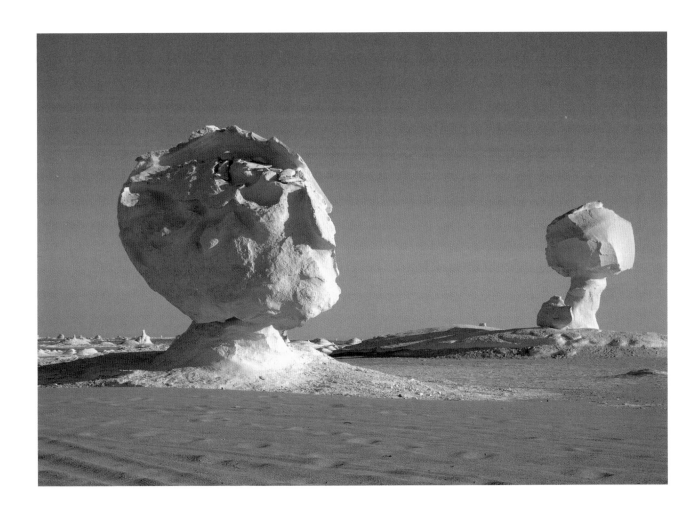

**PREVIOUS SPREAD** WALL OF SAND A rolling wall of sand in the Sahel, Mali. The largest sandstorms occur in the Sahara and can be a mile high – easily visible from space. Some travel thousands of miles across the Atlantic as far as Brazil, fertilizing the Amazon in the process.

**ABOVE** ALIEN FORMS Giant chalk mushrooms – all that remain of an ancient seabed in Egypt's Western Desert, sculpted over time by wind-blown sand. In deserts, baking sun, cold nights and the force of water and wind have created some of the world's most spectacular landscapes.

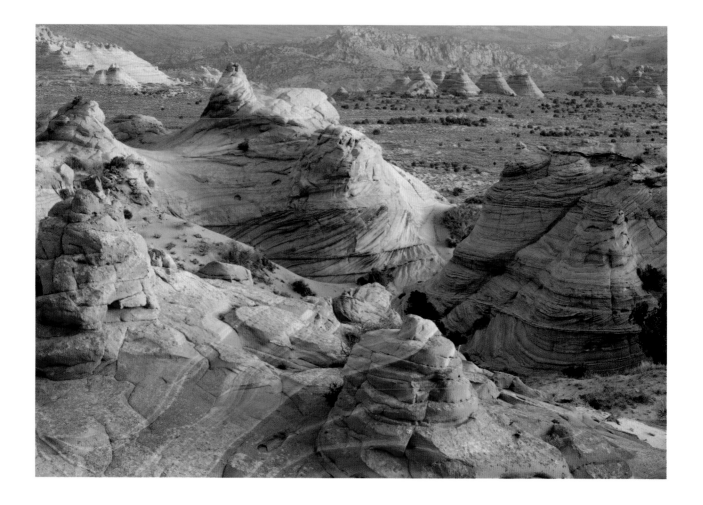

WATER SCULPTURE Petrified sand dunes in Arizona, eroded by the force of ancient river torrents that flowed millions of years ago. Water has played a surprisingly significant role in shaping dramatic desert landscapes in times past, especially in North America.

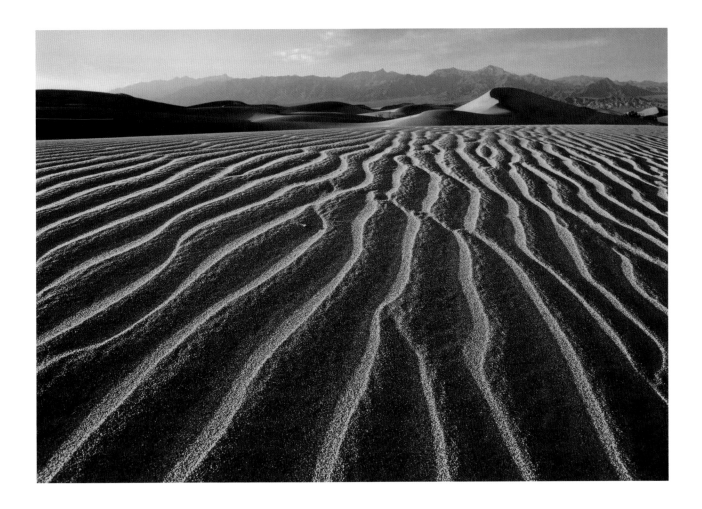

**ABOVE** DESERT HEAT California's Death Valley – a contender for one of the hottest places on Earth. In July 1913, a sizzling 57°C (135°F) in the shade was measured here, though the record is claimed by El Azizia in Libya, with a top shade temperature of 57.8°C (136°F).

**OVERLEAF** SAGUARO FOREST Giant water-storing cacti in Saguaro National Park, Arizona. Saguaro can be 15 metres (50 feet) tall and live to be 200 years old, taking the place of trees in a desert landscape and providing food and nesting places for many animals.

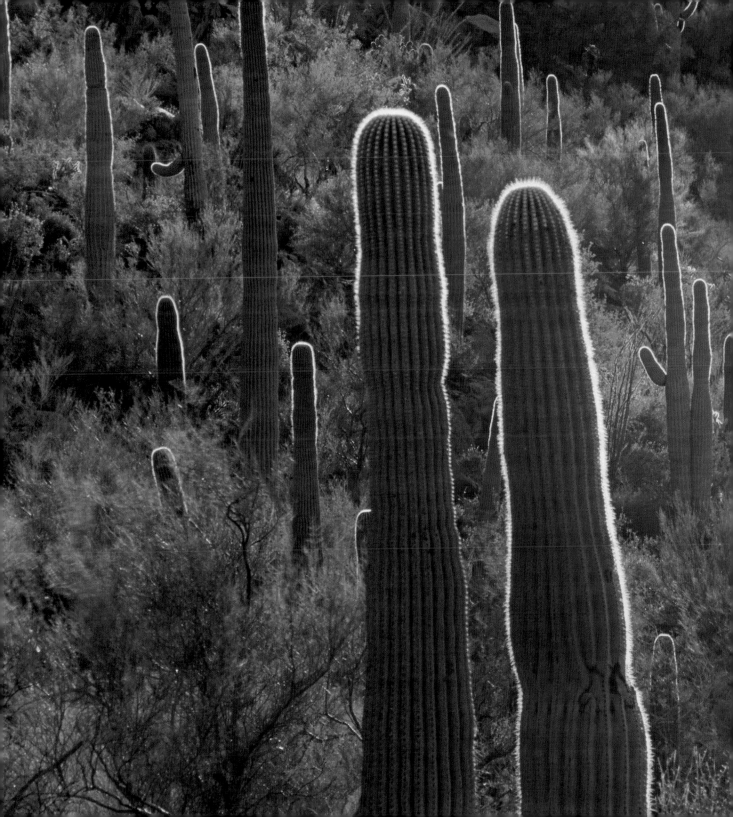

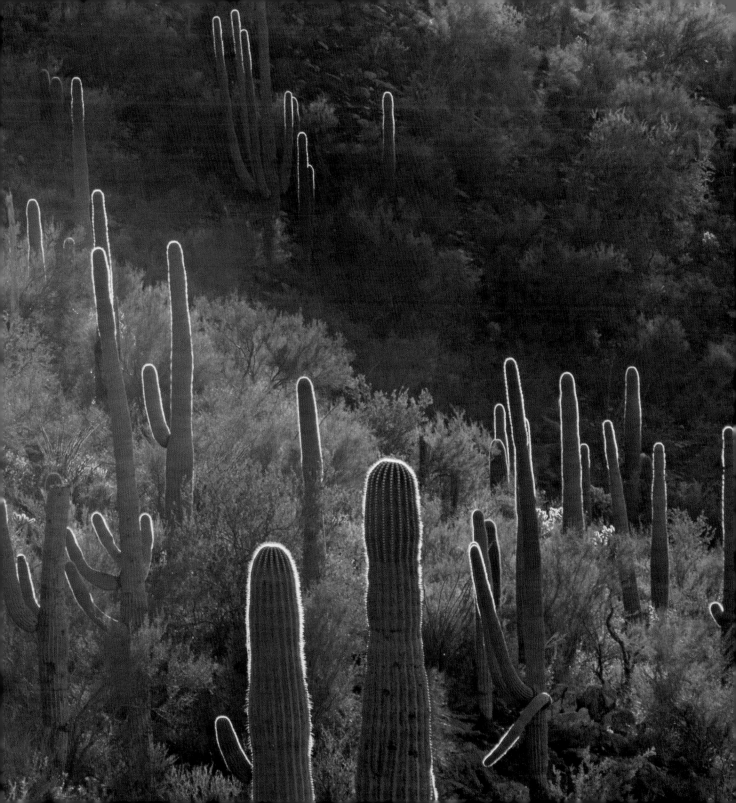

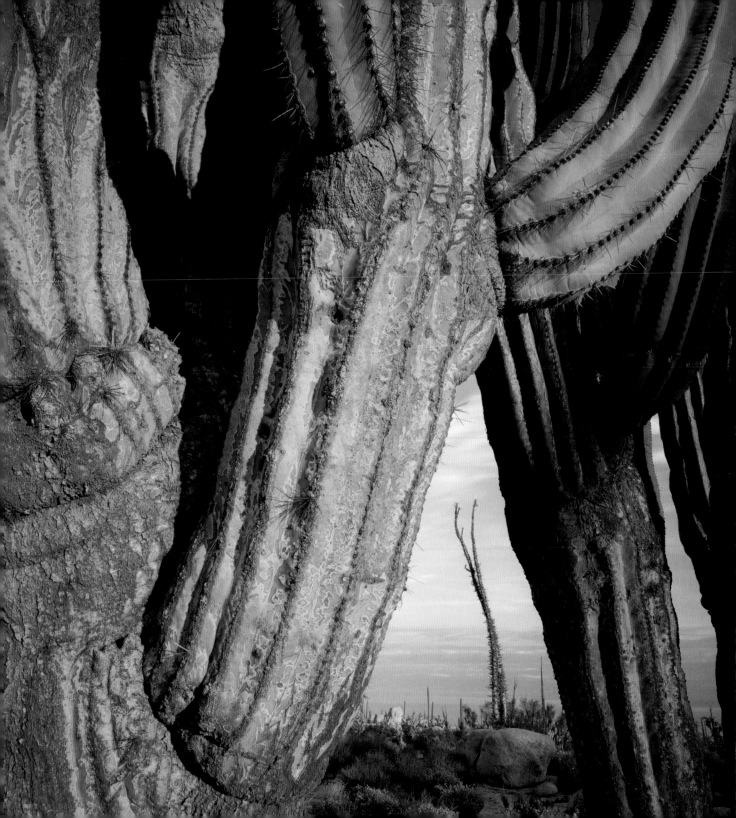

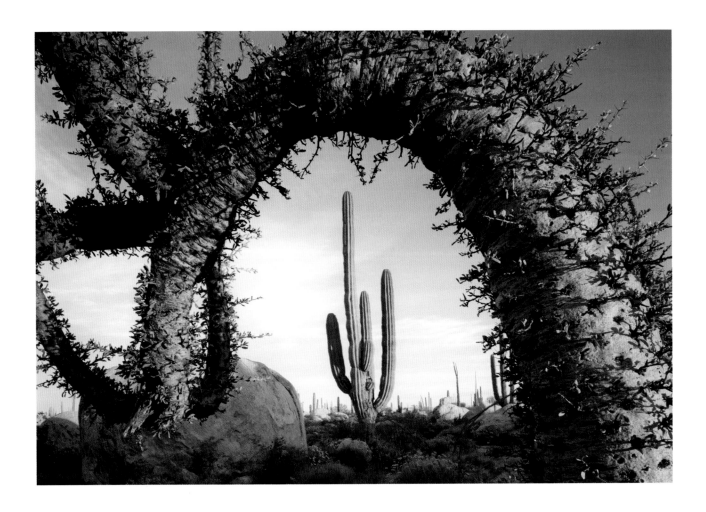

**LEFT** WATER RETENTION The weathered, pleated skin of cardon cacti. Like saguaro cacti, they are superbly adapted for water storage, with pleated, concertina stems and extensive root systems for taking up the huge quantities of water that may fall in a desert storm.

**ABOVE** BOOJUM MAGIC A boojum 'tree' after desert rain. The strategy of this succulent, from Mexico's Baja California peninsula, is to remain dormant for most of the year, protected by its thick bark, but produce lots of tiny leaves on its twiggy branches immediately after rain.

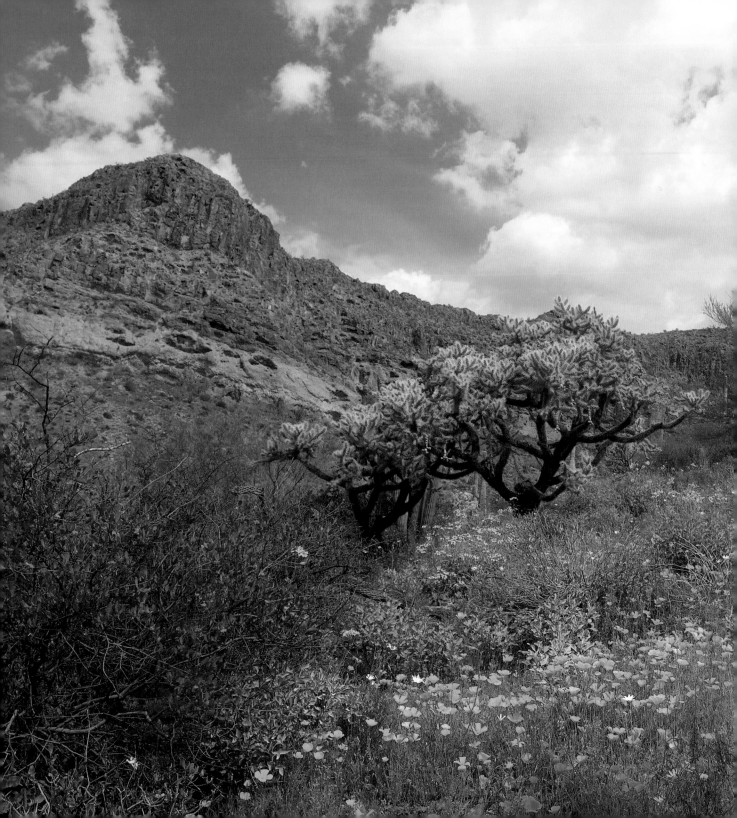

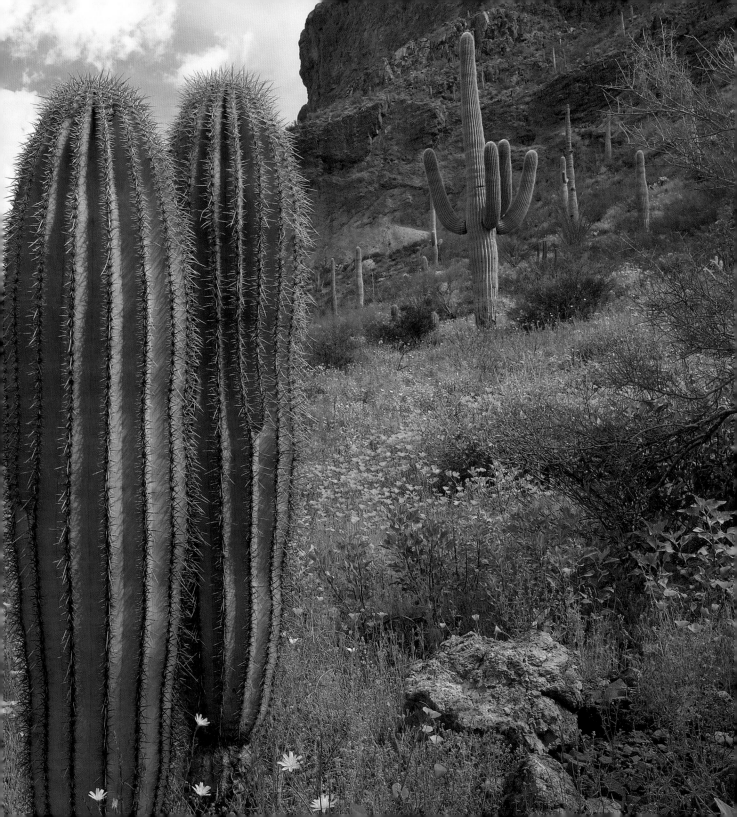

'We have such a narrow vision of what fertility is about. We think in terms of deep soil. Most of the planet manages to get by on substrates we wouldn't even recognize as soil, and that moment the dormant seeds in a desert are brought into this astonishing flowering is to me a symbol of the fact that, even in the most deprived conditions, life manages to be triumphant.' RICHARD MABEY

PREVIOUS SPREAD DESERT FLOWERING Swollen saguaro cacti and teddy-bear cholla in the Sonora Desert, surrounded by desert flowers including Arizona poppies, brought to life after a sudden storm. RIGHT A cholla surrounded by flowering brittlebush and red owl's clover.

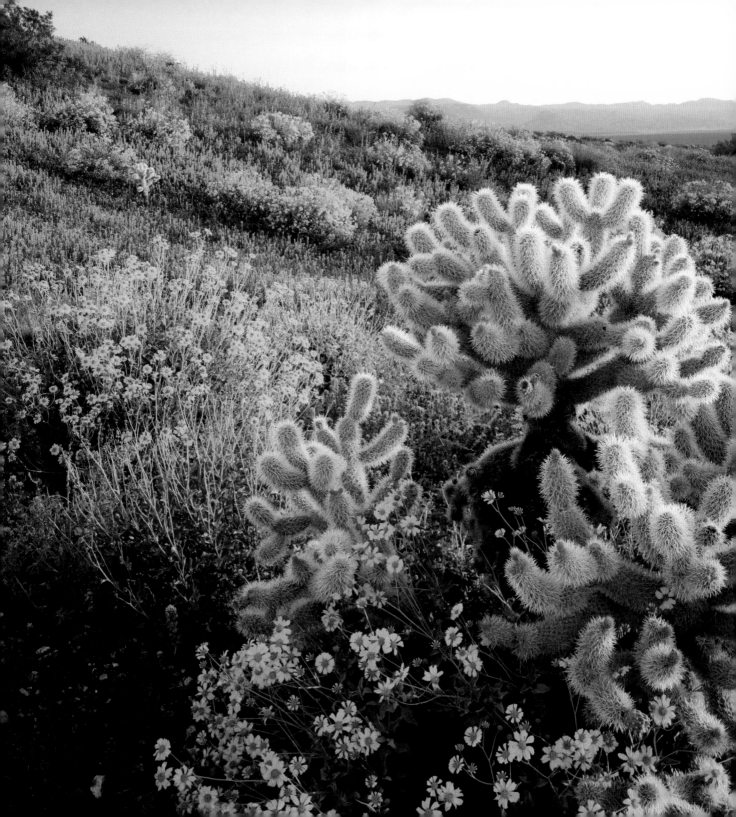

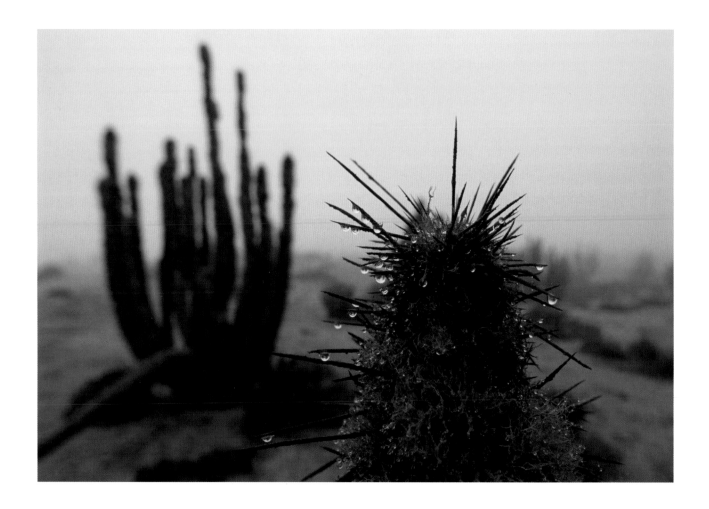

**ABOVE** FOG-CATCHERS An Atacama Desert cactus, *Eulychnia*, with its only source of water: dew from early morning fog sweeping in from the sea. The cold Pacific water at the edge of the desert acts as a permanent rain barrier, making the Atacama the driest desert in the world.

**RIGHT** ATACAMA DUST DEVIL A typical desert dust devil whirling over the interior of Chile's Atacama Desert, caused by extremely hot air near the surface rising quickly through a pocket of cooler low-pressure air. Less than 2mm of rain is an annual average here.

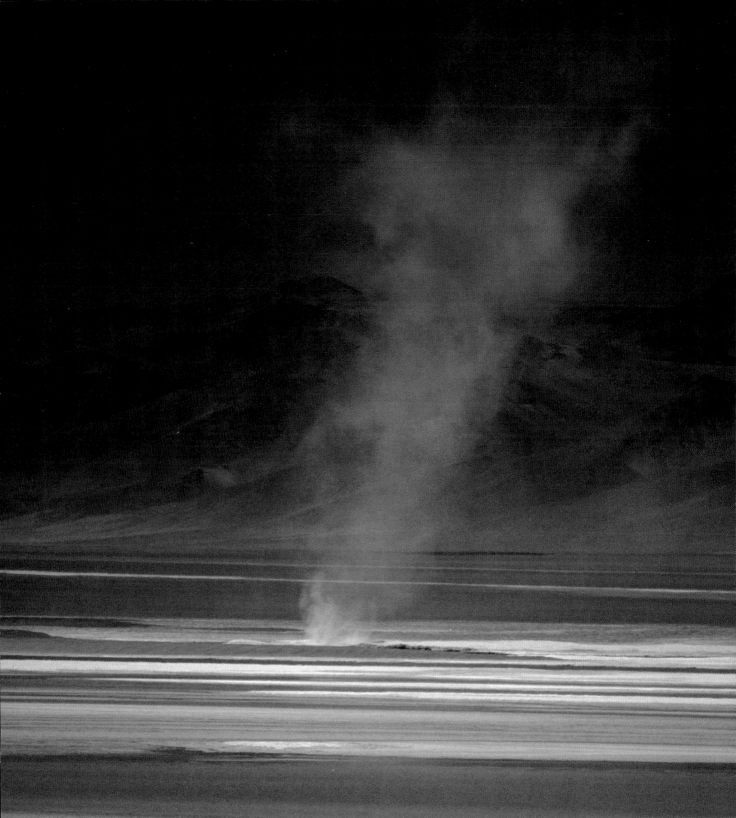

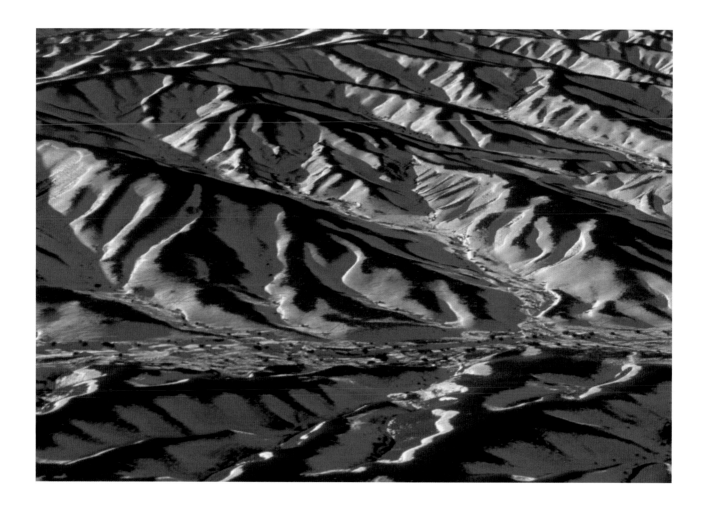

FROZEN DESERT The Gobi in winter, one of the coldest places on
Earth and certainly the coldest desert, falling from 40°C (104°F) in the
summer to -40°C (-40°F) in the winter. Some rain does fall but is locked
up as snow, which covers this huge desert for two months of the year.

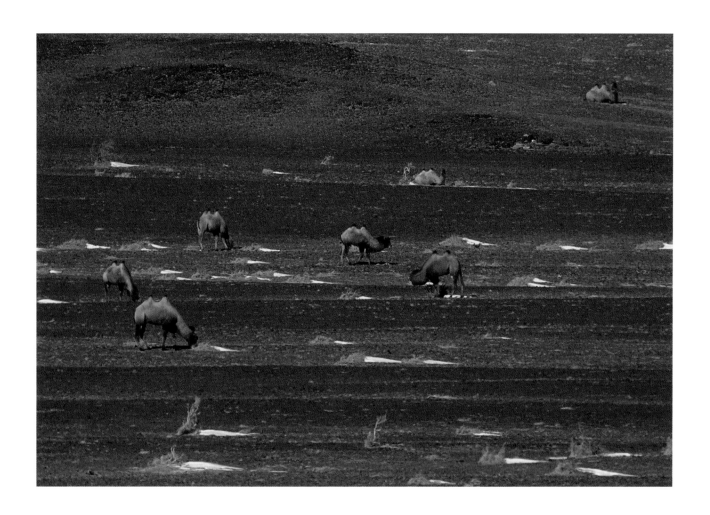

GOBI SURVIVORS Two-humped Bactrian camels – the last truly wild camels – eating snow. Just a few populations remain in China and Mongolia, filmed in the Gobi by the *Planet Earth* team. They are adapted to both extreme cold and extreme heat as well as drought.

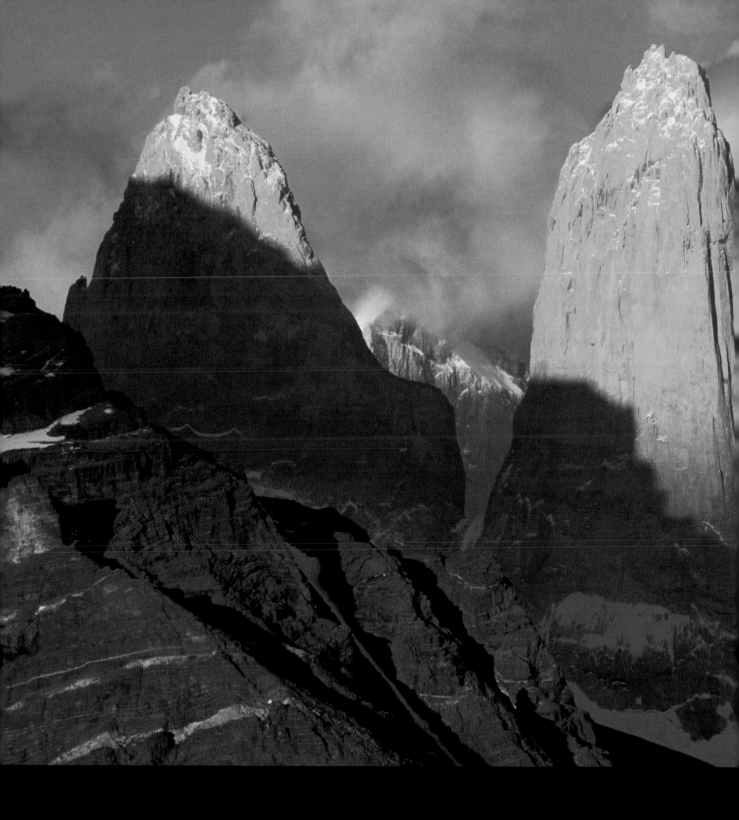

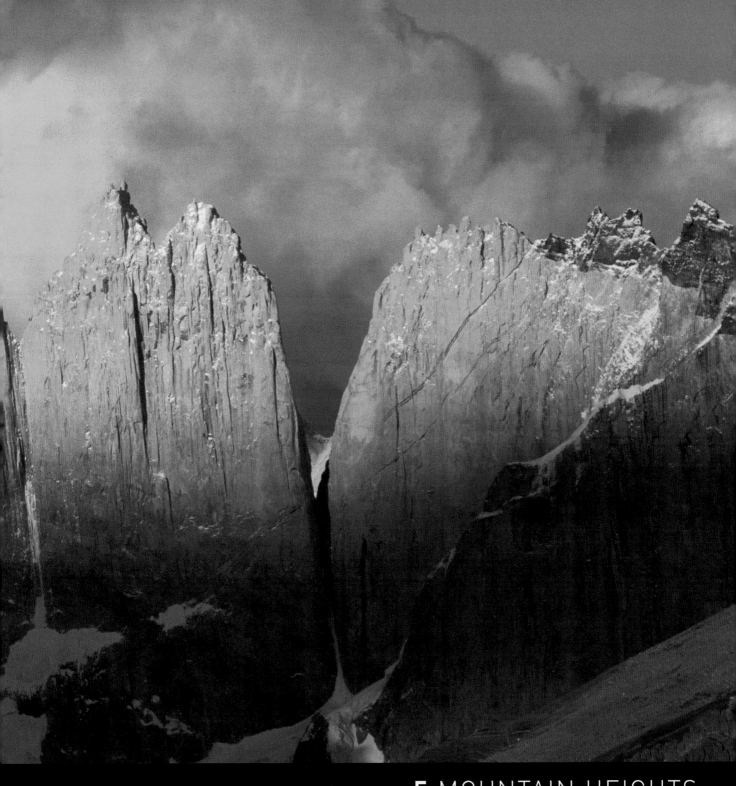

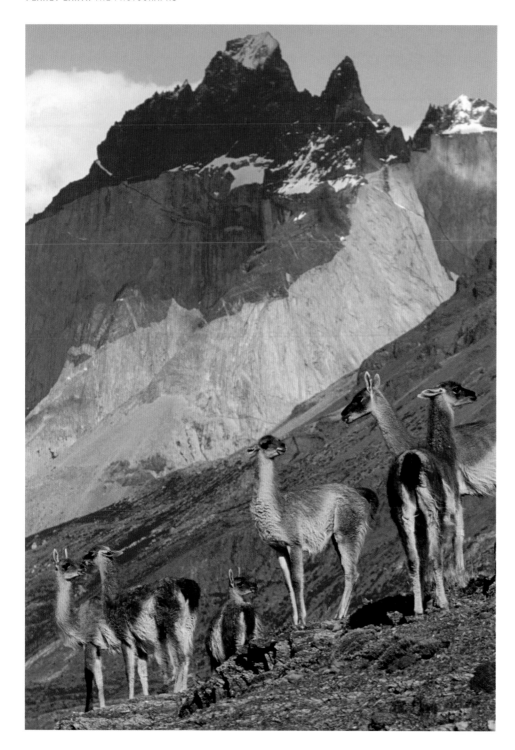

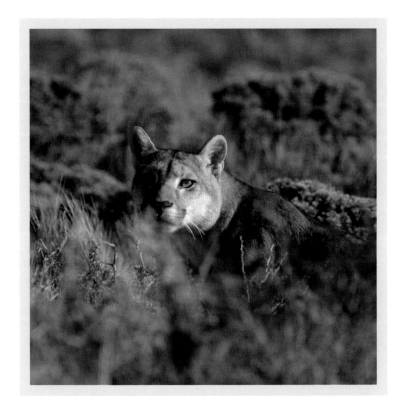

**LEFT** MOUNTAIN CAMELS A bachelor herd of guanacos grazing below the three towers of Torres del Paine in the Andes – the longest mountain chain on Earth. They are adapted to alpine conditions, with dense, woolly coats that help them endure subzero temperatures.

**ABOVE** MOUNTAIN LION The Patagonian puma filmed with her cubs by *Planet Earth*. Puma is the Inca word for 'powerful', and the main prey animals for this race of mountain lion – the largest of all the races – are guanacos. Being large also helps it conserve heat in winter.

'The expenditure of ... up to even a few million, dollars today, if it can bring a species through that has been on Earth for say a million years and has so much to give us, if we can keep it alive, in every sphere of human consciousness – aesthetic, scientific, relation to the environment – yeah, that's a very good investment. It's sure a better investment than conducting wars.'

# PROFESSOR E.O. WILSON

**RIGHT** ROCKY MOUNTAINEER A mountain goat high up in the Rockies – a series of mountain chains that extends down the western edge of North America. It is not a true goat but is adapted for mountain life with traction pads, a deep chest, massive shoulder muscles and a double coat.

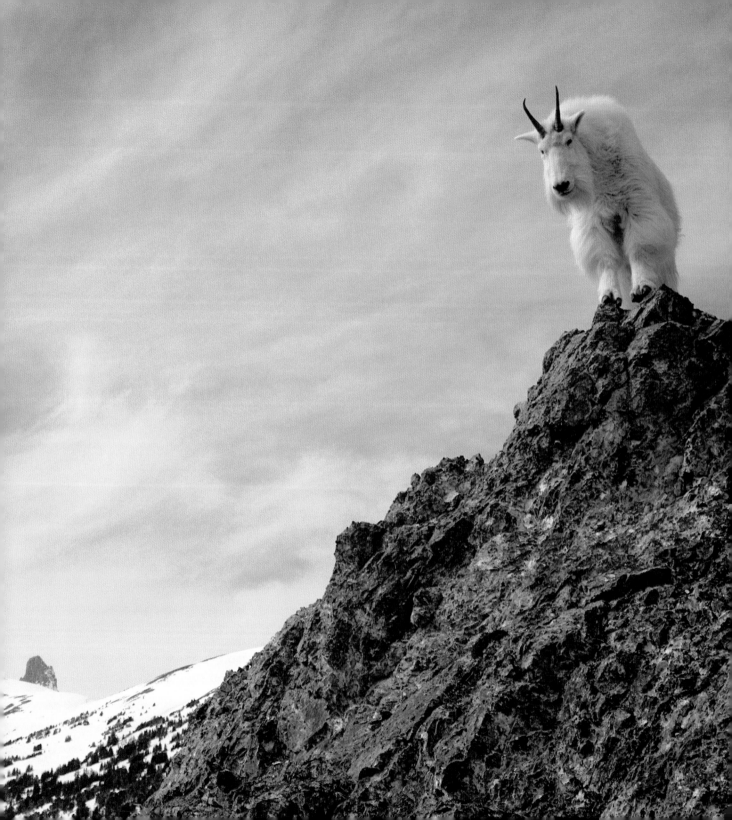

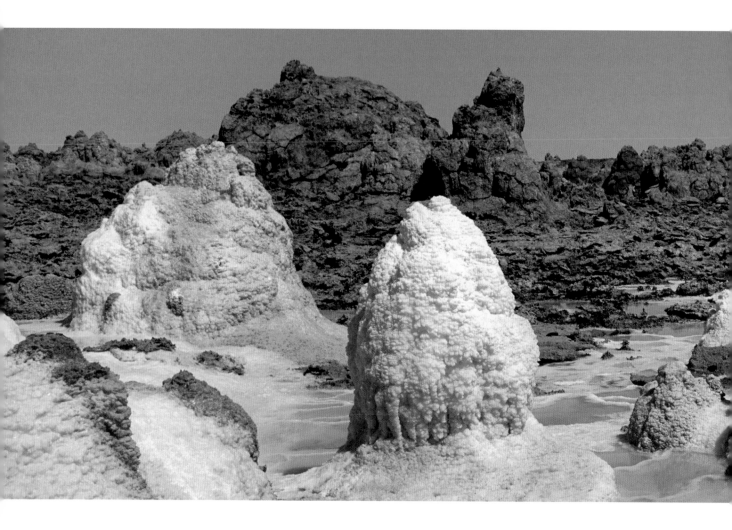

VOLCANIC ORIGINS The sulphur-encrusted rocks and acid pools of
Dallol Springs, in Ethiopia's Danakil Depression – one of the most hostile
places on Earth. These volcanic vents lie below sea level at the northern
end of Africa's Great Rift Valley.

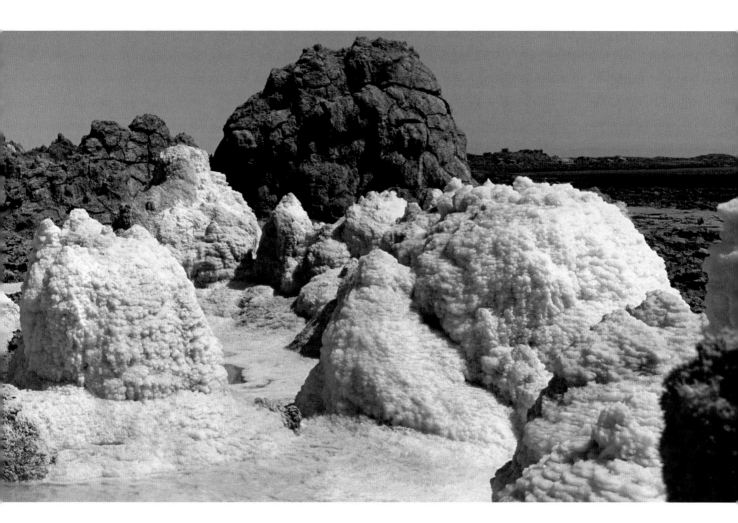

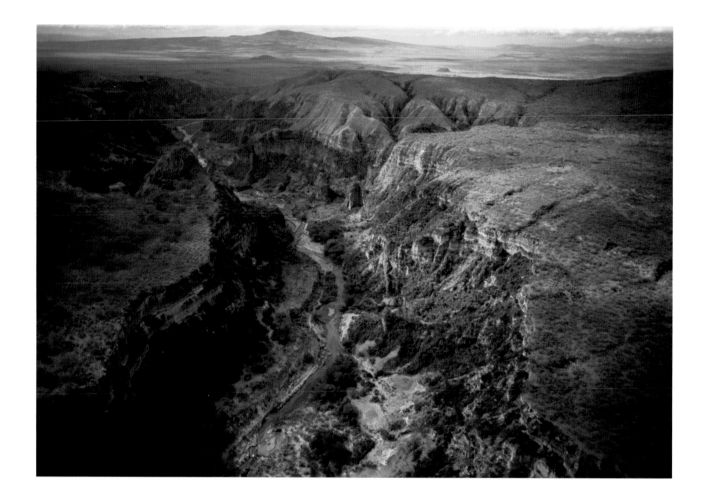

THE GREAT RIFT Kenya's Hell's Gate, one of the more dramatic
chasms forming part of the huge depression known as the Great Rift
Valley. Formed 100 million years ago, it is a massive crack between two
fault lines that is still growing.

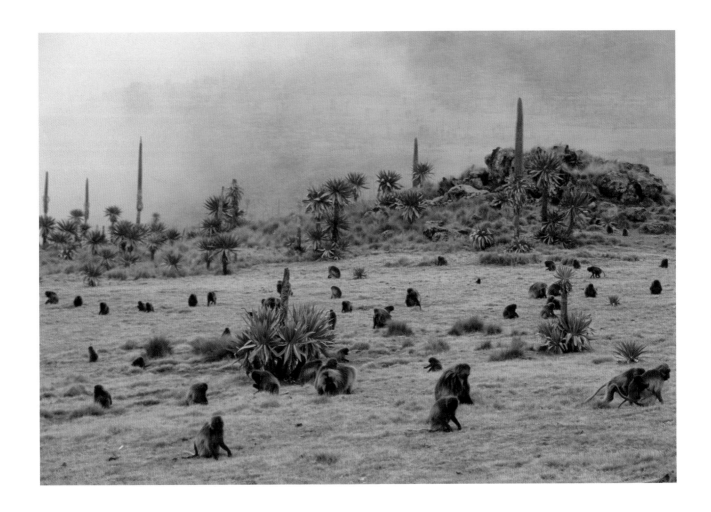

**ABOVE** THE GRASS PICKERS A troop of geladas feeding on the protein-rich alpine grasses in the Ethiopian Highlands – the roof of Africa. The mountains are their refuge, away from most predators and competing grazers and with safe sleeping places on the mountain cliffs.

**OVERLEAF** GELADA WATCH A male and female bask in the sun on their 4km- (2.5-mile) high mountainous retreat. Their thick coats protect them from the cold. Ethiopian wolves are potential predators, but the real threat is encroaching agriculture and climate change.

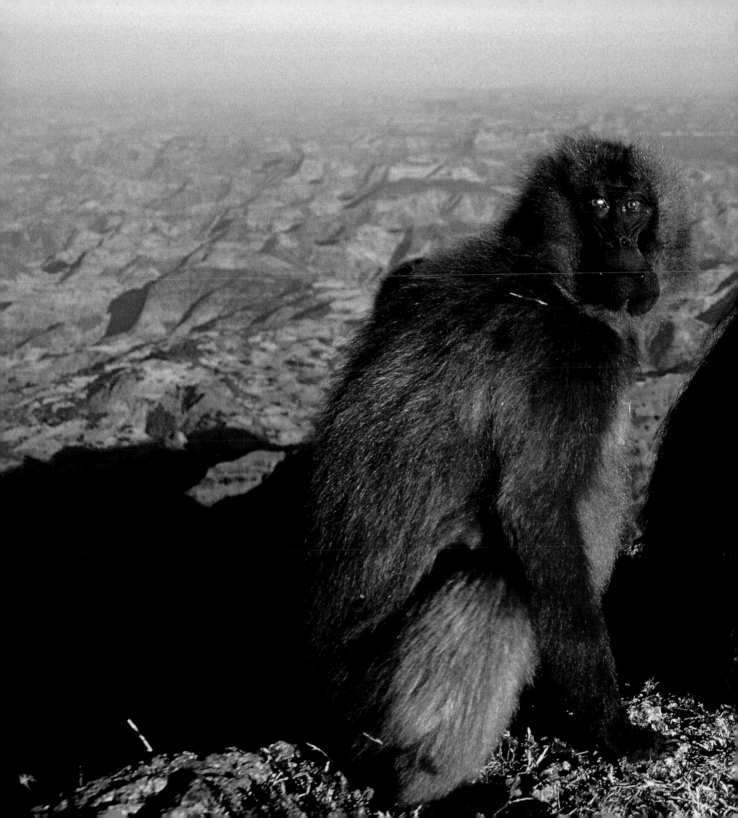

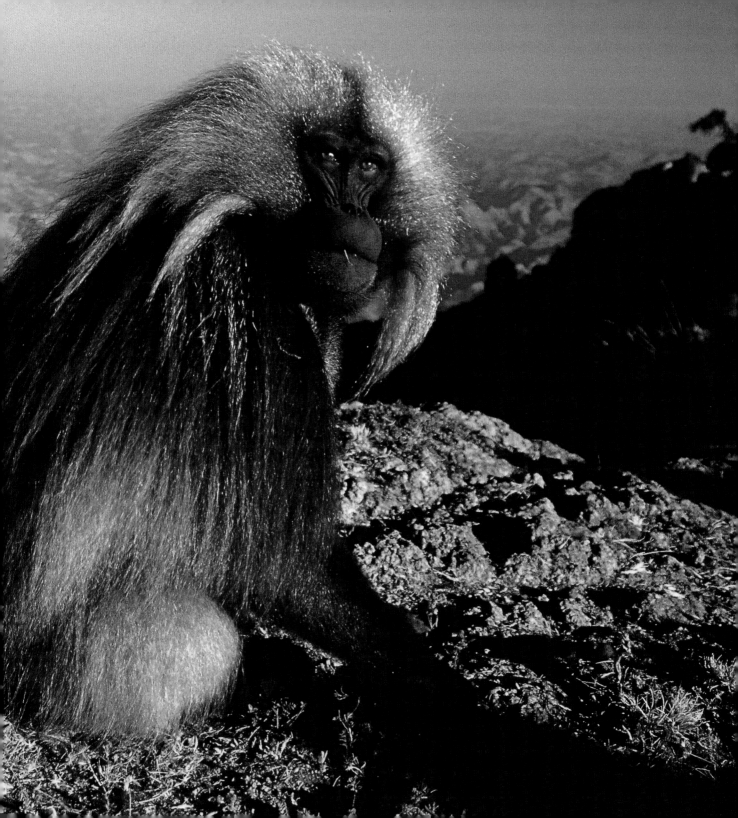

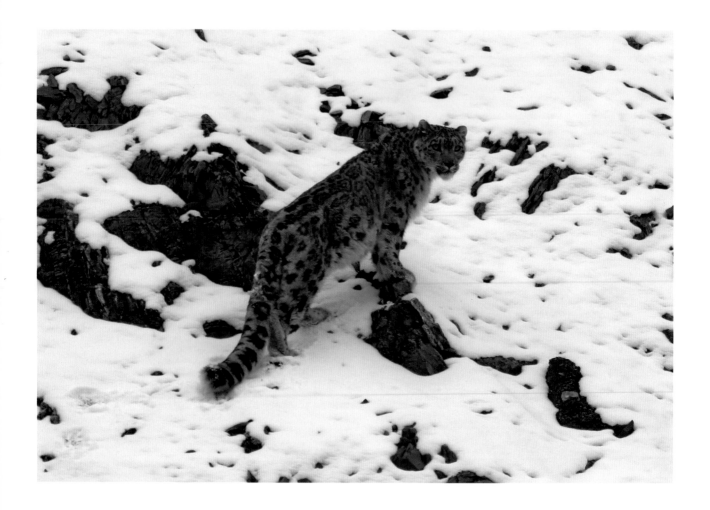

**ABOVE** SNOW CAT A wild snow leopard hunting. *Planet Earth* filmed snow leopards in the Karakoram Mountains in Pakistan. Here as everywhere, they are threatened by poachers (after their bones and pelts) and a reduction in prey due to human encroachment on their habitat.

**RIGHT** RIVER OF ICE Pakistan's Boltoro Glacier – 60km (37 miles) long and up to 6km (3.7 miles) wide – grinding away a huge valley as it slowly descends. Together with its 30 tributary glaciers, it forms part of the largest mountain glacier system on Earth – a powerful erosive force.

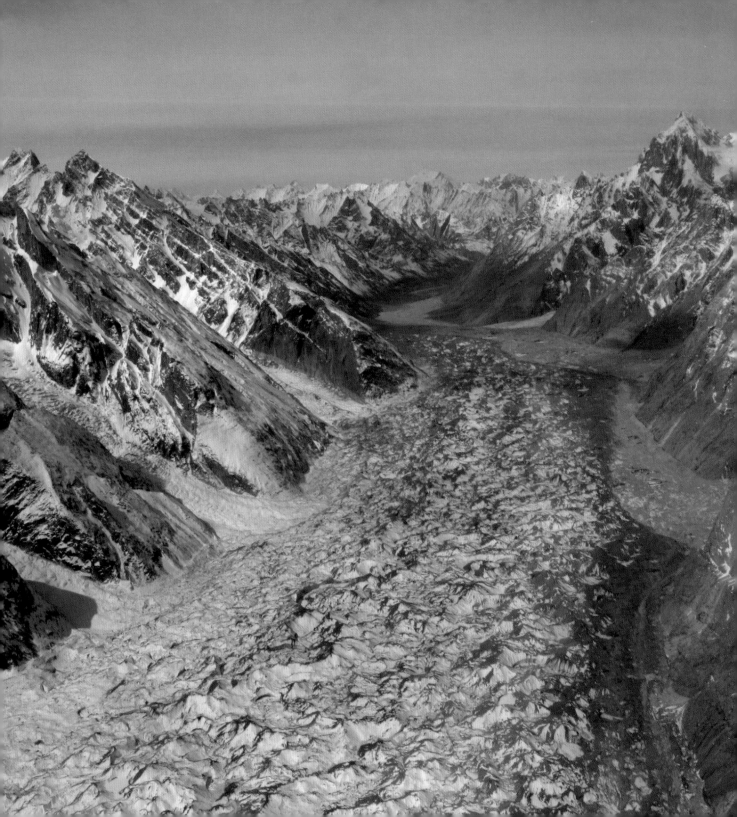

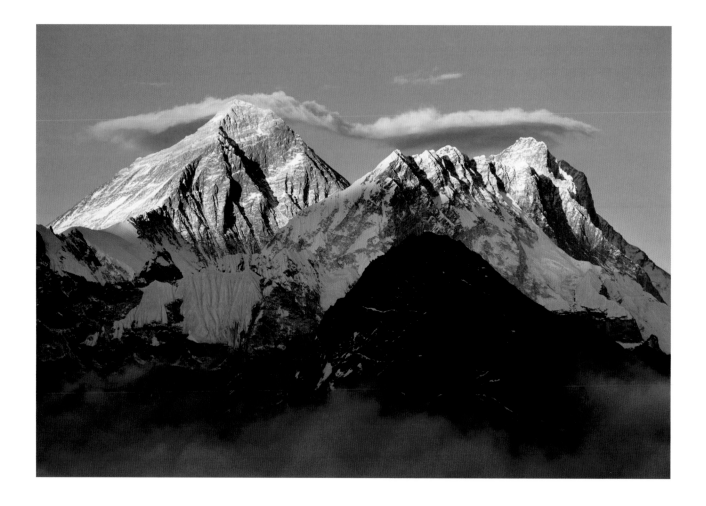

**ABOVE** THE PEAK OF ALL PEAKS Everest – the highest point on Earth, at 8850 metres (29,035 feet). It is so high that the top is relatively snow free. Its origins are hinted at by the sedimentary rocks on its flanks, lifted up from the floor of an ancient ocean.

**OVERLEAF** THE GREAT BARRIER Morning mist rising from the Tibetan section of the Himalayas. This great fold in the Earth's crust, formed by the continental plate of India colliding with Asia, stretches across a sixth of the circumference of the planet and is still rising.

WHEN THE EARTH'S
GREAT TECTONIC
PLATES COLLIDE,
THERE IS NO PLACE
FOR THE ROCKS
TO GO BUT UPWARDS,
INTO MOUNTAINS.

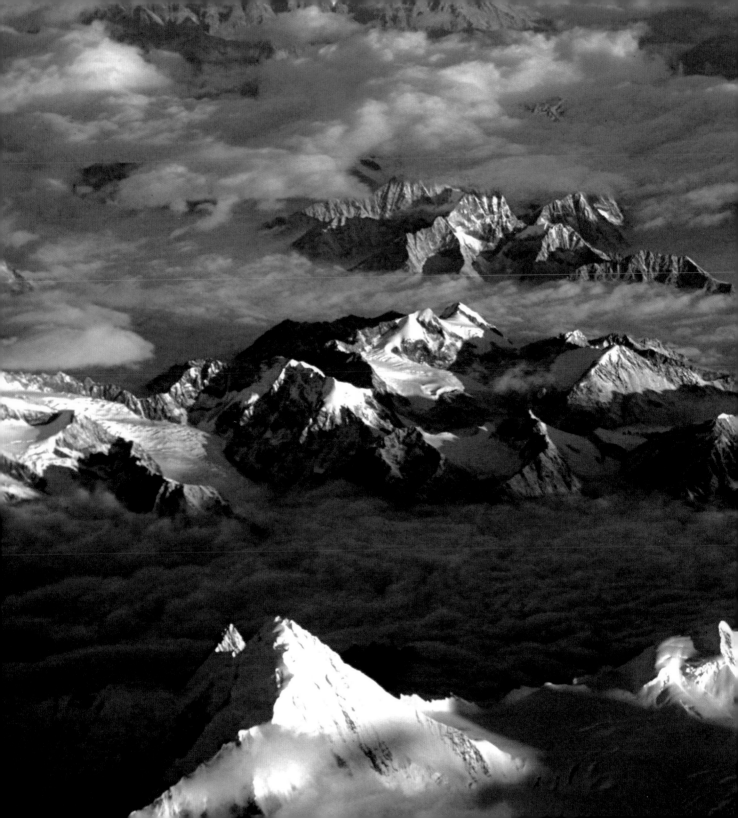

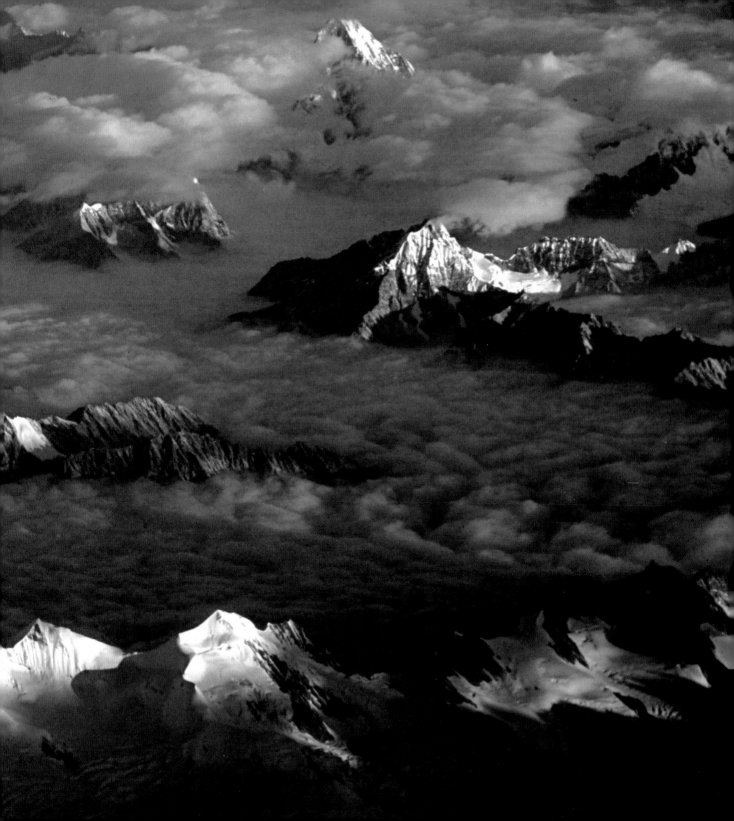

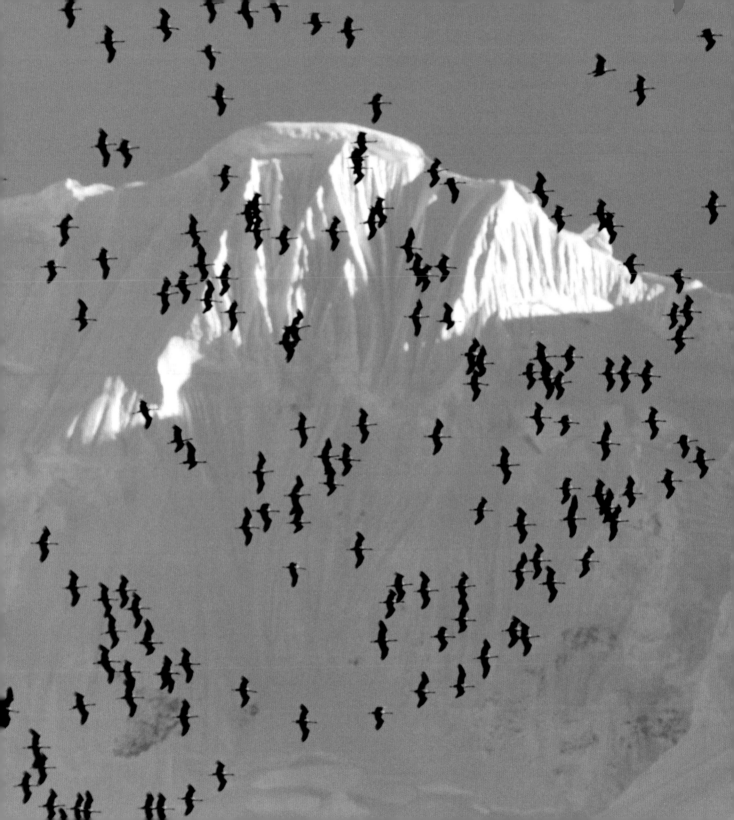

'Seeing these kinds of things does change people, and that's how you get people's hearts, to bring them close to nature.' TONY JUNIPER,

FRIENDS OF THE EARTH

LEFT HIGH FLYERS Demoiselle cranes migrating from central Asia over the Himalayas to India. More than 50,000 demoiselle cranes make the annual journey. Even they cannot fly high enough to cross the peaks but must follow an ancestral route through the Kali Gandaki pass.

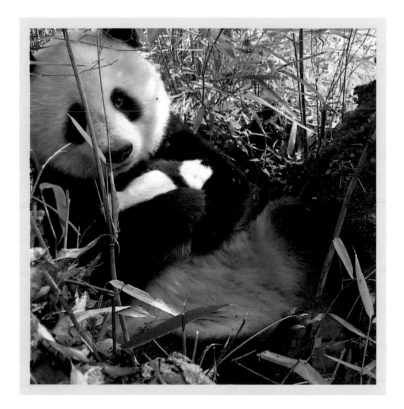

PANDA BEAR A wild panda cradles her three-month-old cub. Pandas
are now confined to central China in diminishing bamboo habitat on the
flanks of the Himalayas. They produce tiny babies, whose growth is slow,
as a diet of bamboo leads to relatively low-quality milk.

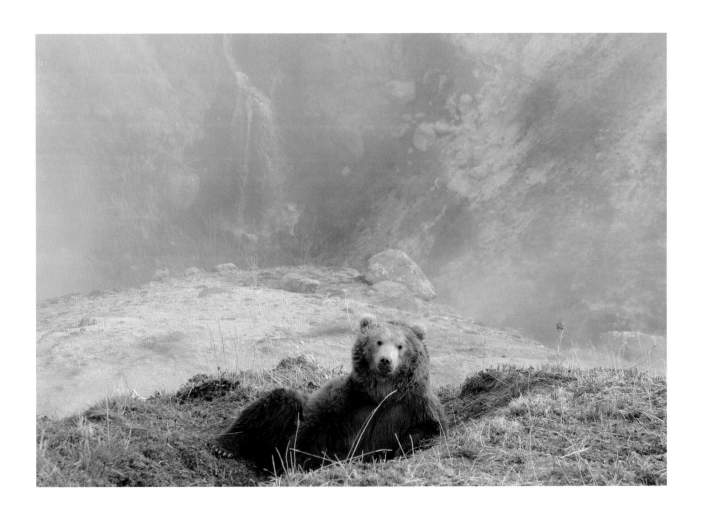

VOLCANO BEAR A grizzly relaxes on heated soil in the Valley of the Geysers, in Kamchatka's Kronotsky Nature Preserve, Russia. In this volcanically active area, mountain building is at work, and in spring 2007, the bears warm haven was partially buried as a quake caused a landslide.

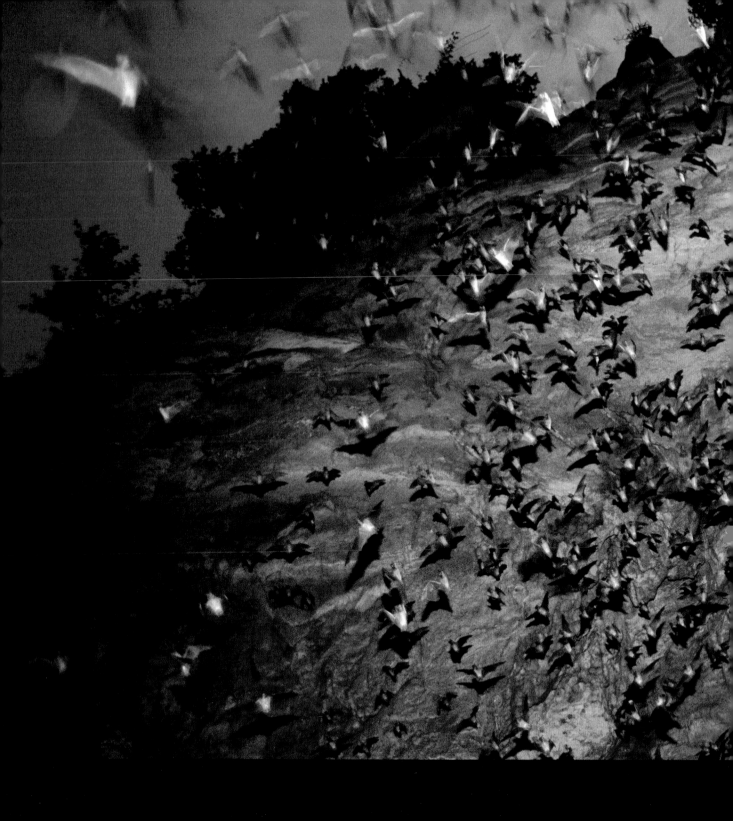

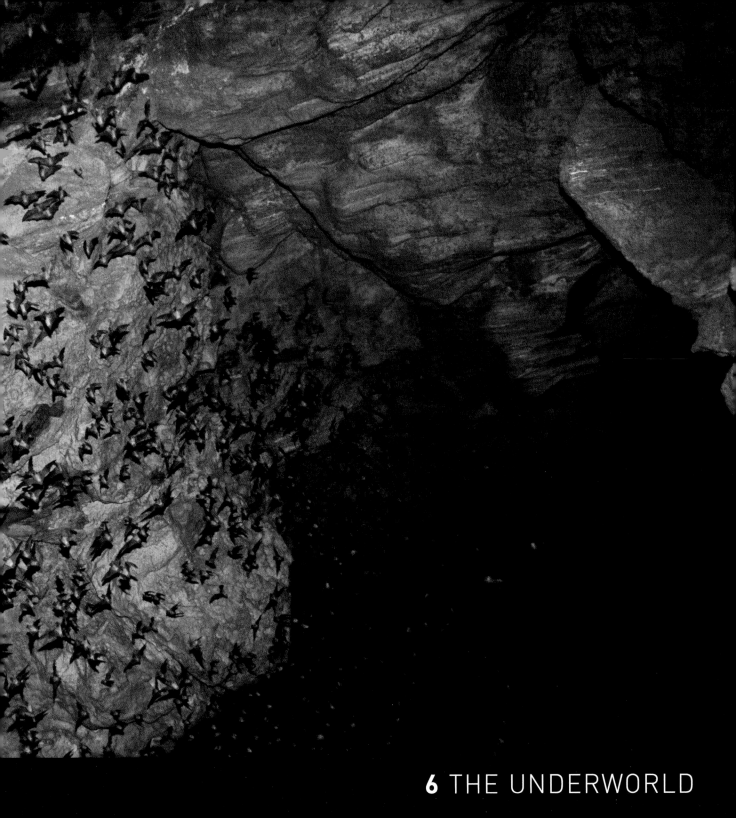

**6** THE UNDERWORLD

# CAVES ARE THE LEAST-KNOWN ENVIRONMENTS ON LAND — NO ONE KNOWS THEIR FULL EXTENT — AND THEY ARE HOME TO SOME OF THE STRANGEST ANIMALS.

**RIGHT** THE DEPTHS The descent into Krubera Cave in the limestone massif of Arabika, on the Black Sea. The expedition would reveal it to be the deepest cave yet discovered, dropping down to 2km (1.2 miles) below the surface. Huge areas of the underground world have yet to be explored.

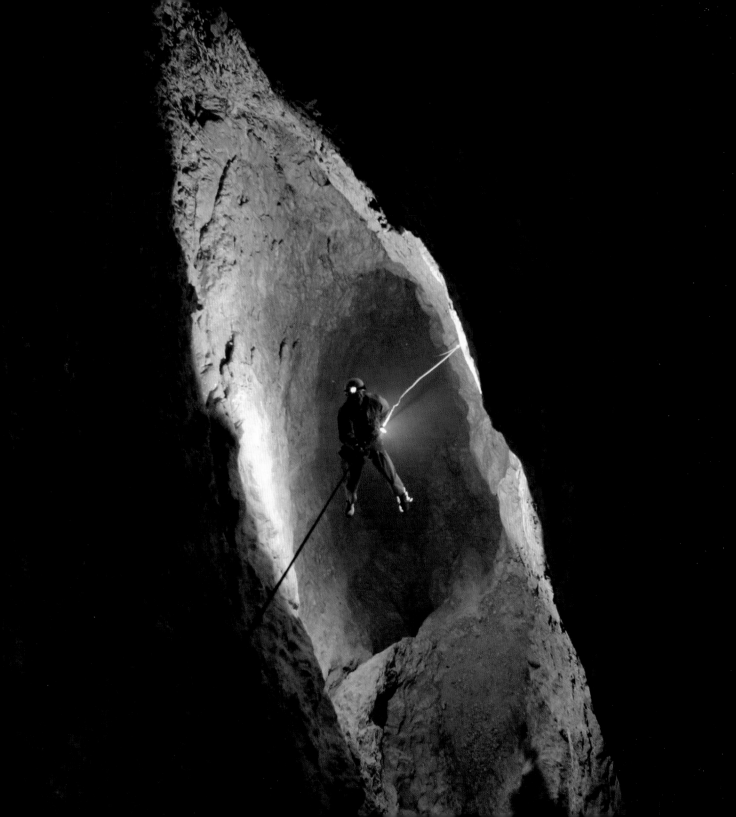

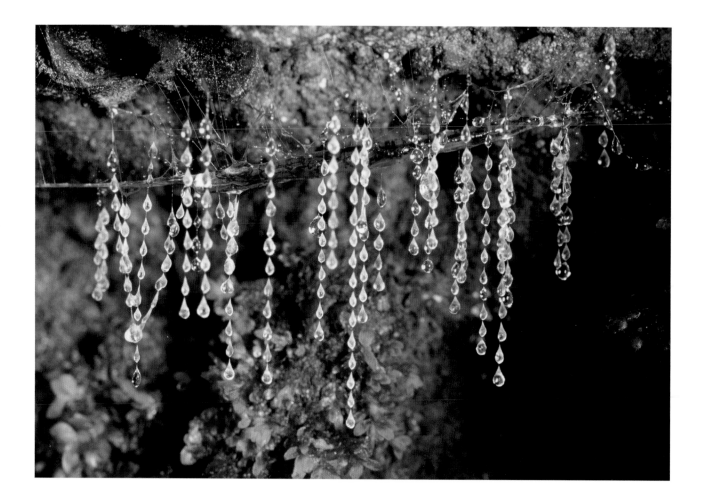

PEARLS OF DEATH A curtain of mucus-laden silk threads hangs from
the roof of Mangawhatikau Cave in New Zealand. This sticky veil is spun
by glow-worms – the larvae of a tiny gnat – to trap flying insects attracted
by a chemical light produced in the glow-worms' bottoms.

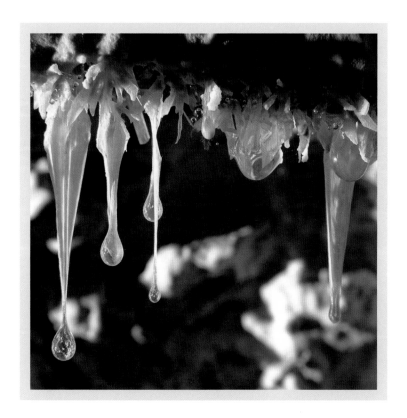

DRIPPING SNOTTITES Living mucus-like stalactites grow from the roof of Mexico's Villa Luz Cave. Each is a colony of fast-growing bacteria, multiplying at up to a centimetre a day and living on hydrogen sulphide fumes in the cave. The drips they excrete are pure sulphuric acid.

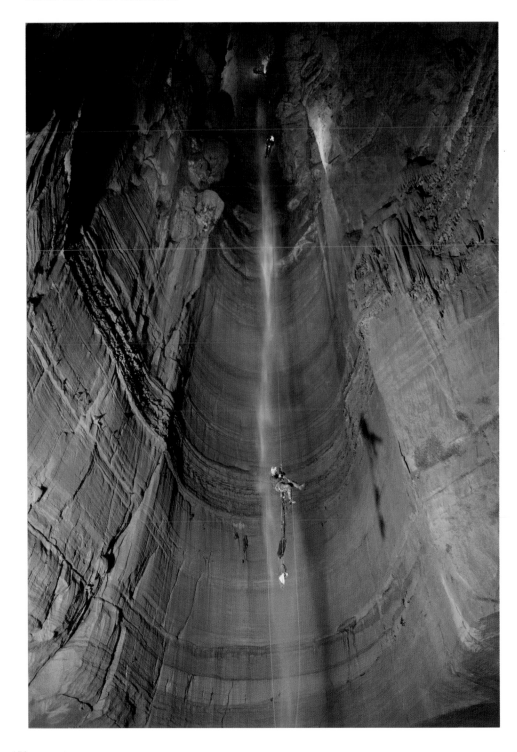

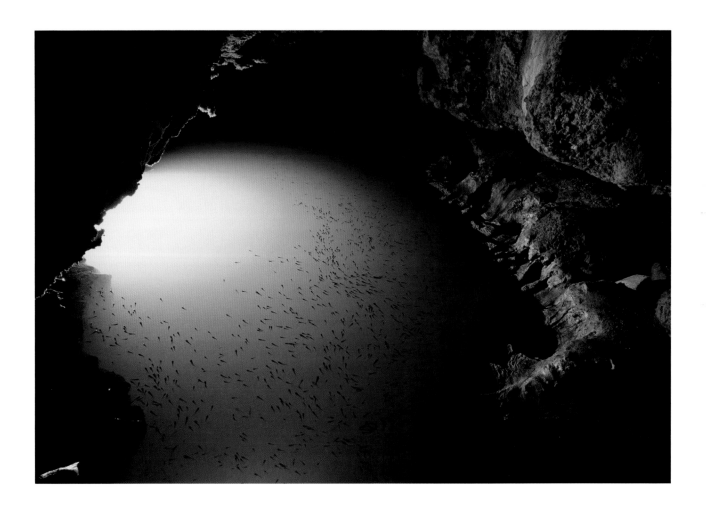

**LEFT** THE DROP Cavers light the 84-metre (280-foot) drop of Mystery Falls in the limestone cave system of Tennessee. Huge caves have small beginnings. Water seeps through the limestone, turning to carbonic acid as it absorbs CO2 and, over eons, corrodes gaps in the rock.

**ABOVE** THE POISON CAVE Hydrogen sulphide percolates up from oil deposits deep below and bubbles through spring-fed pools, filling Villa Luz Cave with toxic fumes. The cave is being corroded from the inside with caustic chemicals, and the fumes feed a slimy lining of bacteria.

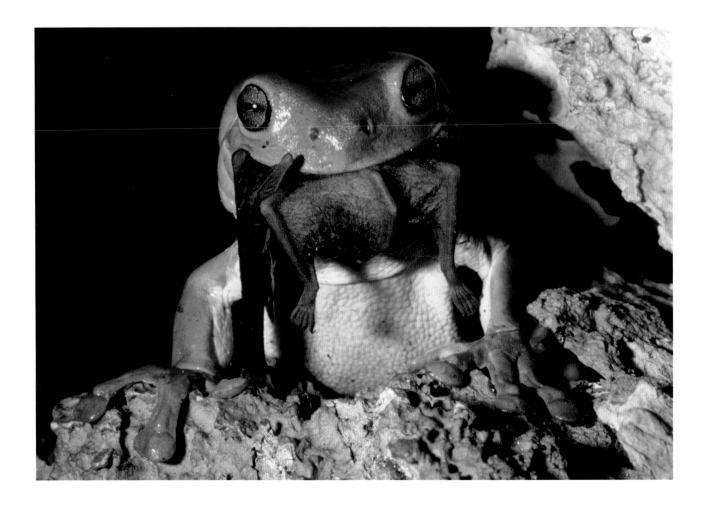

BAT SNACK An Australian green treefrog grabs a young bat that has
crash-landed while exiting from Bat Cleft Cave in Mount Etna Caves.
The frogs are not troglobites (cave-inhabitants) but have learnt that a
maternity roost of little bent-winged bats offers easy pickings.

'Each species is a product of up to hundreds of thousands to millions of years of evolution. And each is exquisitely adapted to some part of the environment in which it lives and the way that it interrelates with other species … It's an irreplaceable treasure. So we should value it for that reason.'

**PROFESSOR E.O. WILSON**

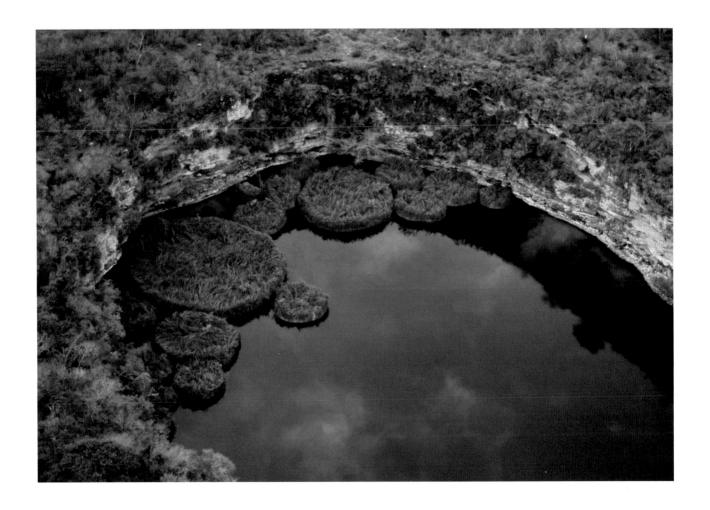

**ABOVE** ENTRANCE TO THE DEEP An incredibly deep cenote, or sinkhole, at Aldama, Mexico. Slightly acidic underground rivers have dissolved the limestone from below to create vast caverns with thin roofs. When a roof, collapses a cenote is created.

**RIGHT** UNDERWATER MARVELS One of the caves of Grand Cenote, Yucatán, Mexico, drowned by flood waters from the last ice age. The formations have changed little from that time. When filming, the *Planet Earth* team used guide ropes to find the long way back to the exit.

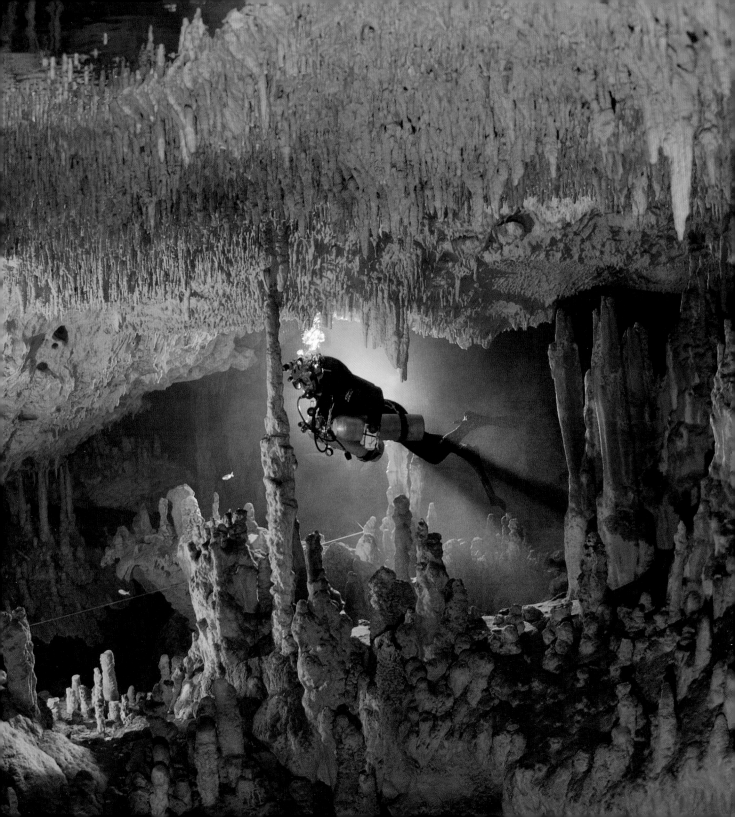

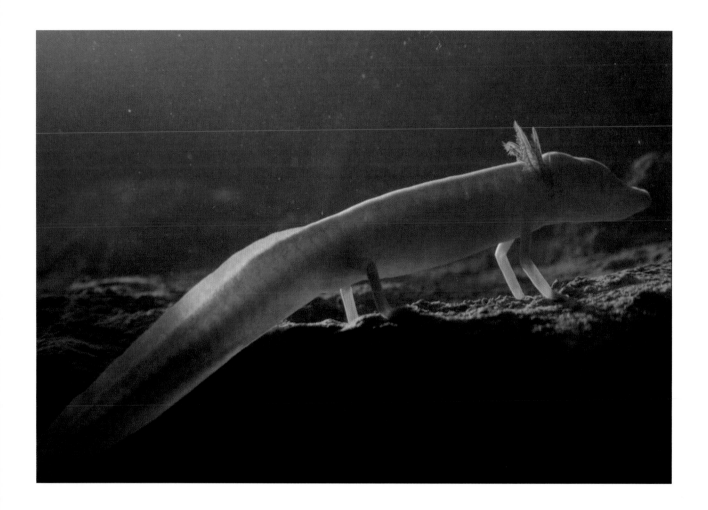

**ABOVE** BLIND SURVIVOR The Texas blind cave salamander, found in just one cave system. It spends most of its life motionless, waiting to detect through its sensitive skin the tiniest ripple made by its equally rare crustacean prey. It is capable of going without food for several years.

**RIGHT** THE WORLD'S MOST BEAUTIFUL CAVE The Chandelier Ballroom, one of many 'rooms' in New Mexico's Lechuguilla Caves that Planet Earth was given special access to. The 'chandeliers' are formed by water containing dissolved gypsum seeping very slowly through the rock.

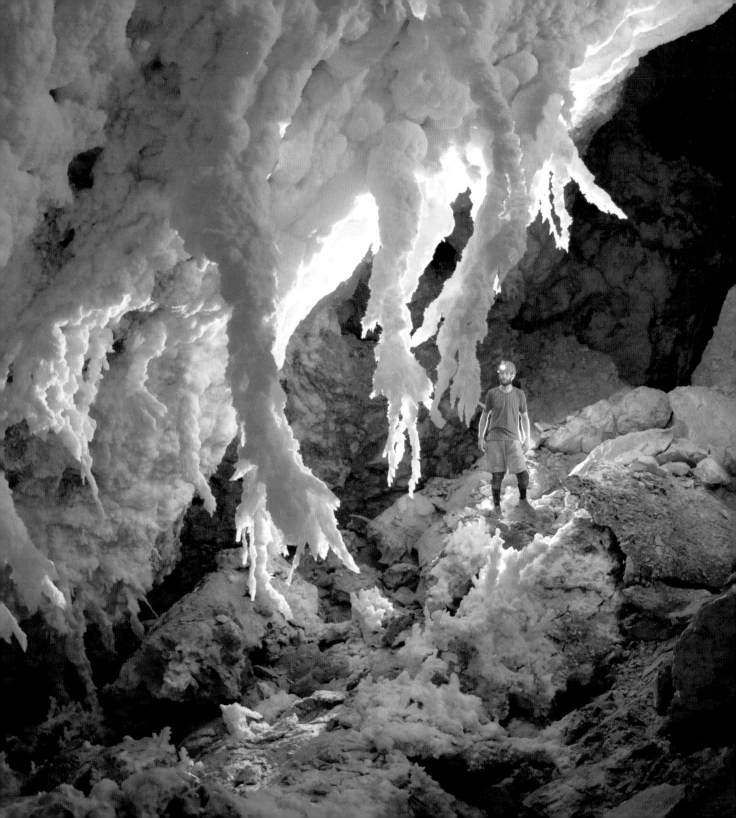

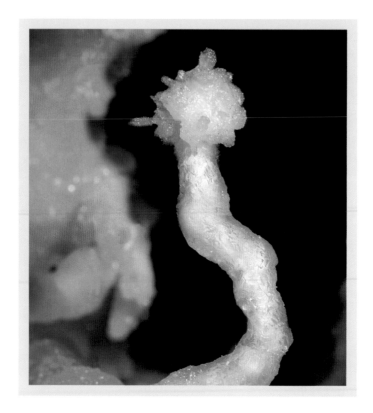

**ABOVE** THE BLUE-TIPPED HELICTITE A unique, delicate crystal formation, from a secret cave location in France. Its meandering shape is the result of calcite deposited through capillary action against the force of gravity, and it is tipped with aragonite (a kind of calcium carbonate).

**RIGHT** CAVE PEARL A comparatively huge, 3.5cm (1.4-inch) diameter cave pearl from France. Just like a real pearl, it has formed when calcite has precipitated evenly around a grain of grit, probably in a shallow pool. Some caves have carpets of pearls.

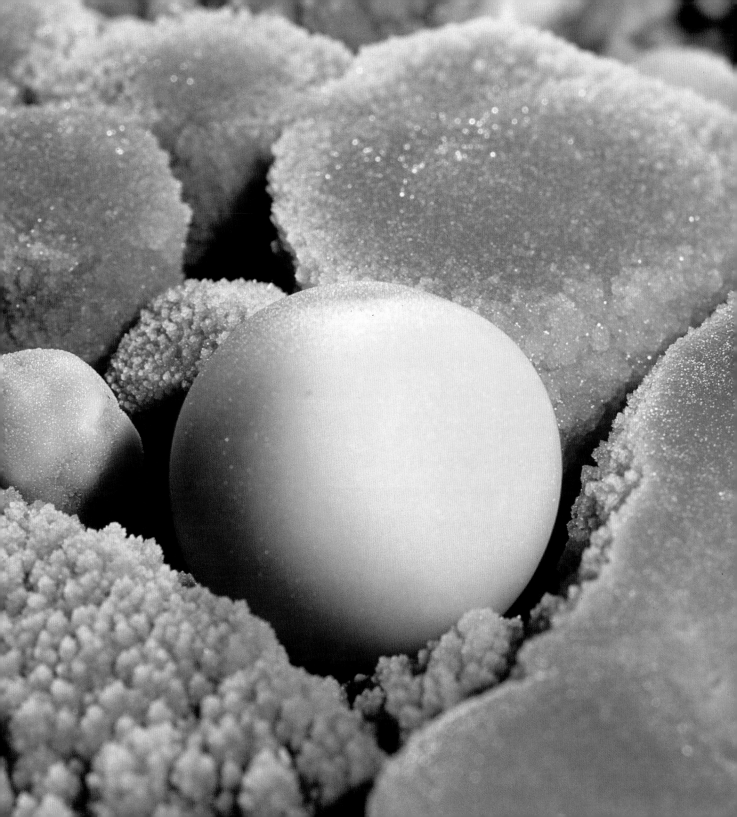

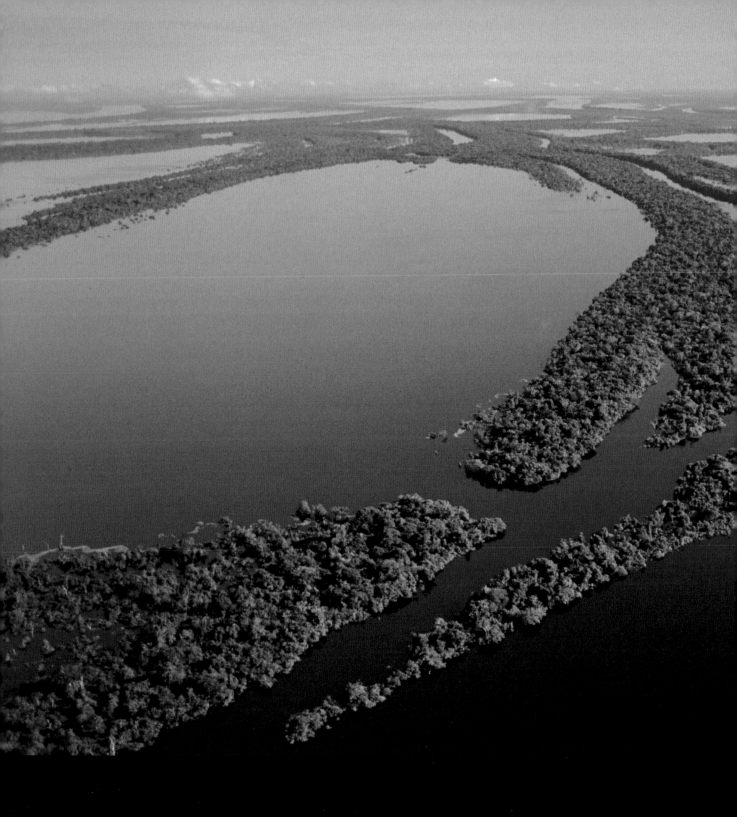

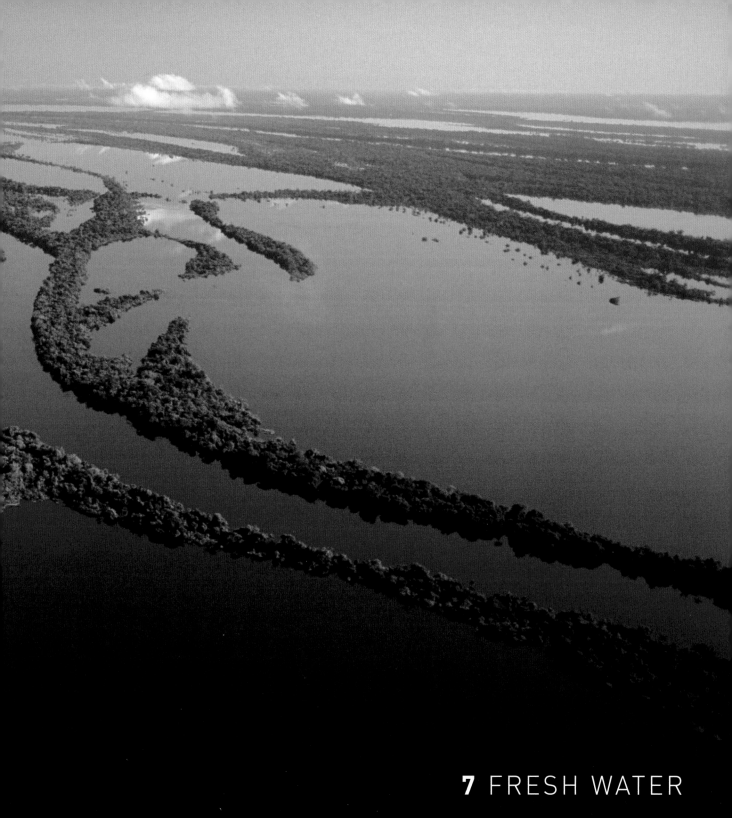

**7** FRESH WATER

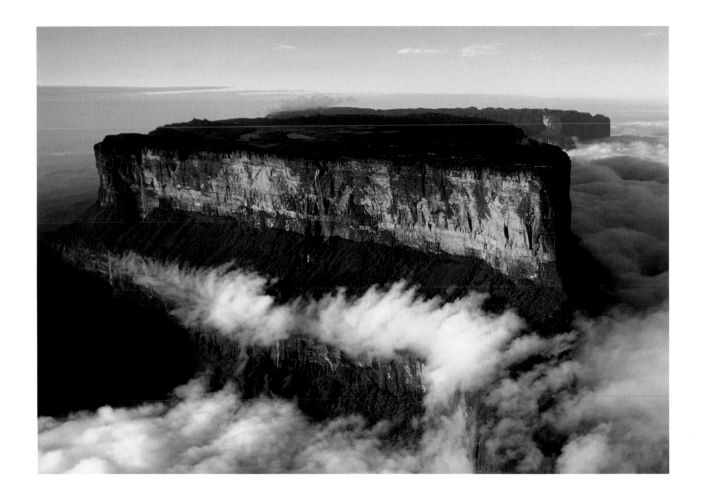

**ABOVE** THE SOURCE The ancient tepuis, or mountain plateaus, of southern Venezuela rising some 1000m (3280 feet) above the rainforest and into the clouds. The clouds produce rain, and the almost daily downpours on the plateau are the source for the great rivers below.

**RIGHT** ANGEL FALLS The world's highest waterfall, Angel Falls, pouring from the summit of Auyan Tepuis, or Devil's Mountain. The descent creates a force so great that much of the plunging water turns into fine mist. Eventually the water feeds into Venezuela's Orinoco River.

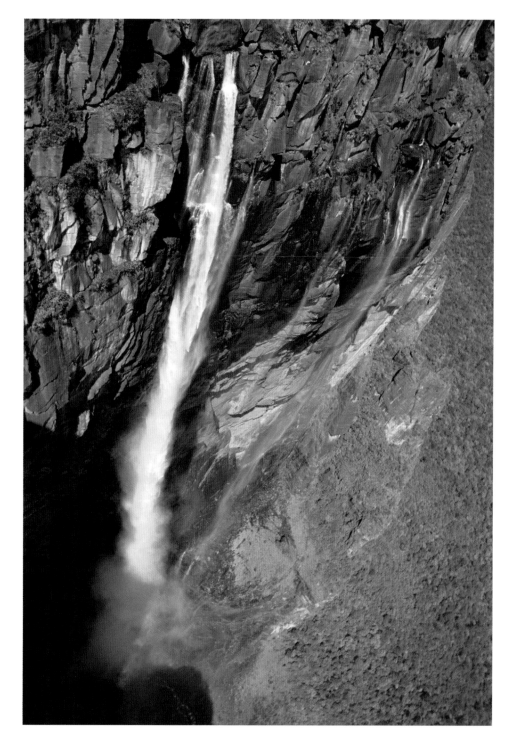

FRESH WATER IS THE MOST PRECIOUS RESOURCE WE HAVE. JUST 3 PER CENT OF THE PLANET'S WATER IS FRESH, AND 70 PER CENT IS LOCKED UP AS ICE AND SNOW.

**RIGHT** THE GREAT WATER The mighty Iguaçu Falls on the border of Brazil and Argentina. Here the Iguaçu River has eroded soft rock lying over hard rock, creating a huge waterfall 2.5km (1.5 miles) across. The volume of water is so great that you can hear the falls miles away.

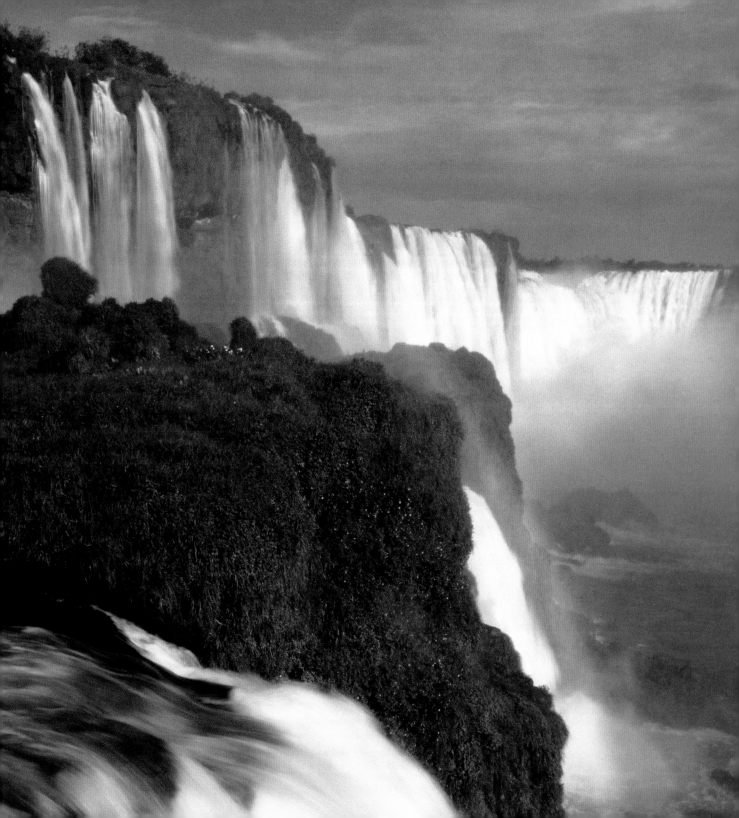

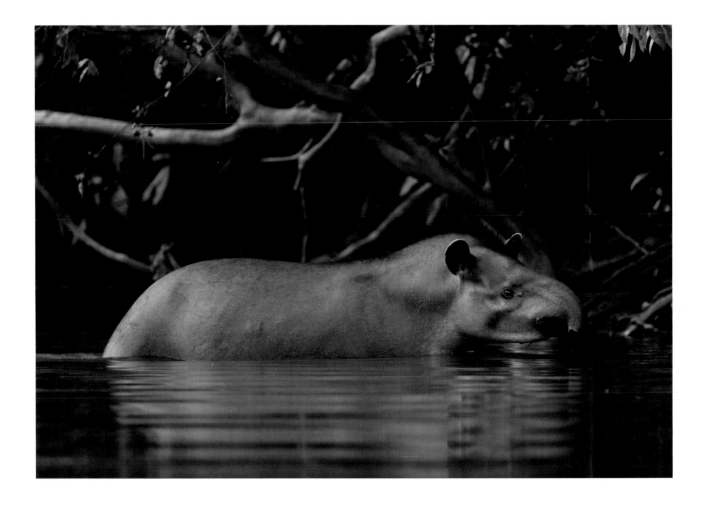

**ABOVE** RIVER MAMMAL A Brazilian tapir in its element. In the wet season, rivers spill onto the Amazonian floodplain and into the forest itself. So animals that can't climb or fly must be adapted to life in water.

**RIGHT** AMAZON FISHERS Curious giant river otters in an Amazonian tributary. They are the largest of all the world's otters, threatened by loss of their favoured fishing haunts, water pollution and poaching.

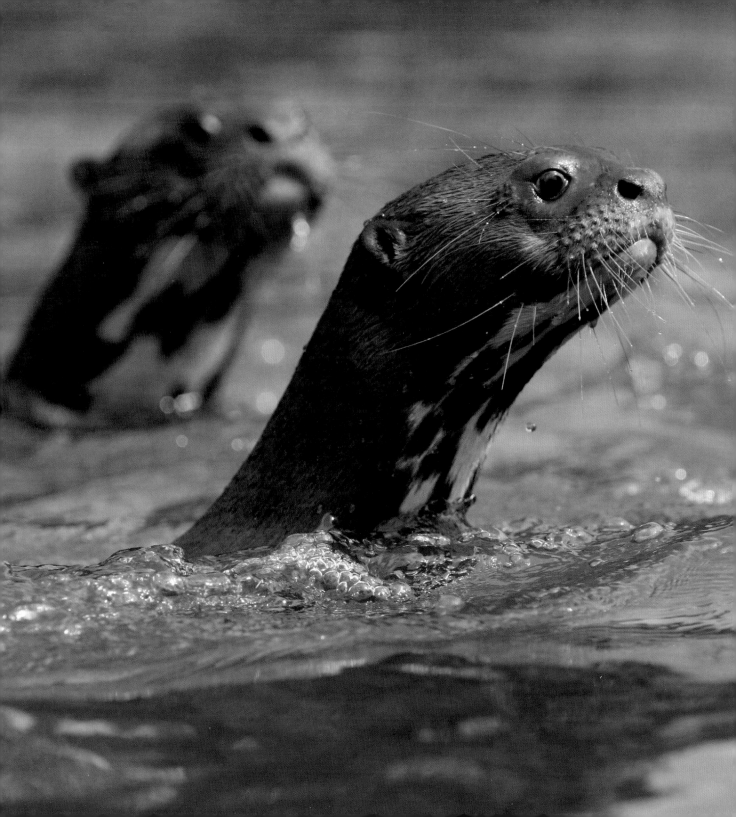

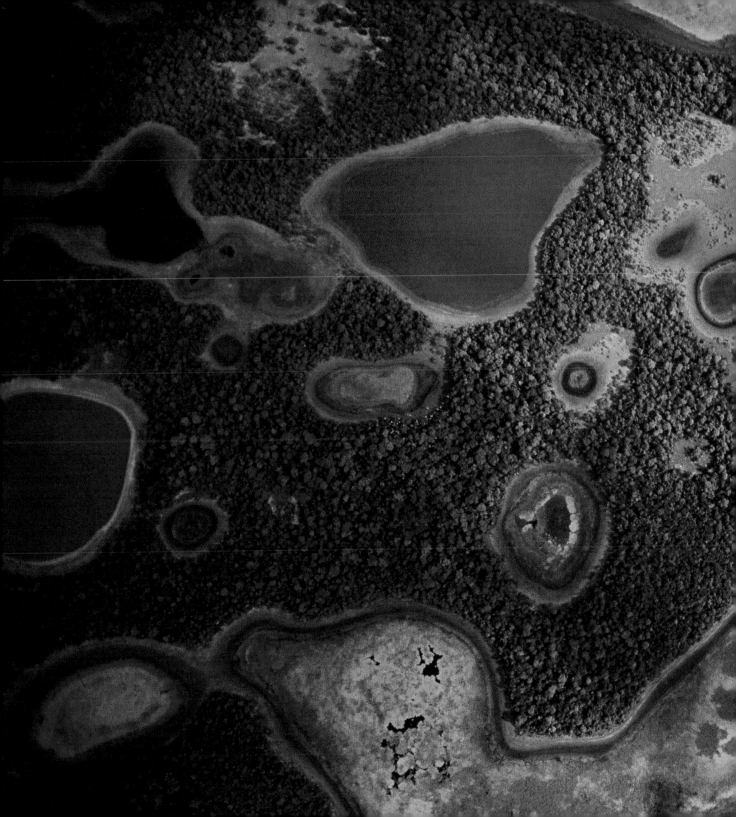

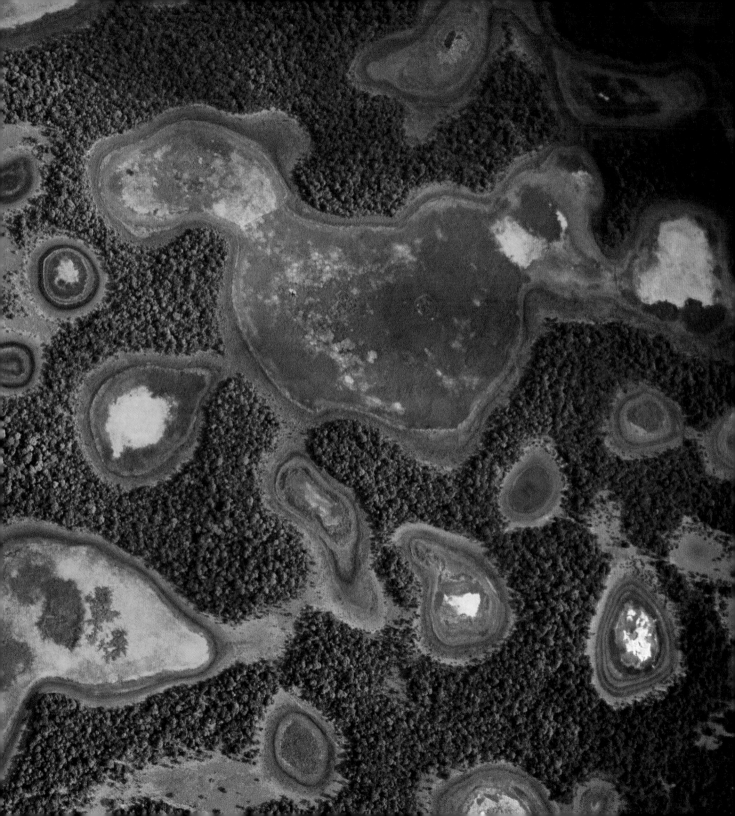

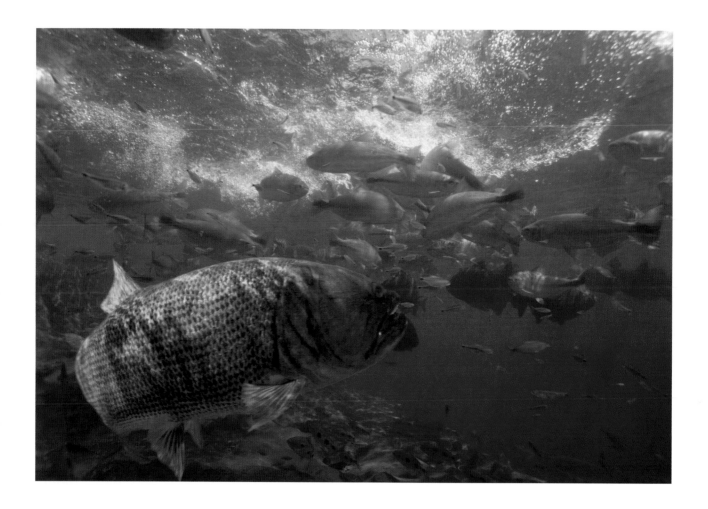

PREVIOUS SPREAD THE WORLD'S LARGEST WETLAND The vast
Pantanal, southern Brazil – a wetland the size of England, formed each
wet season when the Paraná River empties over its floodplain. Its
nutrient-rich waters support a diverse community of animals and plants.

ABOVE RIVER TIGER The yellow dorado, the largest predatory fish in
the Pantanal, stalking piraputanga fish feeding on falling figs.
RIGHT PIRANHAS Sharp-toothed red-bellied piranhas. They eat fish
and insects but also seeds, shoaling to avoid being eaten themselves.

172

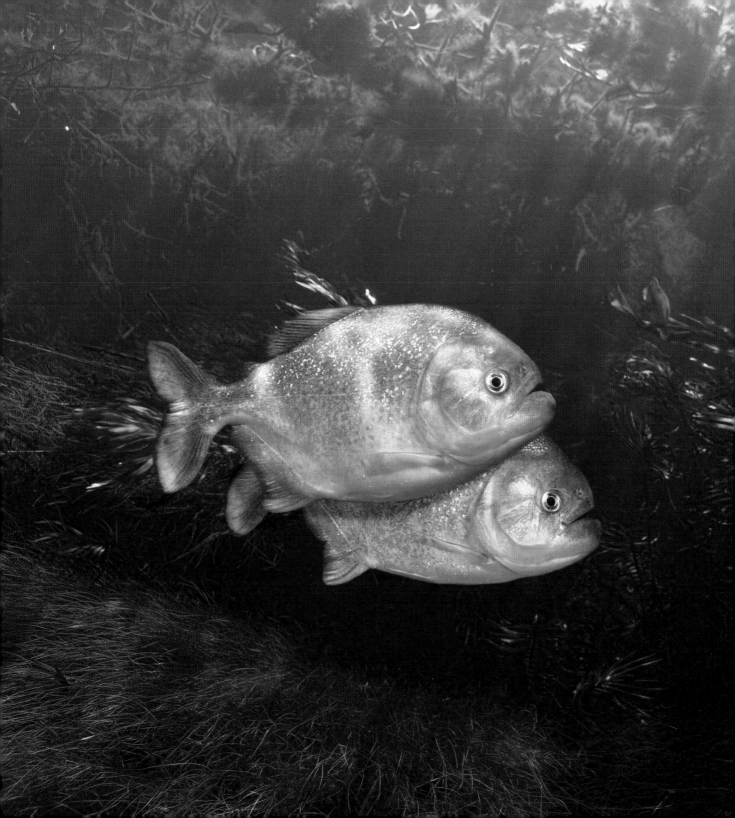

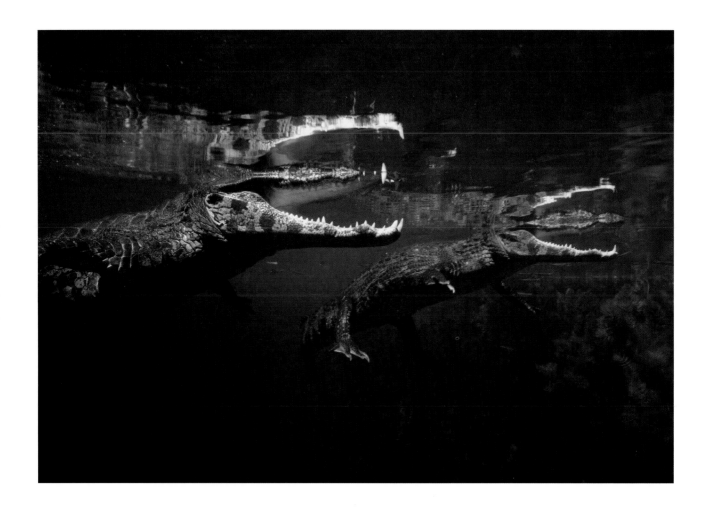

OPPORTUNISTS Spectacled caiman facing into the current of a river
channel, mouths slightly open, ready to snap up any fish that arrive in the
incoming water. When the waters recede, they become nomads, walking
over the Pantanal plain in search of remnant bodies of water.

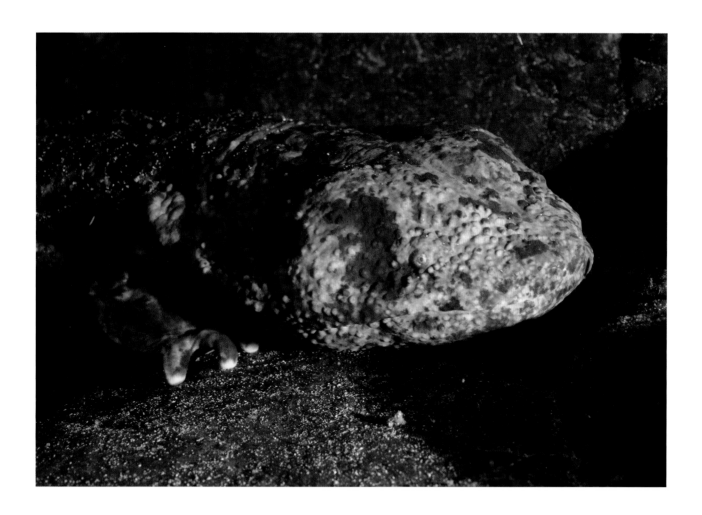

COLD-WATER GIANT A Japanese giant salamander in its underwater daytime retreat. At night, it emerges to hunt fish in the cold, fast-flowing mountain streams of northern Kyushu Island and western Honshu. This long-lived amphibian can grow to be 1.5 metres (nearly 5 feet).

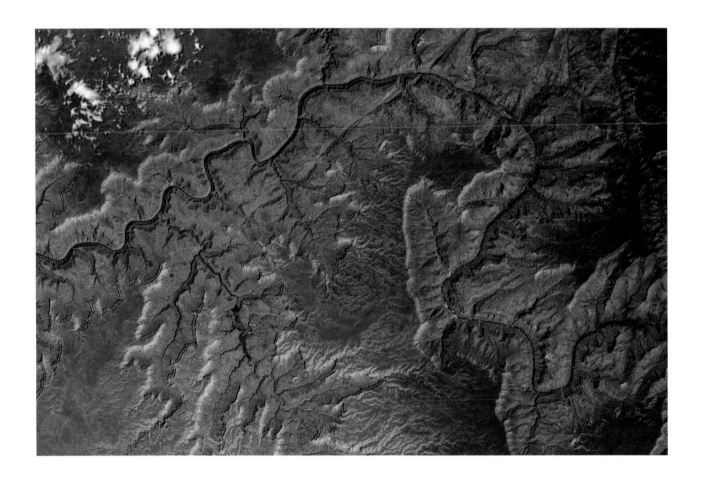

**ABOVE** CANYON SCAR Arizona's Colorado River canyon – proof of the erosive power of surging water. It is one of the planet's few physical landmarks visible from space, appearing as a 1600km (994-mile) scar.

**RIGHT** RIVER POWER Just one part of the Grand Canyon. It has been carved by the Colorado River – up to 1.6km (1 mile) deep in one place – over 5 million years, and the sandstone is still being eroded.

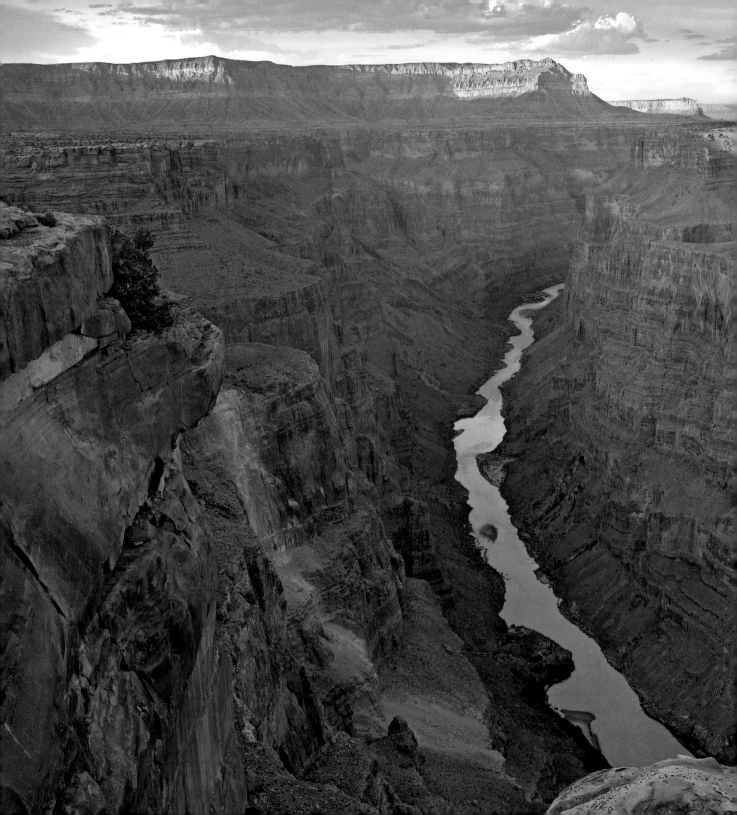

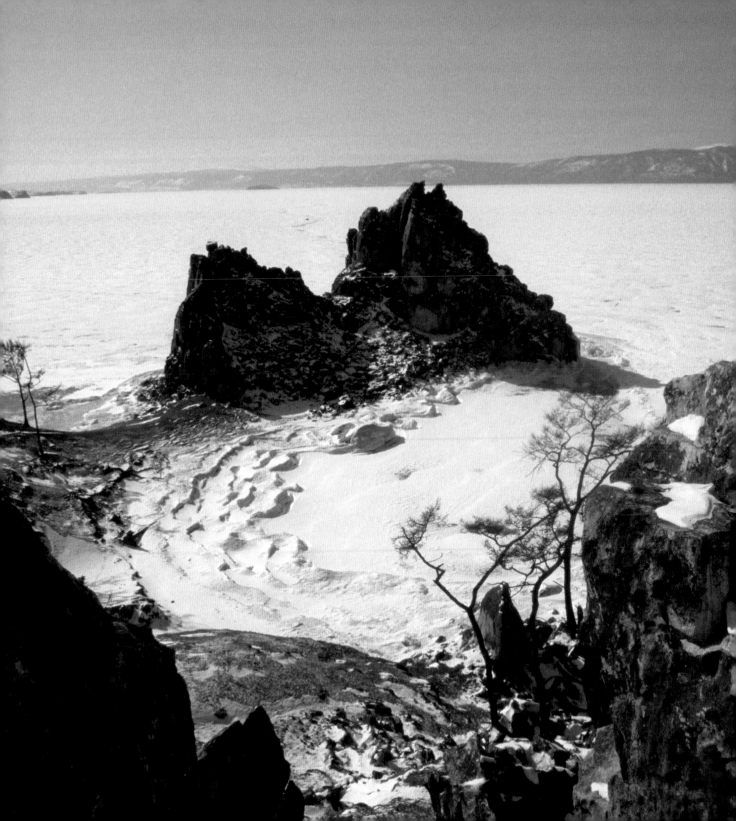

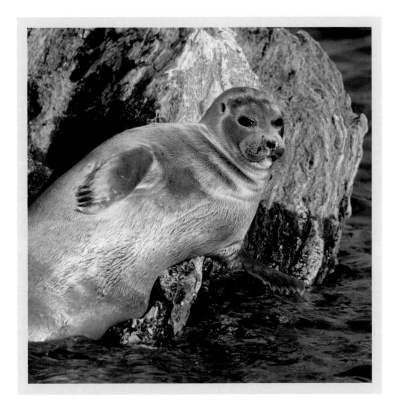

**LEFT** THE ICE LAKE Lake Baikal in Siberia, holding a fifth of the world's surface fresh water. It is more than 1.6km (1 mile) deep, and for more than five months is frozen shut by ice 1.2 metres (3.9 feet) thick. Under the ice is a profusion of life, filmed by a brave *Planet Earth* team.

**ABOVE** ARCTIC SURVIVOR The Lake Baikal seal, or nerpa – the world's only freshwater seal – which may have come from the Arctic some 22 million years ago. It is capable of diving down deep after fish and survives the winter freeze by gnawing breathing holes in the ice.

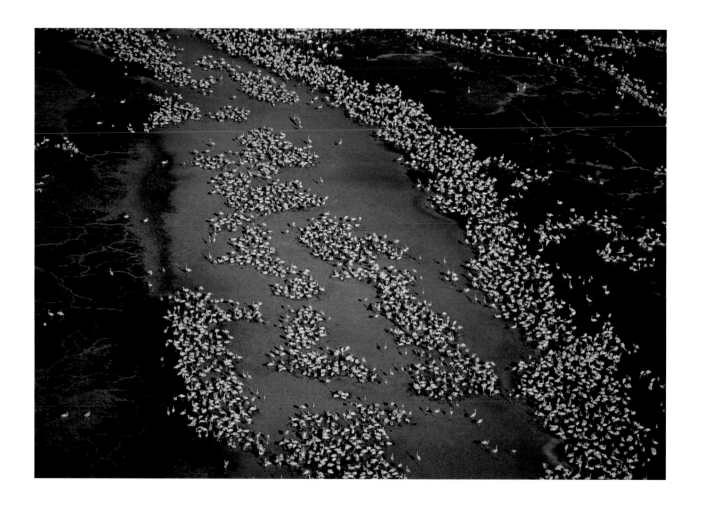

**ABOVE** CAUSTIC REFUGE Lake Natron, Tanzania – one of a chain of
Rift Valley soda lakes and a safe refuge for nesting lesser flamingos. Few
predators will venture into the centre of this caustic environment.

**RIGHT** SODA BIRD A lesser flamingo swings its 'upside-down' beak
from side to side, filtering Spirulina (bacteria) from the soda-lake water.
Pigment in the bacteria turns the flamingoes' feathers pink.

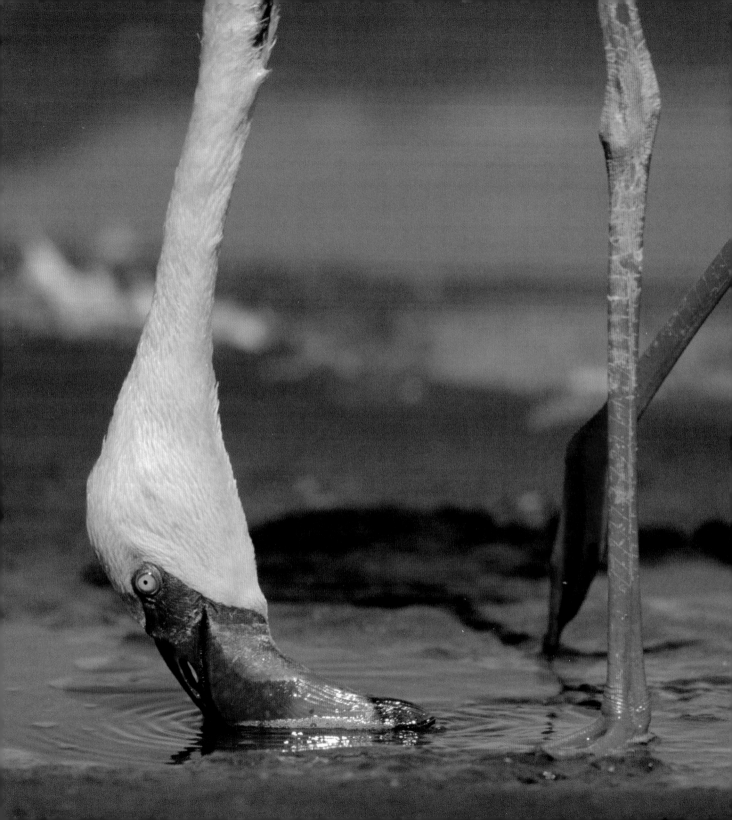

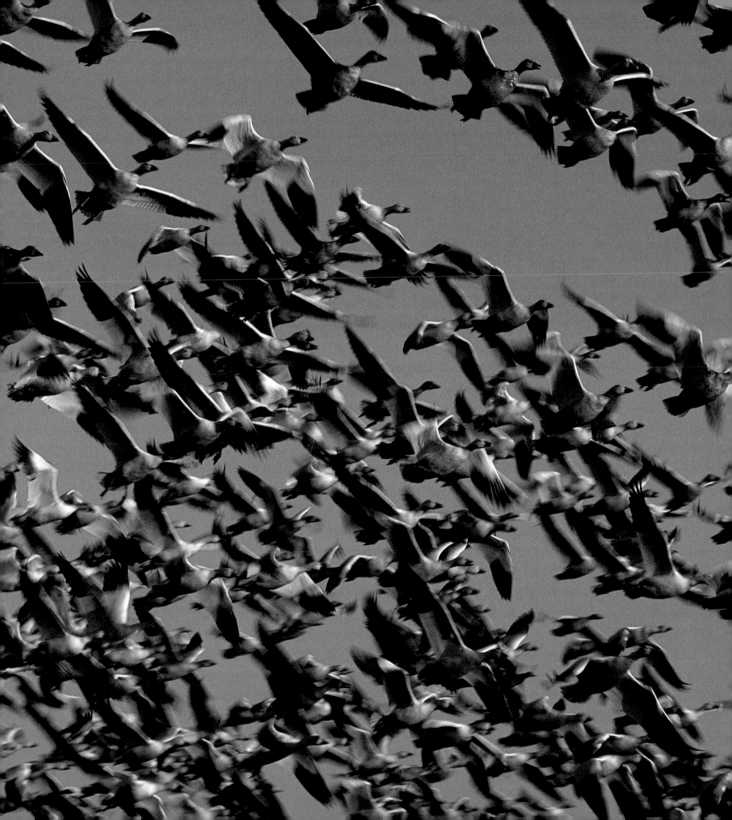

'Climate change is likely to be the biggest influence on the environment over the next 10 to 30 years.'

JEFF MCNEELY, CHIEF SCIENTIST, IUCN —

THE WORLD CONSERVATION UNION

**LEFT** ON THE MOVE Greater snow geese migrating south from the Arctic. They break their journey to feed on the tidal salt marshes in the US. Salt marshes are the end of a river's journey, but for the snow geese, they are a vital place to rest and graze on their way to their wintering grounds.

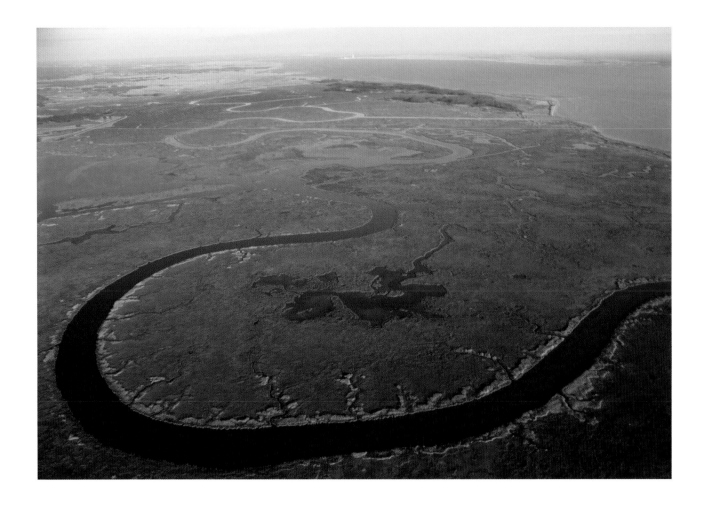

DELAWARE HAVEN End of the journey for the Delaware River. As it reaches the coastal plain, it starts to deposit sediment, splitting into channels and building up the delta as it expands into the sea. This is salt-marsh habitat, which is such a vital feeding area for many birds.

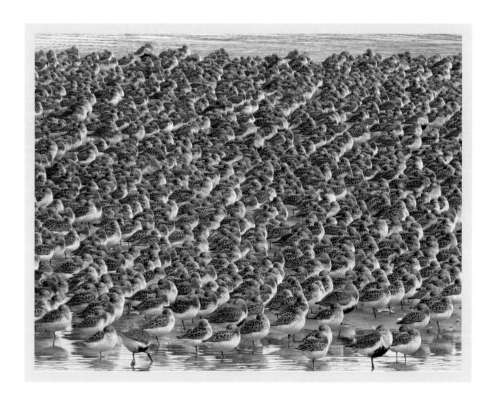

SPRING BREAK Western sandpipers roosting on mudflats on the
Copper River delta, Alaska, en route north to their spring breeding
grounds. Migrating waders depend on mudflats, but these refuelling
points are fast disappearing as coastal development increases.

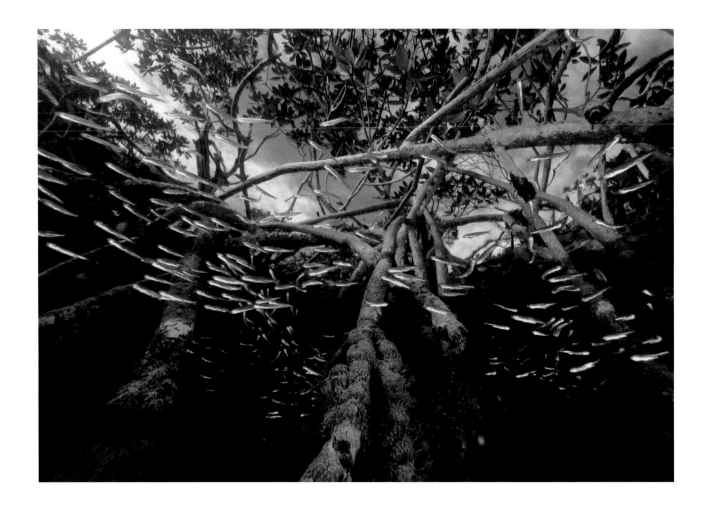

MANGROVE NURSERY A shoal of young fish among mangrove roots.
Salt-tolerant mangroves, with their aerial 'breathing' roots, colonize the
channels and mudbanks of river deltas in tropical areas, providing coastal
protection and vital nurseries for fish.

'Mangroves are nurseries for fisheries. They provide fuel wood. Yet mangroves have relatively poor biodiversity compared to, say, a tropical rainforest. Biodiversity – as measured by number of species – is important, but we should never make the mistake of thinking that, just because a place has more diversity than another, it is automatically more important.'

M. SANJAYAN, LEAD SCIENTIST,

THE NATURE CONSERVANCY

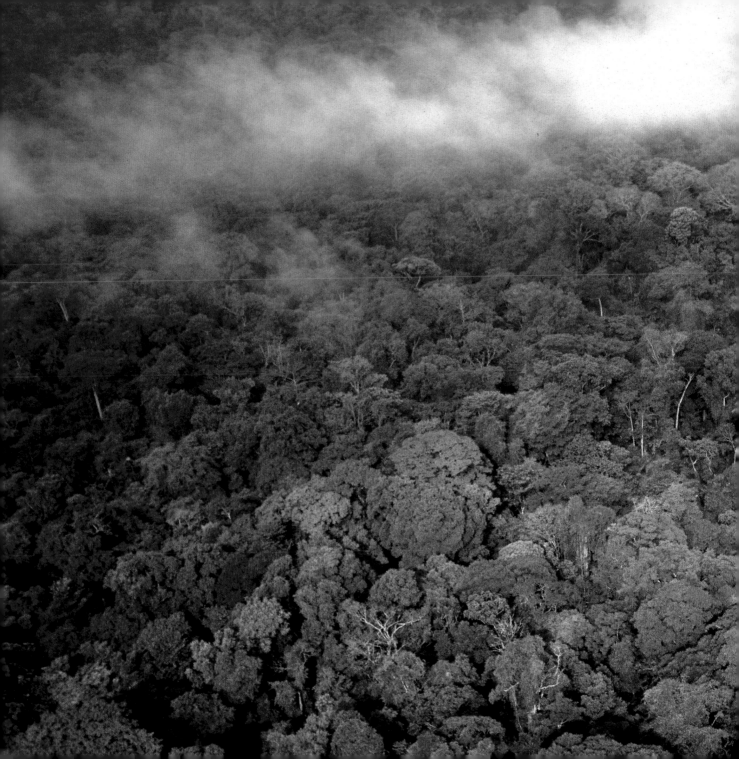

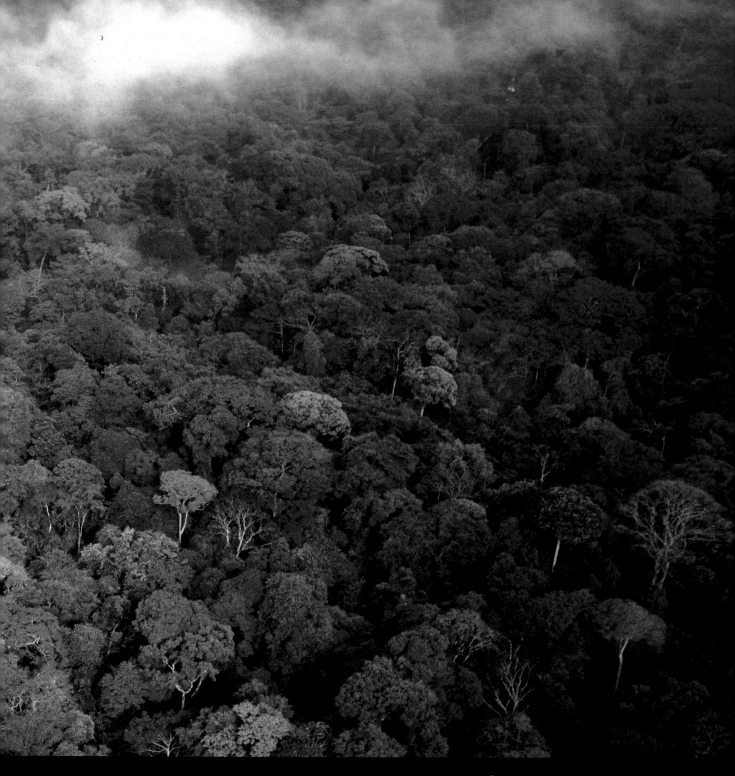

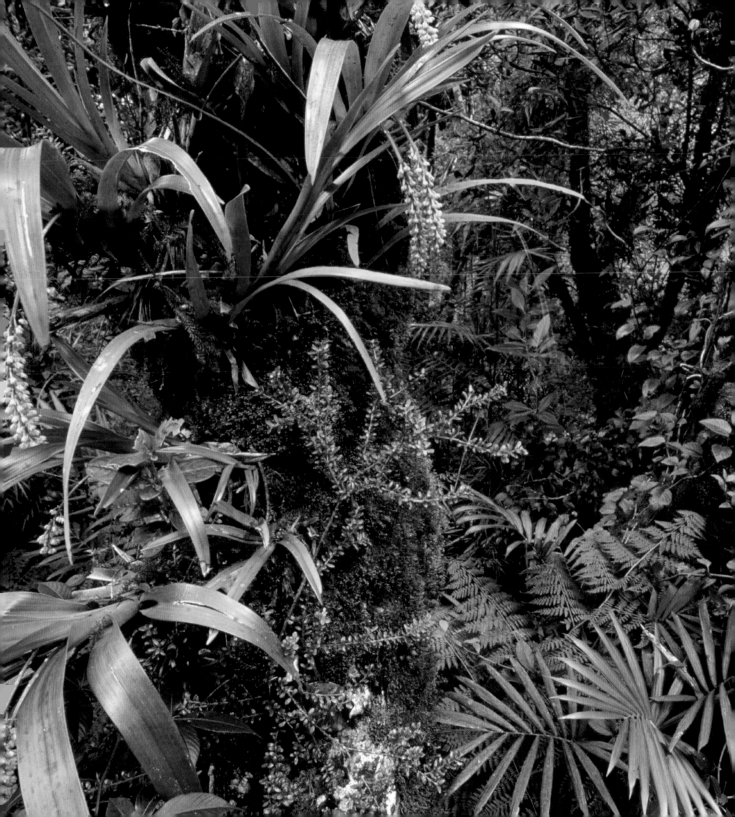

# TROPICAL RAINFORESTS HOLD THE GREATEST DIVERSITY OF LIFE IN ANY ENVIRONMENT ON EARTH, WITH MORE THAN 50 PER CENT OF ALL KNOWN SPECIES.

**LEFT** LAYER UPON LAYER A multitude of orchids, mosses, creepers and other tropical plants festooning the trees of rainforest in Sabah, Borneo.

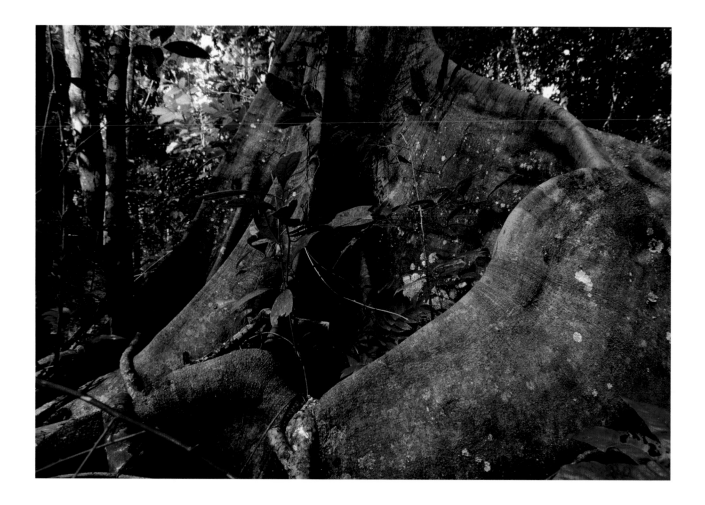

GIANT Modified roots serve as giant buttresses for a massive but shallow-rooted rainforest tree. Such trees need to be securely anchored as they may reach great heights and form a framework for other plants and animals to live on, which adds several tons of weight to their load.

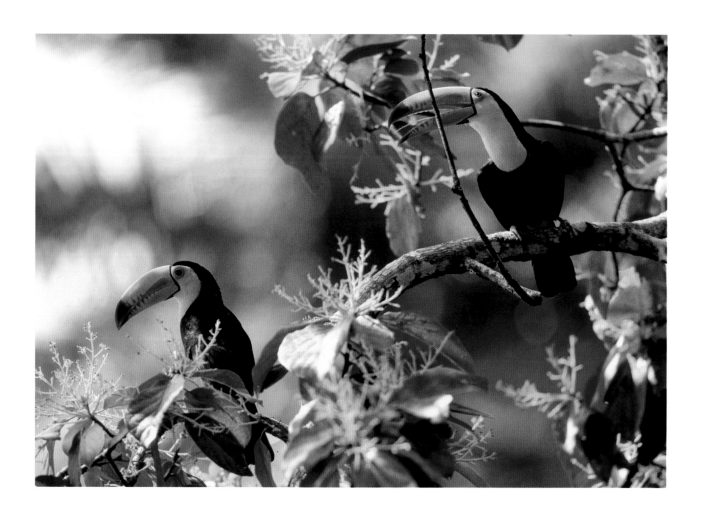

COLOUR IMPRESSION Keel-billed toucans – one of the most colourful of Central and South American birds. They use their dextrous bills to feed on an equally colourful array of fruits, as well as eggs and small animals, and are important dispersers of the seeds of rainforest trees.

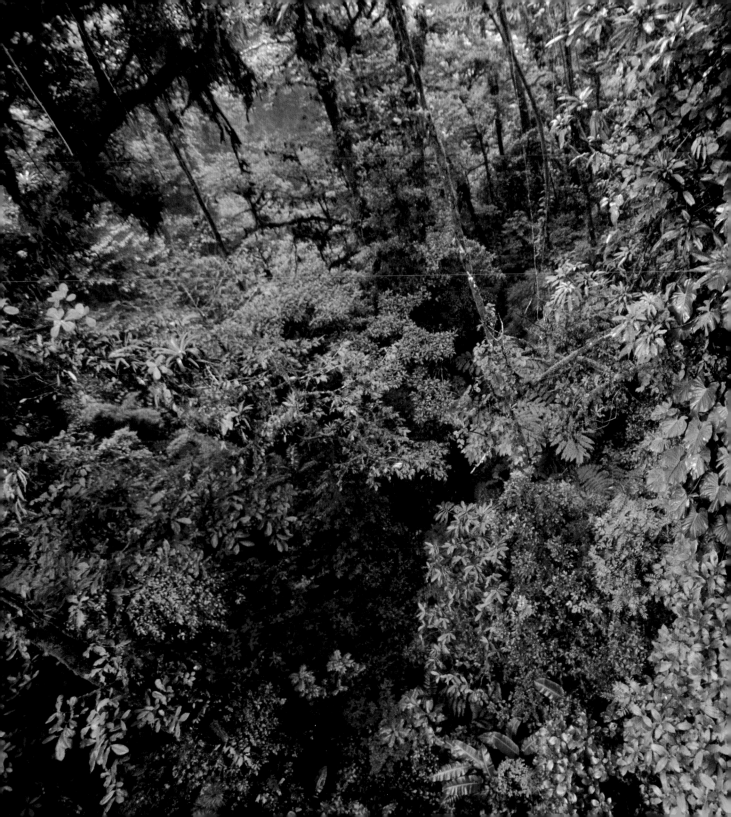

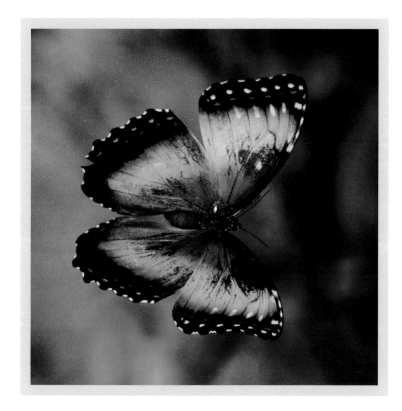

**LEFT** THE CLIMB FOR LIGHT Rainforest trees providing scaffolding for lianas to climb up and communities of plants to cling on to – using every bit of light space. Modern climbing technology allowed *Planet Earth* to film from the canopy right down to the forest-floor tangle.

**ABOVE** FOREST FLASHERS The iridescent blue of a male morpho butterfly's upper wings caught in the light. Males use their reflective wings to flash intimidating messages to rivals but can also disappear in an instant by altering the angle of reflection of their wings.

**ABOVE** PLANTER OF SEEDS An agouti eating the outer flesh of a forest fruit and cracking the shell to get at the nutritious seed inside. It is one of the few animals able to crack Brazil nuts. But it will also stash nuts around its territory, and many trees depend on agoutis as seed planters.

**RIGHT** NECTAR-SIPPING SYLPH A male violet-tailed sylph sipping from hummingbird-bill-shaped flowers in a cloud forest, Ecuador. In the permanently moist air of mountain rainforest, the trees drip with plants. This is prime orchid and hummingbird territory.

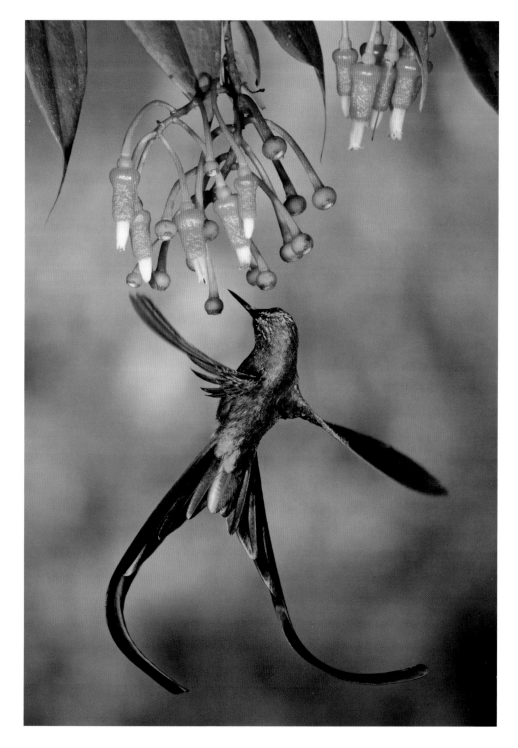

**PREVIOUS SPREAD** MONKEY MEAL A saddleback tamarin feasts on canopy fruit and flowers, Peru. Every monkey has a part to play in the pollination of flowers or dispersal of seeds of rainforest trees and vines.

**ABOVE** PACKAGED FOR DISPERSAL An array of designs for dispersal. A few seeds use spinning means or breezes to move away, but as there is little wind in a rainforest, most rely on animals to move them.

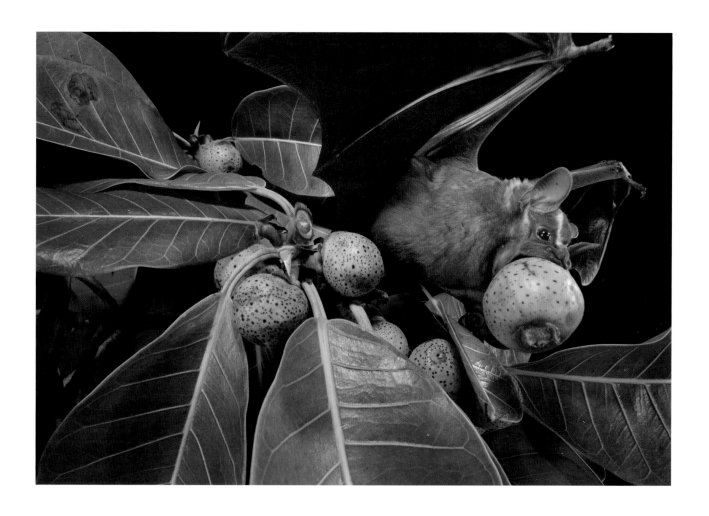

FIG SNATCH A great fruit-eating bat grabs a ripe fruit from a Panama fig tree. Fruit-eating bats are vital rainforest seed couriers, each species having particular alliances with trees and plants.

'We are faced probably with the extinction of at least half the world's frogs. From the speed at which the fungus is spreading and the way it is popping up in new places, I think we shall see massive extinctions probably on a timescale of five years, ten years. And so from the conservation point of view, this is the most urgent species-conservation issue of today.' MARK STANLEY PRICE, CHIEF EXECUTIVE, DURRELL WILDLIFE CONSERVATION TRUST

**RIGHT** MASS MATING Red-eyed treefrogs gather in a frenzy of mating activity, the males wrestling their way to piggyback onto the females. The females will then wander from plant to plant, their suitors still attached, until they find a suitable leaf over water on which to spread their eggs.

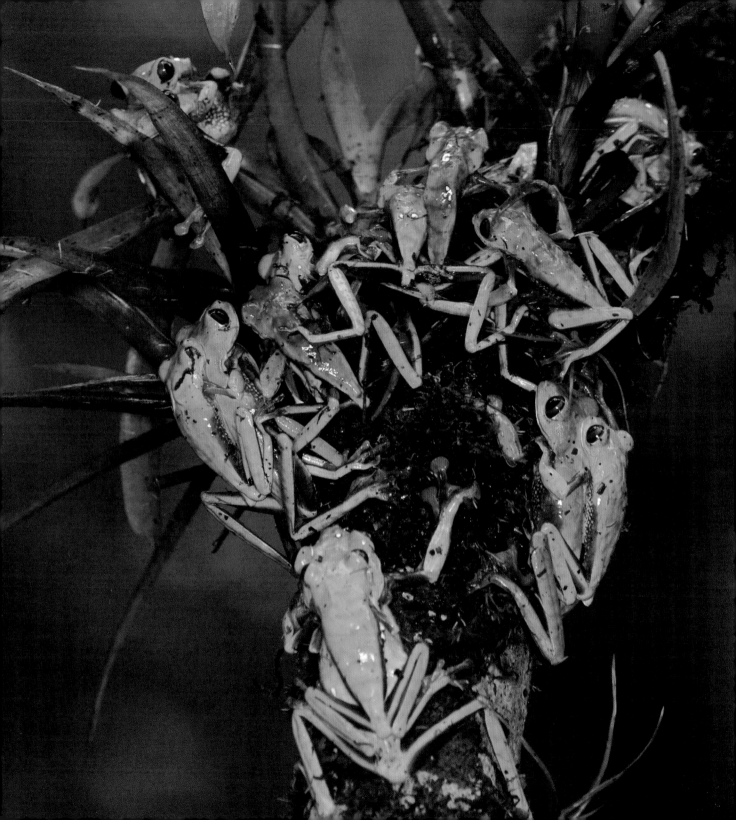

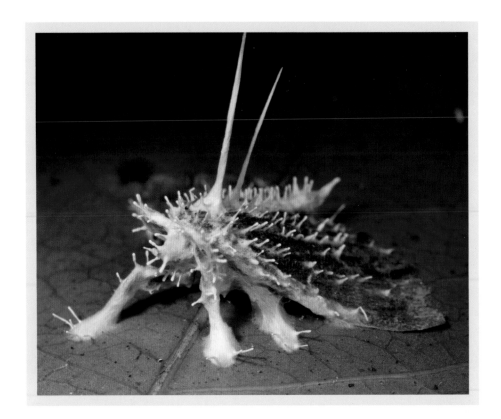

MOTH ENTOMBED The body of a rainforest moth has been used by a
*Cordyseps* fungus as a ready-made growbag and is sprouting fruiting
bodies – part of the endless recycling taking place on the forest floor.

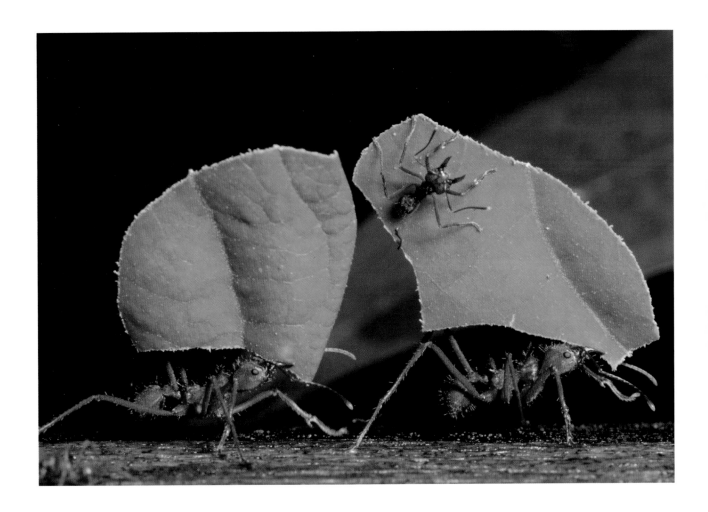

RAINFOREST GARDENERS Leafcutter ants en route to base camp with freshly cut leaves for their fungus farm. They are fussy about which leaves to harvest, as they know exactly what type the fungus digests best.

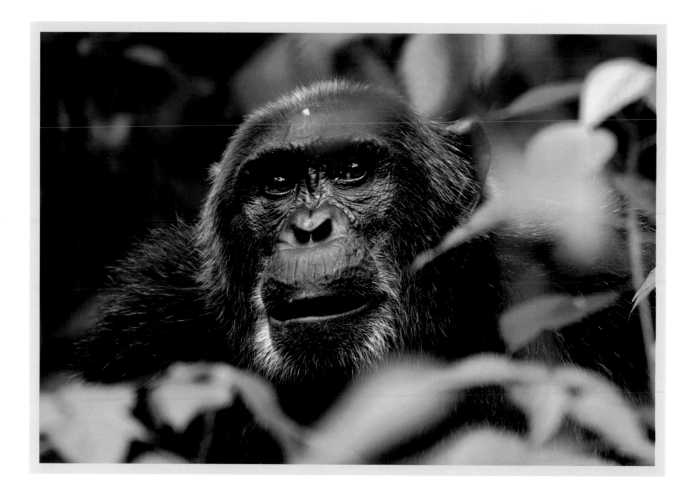

**ABOVE** CHIMP LOOKOUT One of the males of the 120-strong Ngogo troop filmed by *Planet Earth* in Uganda on a territorial patrol. Occasionally, the males will steal females from neighbouring groups.

**RIGHT** GORILLA WATCH Western lowland gorillas resting in trees in the Central African rainforest. Filming lowland gorillas in rainforest is fraught with difficulty, not least because there is comparatively little light.

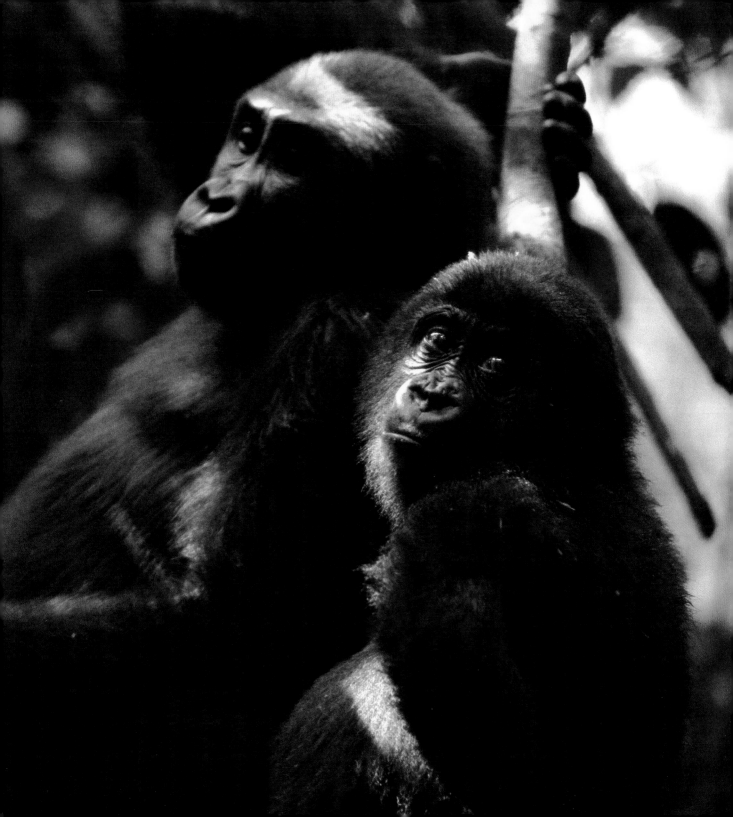

'In any given ecosystem there are some species of extraordinary importance to the health of that ecosystem. This is true of elephants, for example. Something like two thirds of the tree species in western Africa germinate only when processed through an elephant – an elephant eating the seed and excreting it in the forest.'

JAMES LEAPE, DIRECTOR GENERAL,

WWF INTERNATIONAL

RIGHT FOREST EXCAVATOR A forest elephant – smaller and darker than its savannah relative. Recognized as a separate species relatively recently, it has an equally important role in its ecosystem, dispersing seeds, creating paths, digging waterholes and clearing areas where other animals can graze.

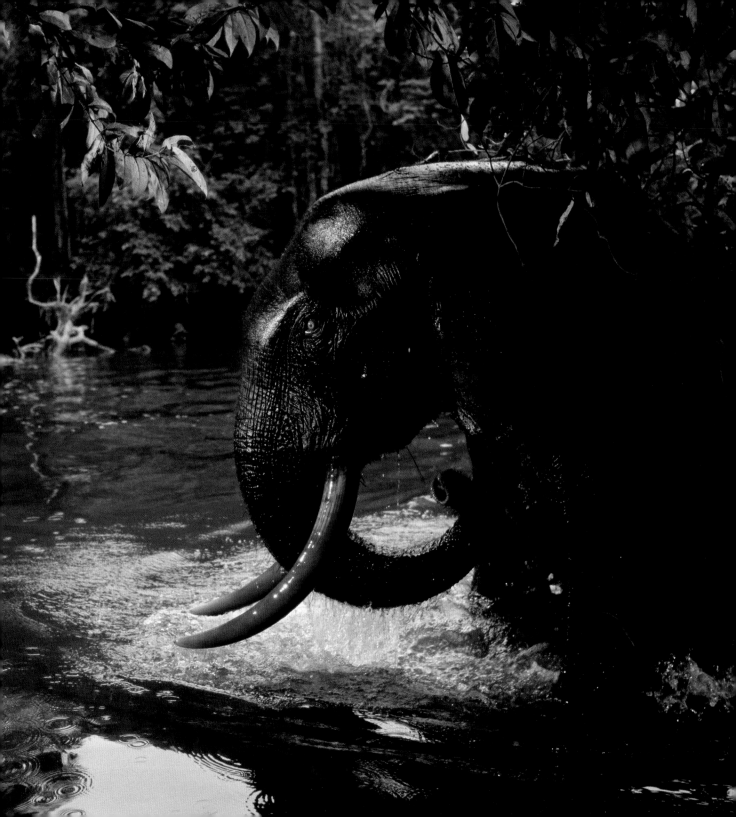

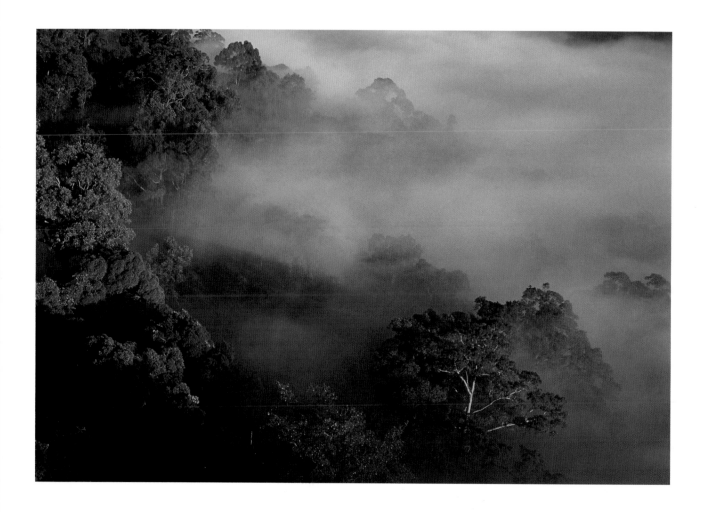

**ABOVE** CYCLE OF LIFE Early morning mist rises off the rainforest canopy in Sabah, Borneo. Perpetual warmth and rain in the equatorial zone have produced one of the richest habitats on the planet.

**RIGHT** HORNBILL AT THE NURSERY A red-knobbed hornbill brings food to his mate cemented into her nest while she broods their young. Hornbills are vital dispersers of seeds in Asian rainforests.

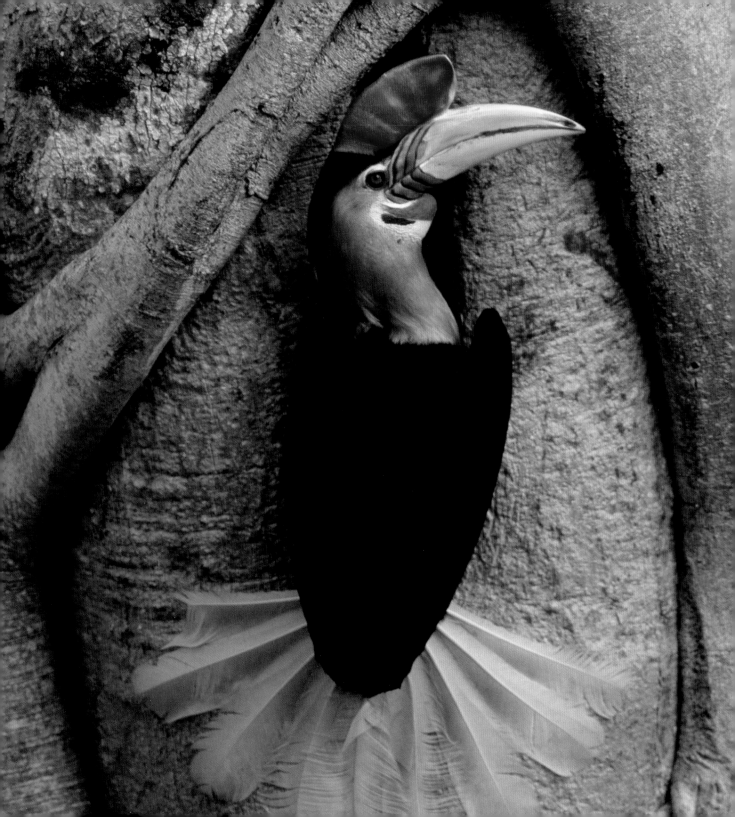

'When you reduce biodiversity, which is a complicated way of saying when you exterminate species, you exterminate links in chains and produce very, very unpredictable and often disastrous consequences. Take the frogs ... for example. Their disappearance can have great consequences for the various creatures that feed upon them or the creatures that they themselves feed on. If they go, the insects proliferate. What happens then? Do some of those insects carry diseases? Every time you change the balance or, worse, eliminate a species, you risk ecological catastrophe.' DAVID ATTENBOROUGH

TREE GLIDER A male Wallace's flying frog parachuting down in search of females. *Planet Earth* used high-speed cameras to capture the graceful descent of these gliding treefrogs in Borneo.

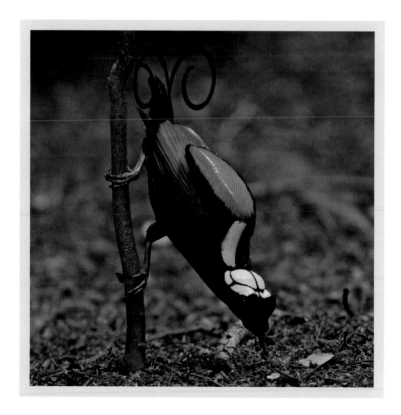

**ABOVE** DISPLAY OF LOVE A male Wilson's bird of paradise poses on his display perch to show off his extraordinary colours and vibrating tail, set to perfection against an arena cleared of all distracting material. With plentiful rainforest food, he can afford such lavish plumage and displays.

**RIGHT** SHIMMER OF BLUE A male blue bird of paradise – filmed for the first time in the wild by *Planet Earth* – flashes his fabulous cape of feathers in an attempt to attract females. He adds to the dazzling effect with an extraordinary, almost electronic-sounding noise.

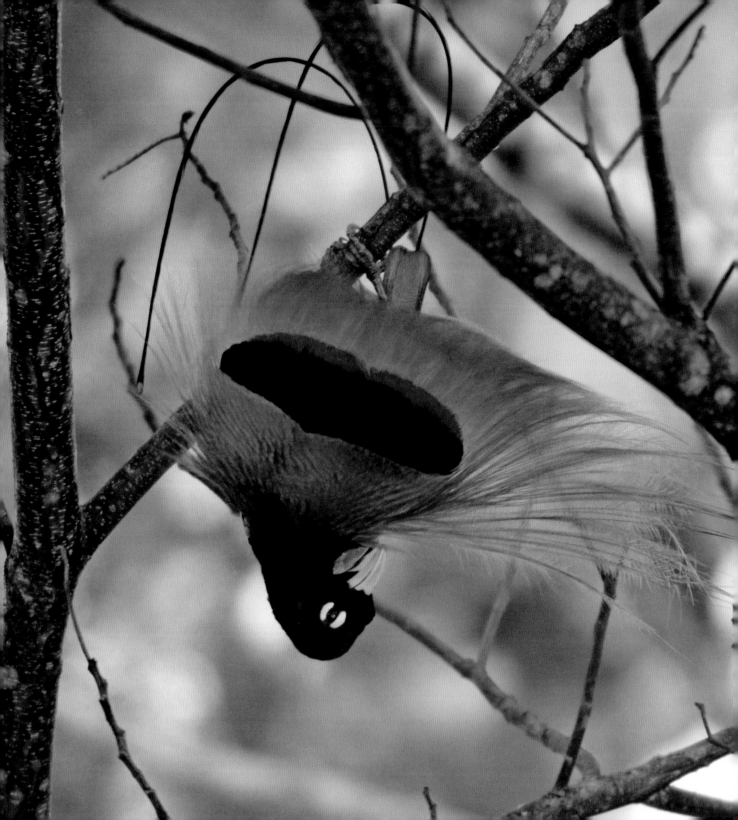

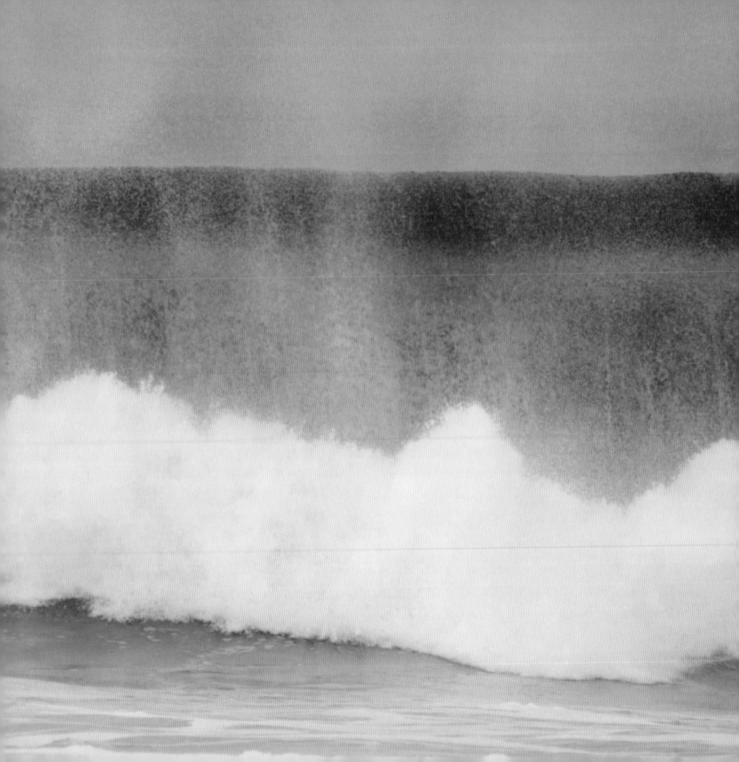

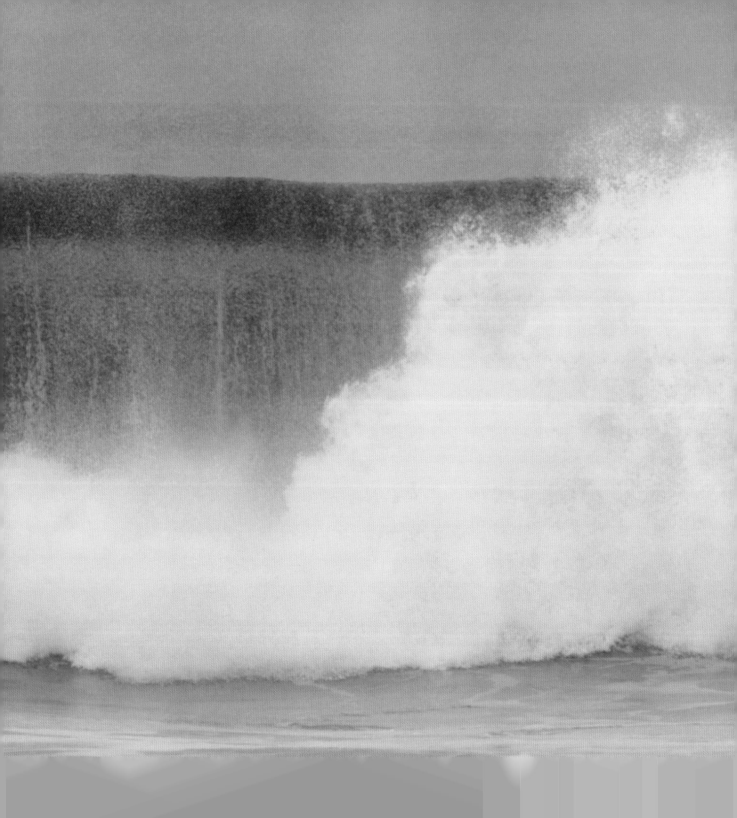

# ONLY 8 PER CENT OF THE OCEAN IS MADE UP OF SHALLOW SEAS — THE SUBMERGED EXTENSIONS OF THE CONTINENTS — BUT THEY ARE BY FAR THE RICHEST PARTS.

**LEFT** CORAL RICHES Australia's famous Great Barrier Reef, stretching for about 2000km (1240 miles) along the coast of Queensland. It is the world's largest (but not longest) fringing barrier reef, made up of a chain of 2000 separate reefs, and can easily be seen from space.

'The destruction that is being wrought by humanity on the oceans is so total, so vast – and so completely beyond the comprehension of most people, because all of it is covered up by this lovely, evocative surface.'

ROGER PAYNE, PRESIDENT,

OCEAN ALLIANCE

RIGHT HUMPBACK NURSERY Mother and calf off Tonga – stars of *Planet Earth*. Humpbacks travel to relatively safe, calm, tropical waters to give birth. A calf will drink up to 600 litres (1268 pints) of milk a day, though its mother won't be able to feed while in these relatively lifeless waters.

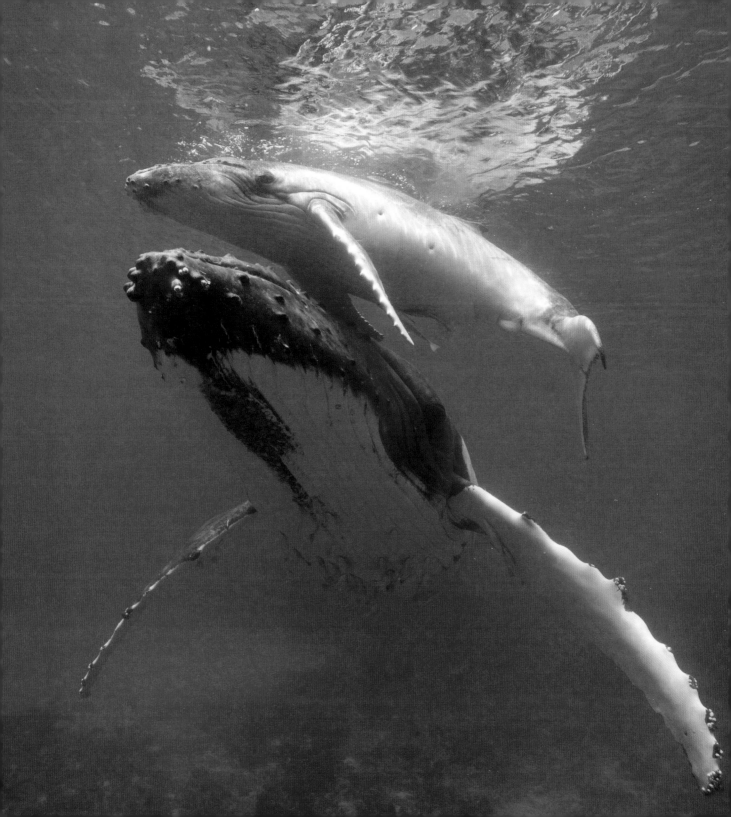

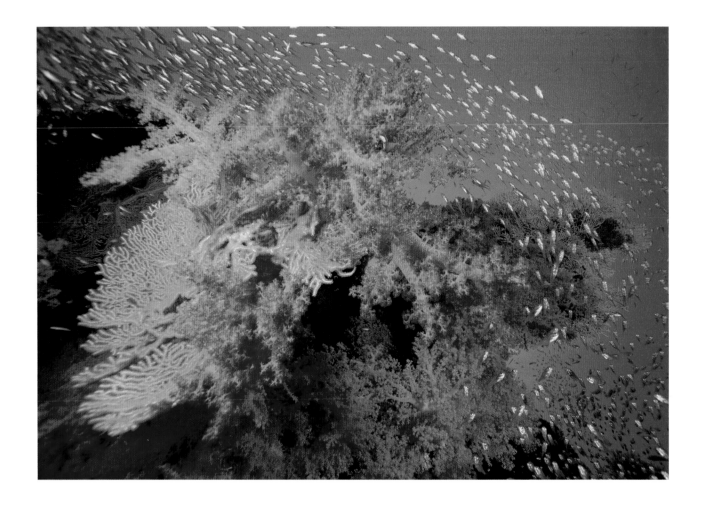

CORAL COLOUR Red Sea soft corals – part of the world's longest
barrier reef and possibly the most colourful, sporting a wealth of soft
corals in a range of fiery colours. Reefs are the most productive habitat in
the ocean, with a diversity of life in every nook and cranny of the coral.

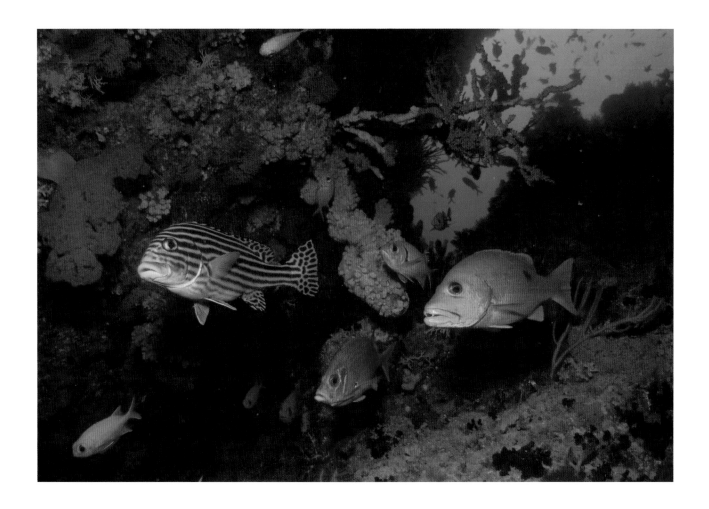

CORAL DIVERSITY Oriental sweetlips and red bigeyes – part of a rich community living among coral in the Maldives. The clear, shallow water that coral needs for the algae housed within it to utilize the sun means colour can be seen and so fish make good use of this to communicate.

223

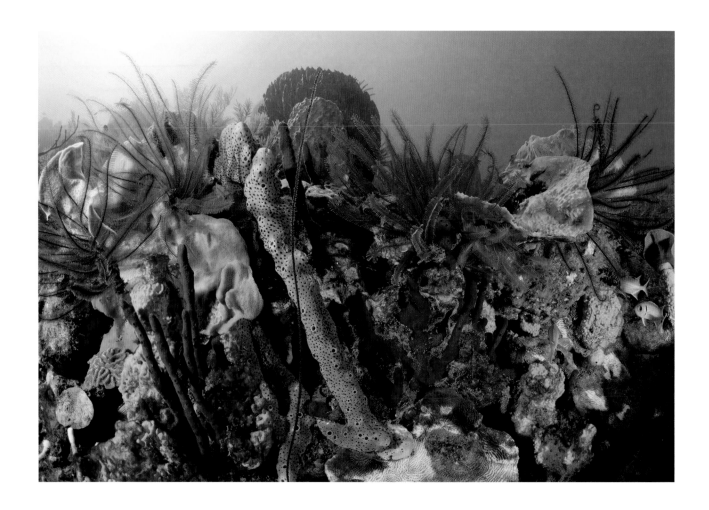

CORAL COMMUNITIES Plant-like crinoids, sponges and many other
animal colonies jostle for a foothold on the elevated vantage point of a
coral outcrop. The framework of a reef allows many species to get high
up in the current where they can feed on the nutrients wafting by.

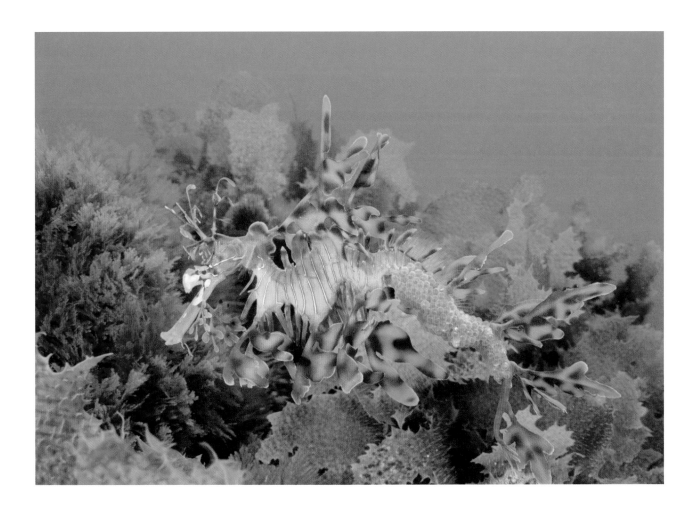

**ABOVE** ROCKY REEF DRAGON A male leafy sea dragon, disguised as seaweed, aerates eggs developing on a brood patch at the base of its tail. Leafy sea dragons are fish related to seahorses and are found only on the seaweed-covered rocky reefs that fringe Australia's southern shoreline.

**OVERLEAF** PACK HUNT A pack of yellow-saddle goat fish flushing out prey from a coral head in the Banda Sea, Indonesia, accompanied by sea kraits. Blue-finned jacks are picking off escaping fish. This hunting association was filmed for the first time by *Planet Earth*.

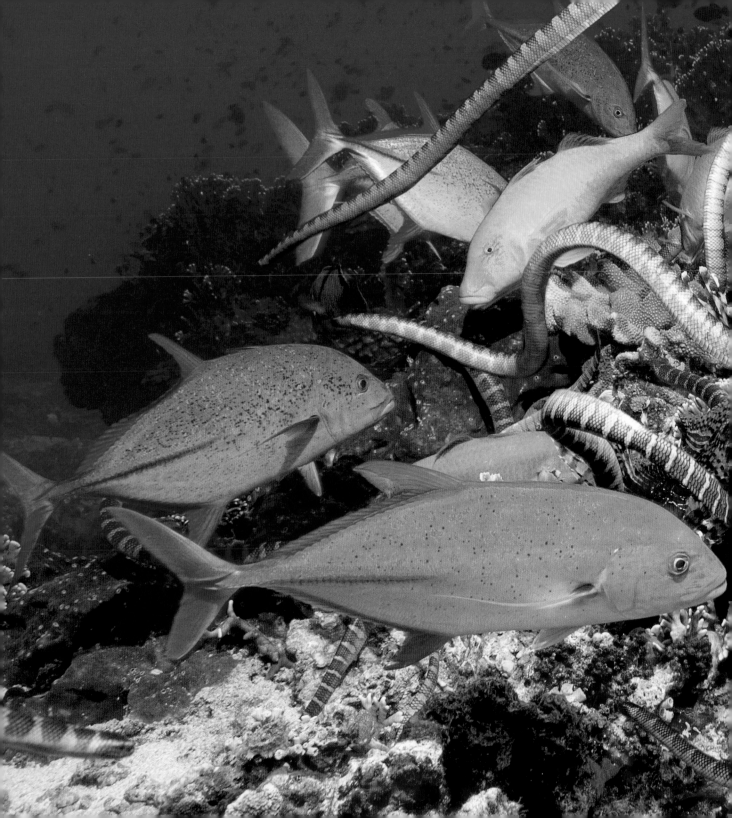

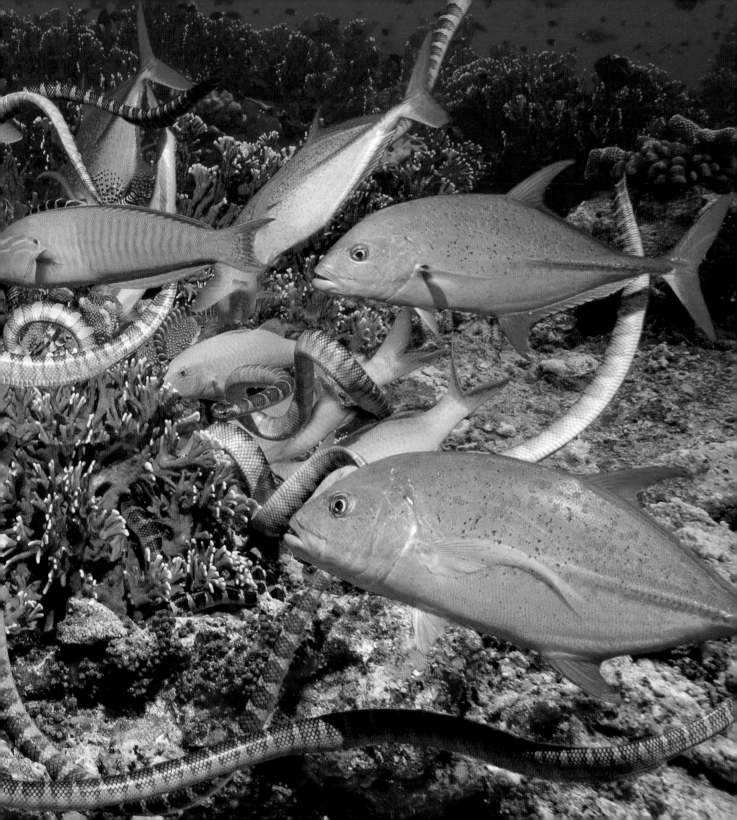

'Climate change is warming the oceans, resulting in more frequent coral-reef bleaching, where the coral ejects its algae partner. We simply don't know how frequently that can happen before it's over for the coral. Increased $CO_2$ is also acidifying the oceans and affecting animals like corals that build shells or skeletons from calcium carbonate.'

# THOMAS LOVEJOY, CONSERVATION BIOLOGIST

RIGHT PINNACLE OF LIFE Encrusting a rocky pinnacle off California are hydrocorals – colonial hydrozoans with limestone skeletons, resembling true coral but found in places reef-building corals can't grow, where the water is cold and the currents are strong. Also clinging to the rock wall is kelp.

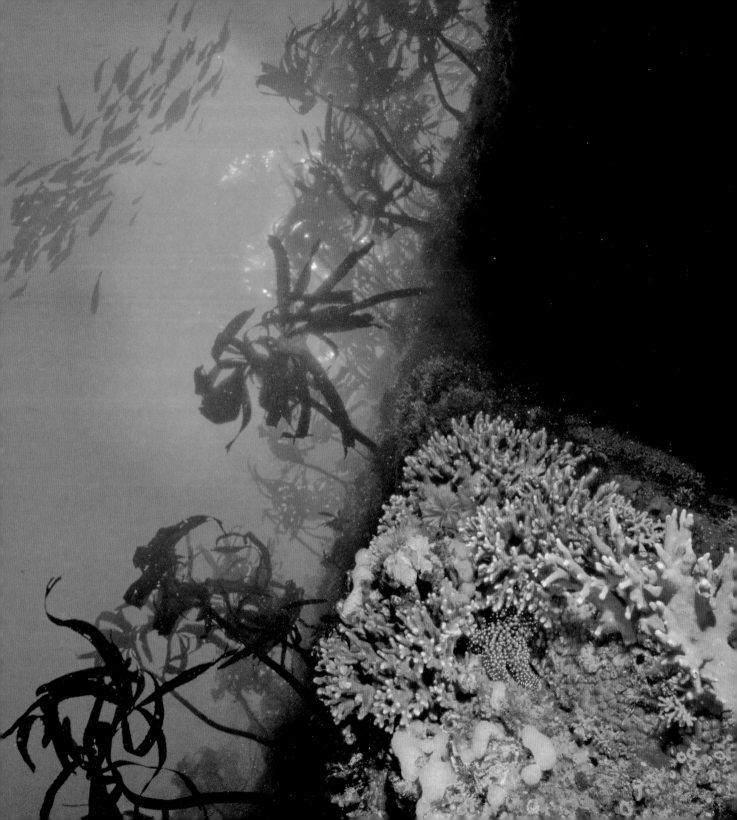

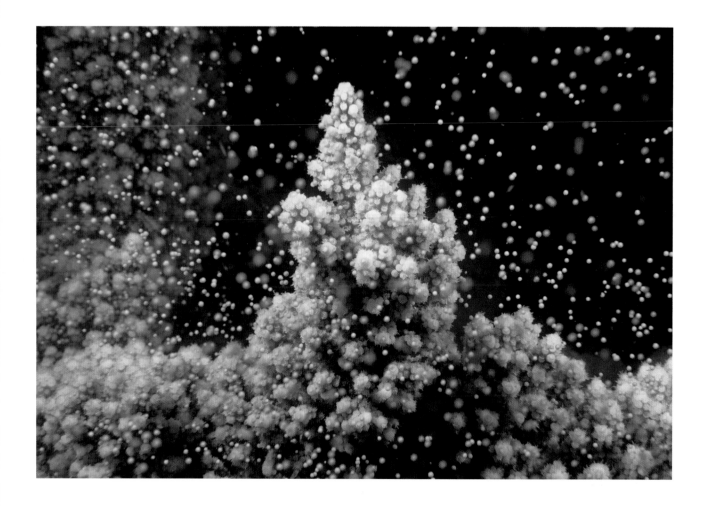

ABOVE CORAL BIRTH A staghorn coral releases bundles of eggs and sperm to add to the snowstorm of spawn as the corals of Ningaloo Reef off Western Australia take part in a mass release at night.

RIGHT REEF SQUID The highly social Caribbean reef squid, making full use of colour in its shallow-water habitat by flashing messages – including sexual interest and alarm – using pigments in its skin.

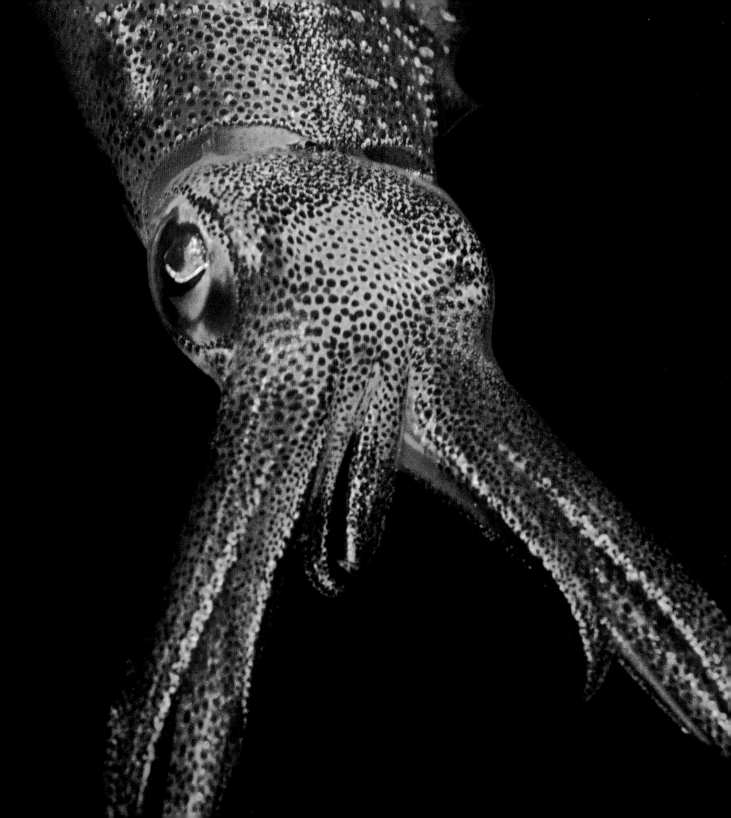

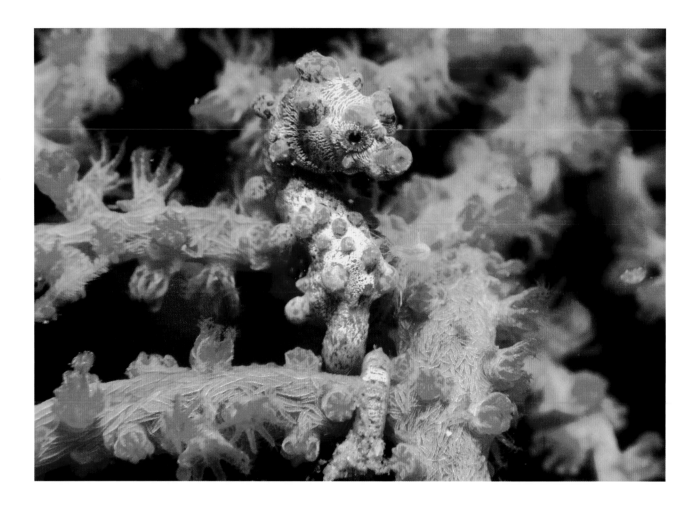

PYGMY WONDER On a coral reef in Indonesia, a pygmy seahorse –
hardly bigger than a fingernail – grips tight to its sea-fan home with its
tail and pretends to be part of the structure, in both colour and form,
sporting body tubercles to match the sea fan's polyps.

'We are maybe losing between 15,000 and 60,000 species a year. When we discover a new species, it is a newspaper headline ... But the rate of extinction is not exceptional – it's not in the newspapers – because it's business as usual.' DR AHMED DJOGHLAF, EXECUTIVE SECRETARY, CONVENTION ON BIOLOGICAL DIVERSITY.

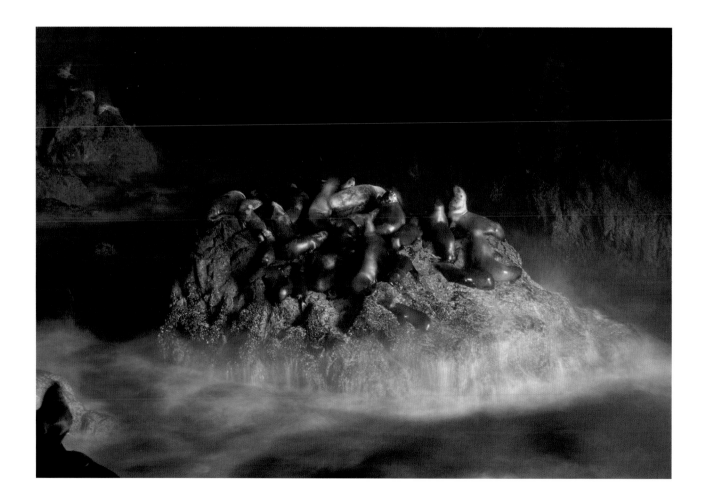

ROCKY RETREAT Steller's sealions at their summer haul-out caves off
the Pacific coast of America. They rely on rocks and offshore islands for
resting, giving birth – and escaping from marauding killer whales. Their
numbers are declining, probably because the fish they feed on are.

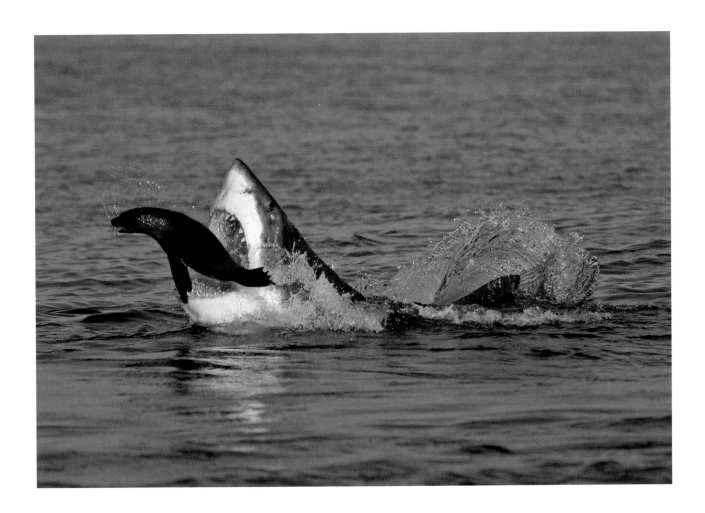

**ABOVE** SURPRISE ATTACK The huge jaws of a great white shark close on a cape fur seal. *Planet Earth* used high-speed film cameras to slow down such a moment 40 times. Great whites off South Africa specialize in surprise attacks, but a seal may sometimes outmanoeuvre the shark.

**OVERLEAF** SARDINE ROUND-UP A bronze whaler circling before charging into the tightly packed 'baitball' of sardines. The migration of sardines up the east coast of South Africa attracts many predators, and when attacked, the fish clump together to try to confuse them.

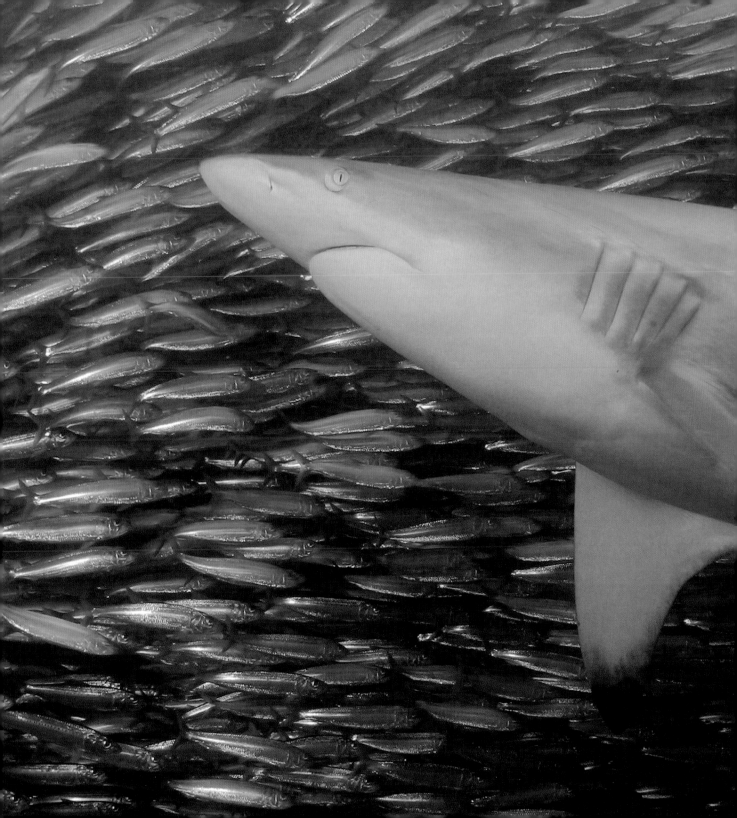

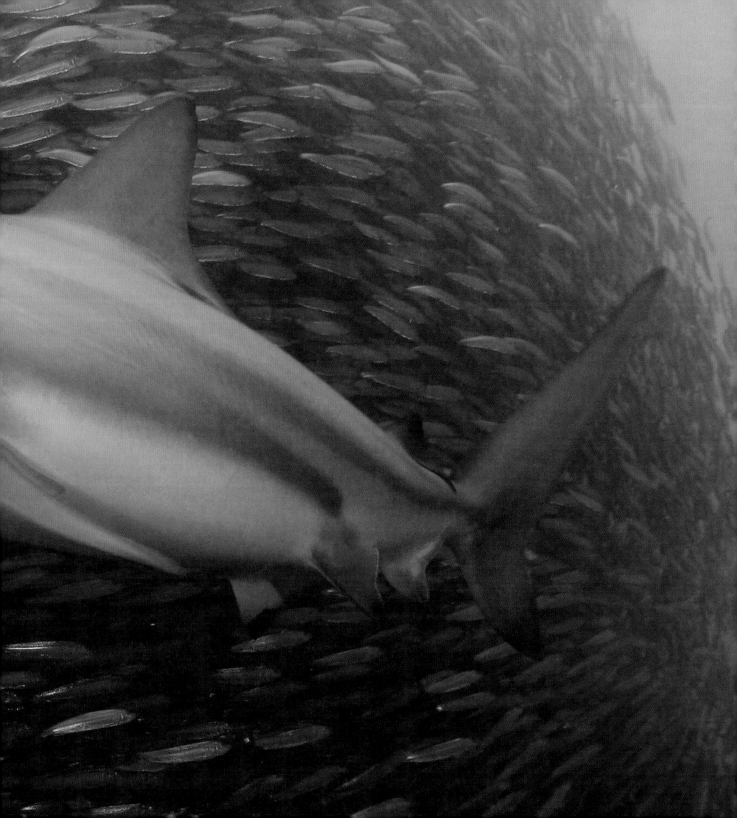

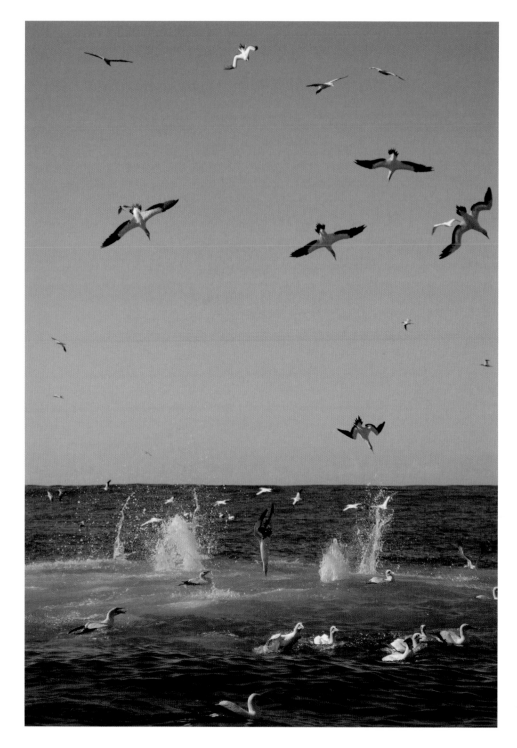

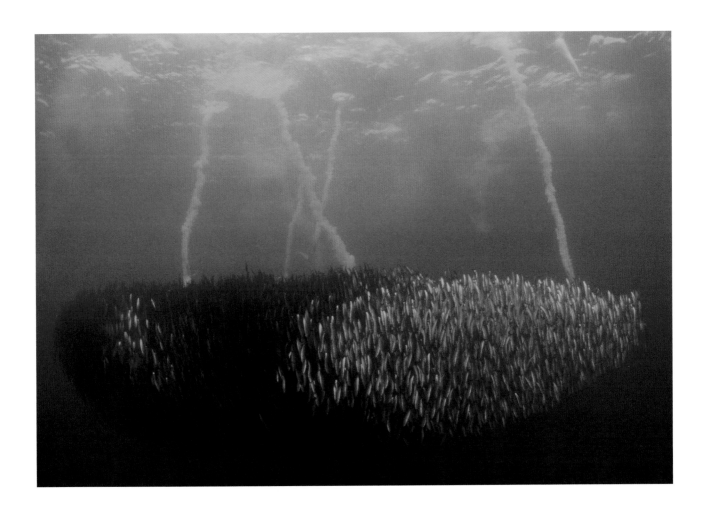

**LEFT & ABOVE** PLUNGING GANNETS Cape gannets diving onto a baitball of sardines, leaving jet streams of bubbles in their wake. The fish have been driven to the surface and pinned there by common dolphins, and it was the dolphins who alerted the gannets to the feast below water.

**OVERLEAF** THE DOLPHIN RUN Common dolphins moving at speed in search of fish, False Bay, South Africa. They may form huge pods of more than 1000 and long hunting lines. When outrunners spot a fish shoal, the entire pod will gather to work as one to herd the fish.

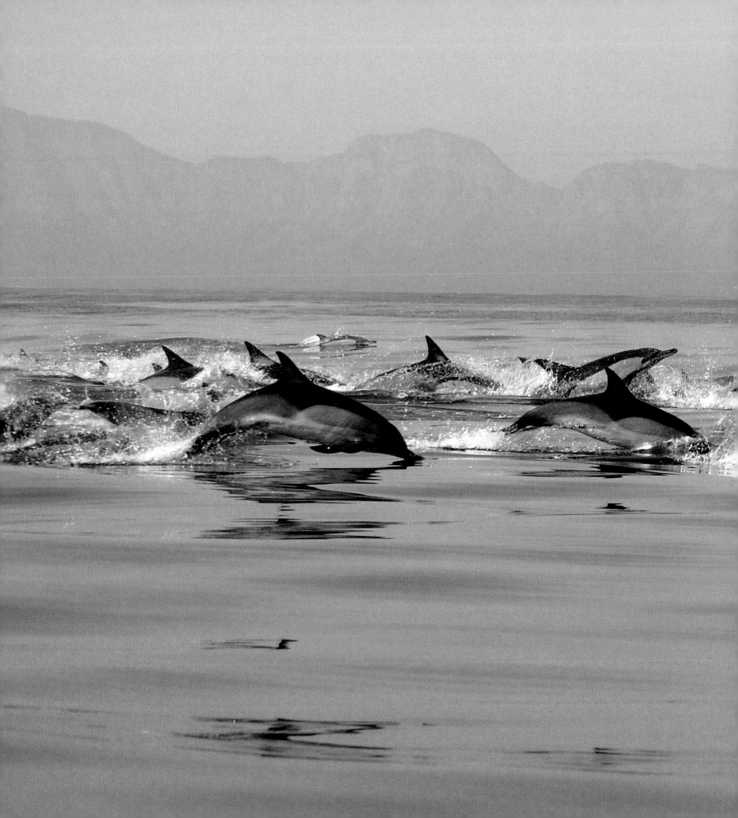

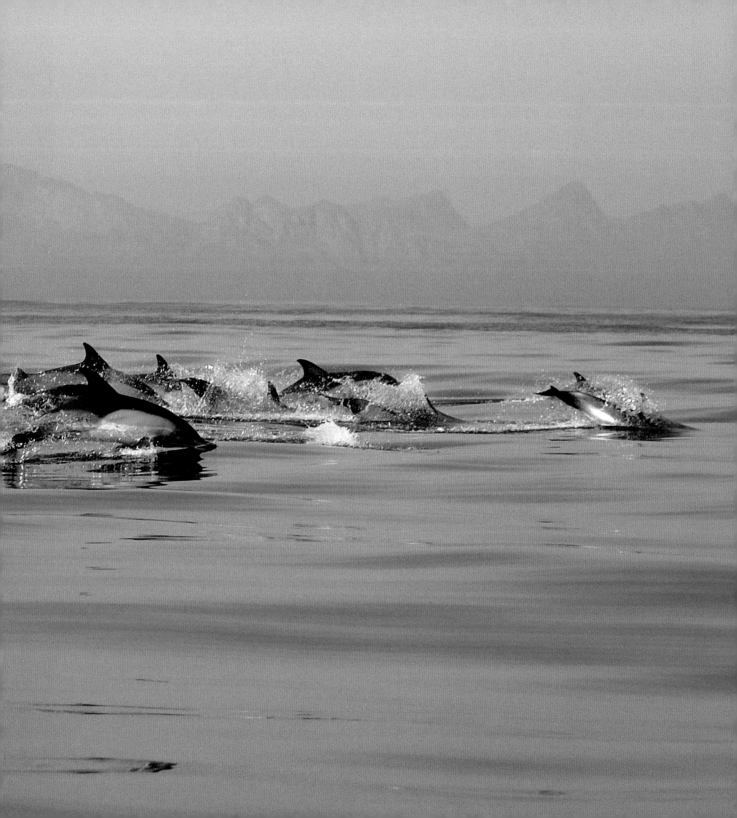

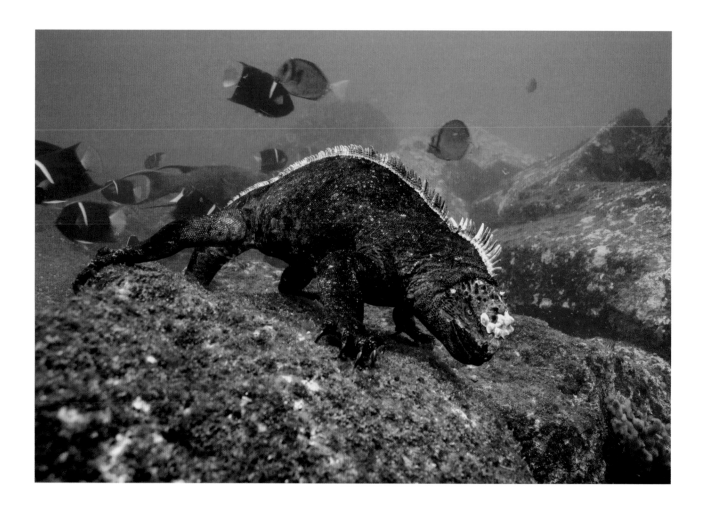

GRAZING LIZARD A marine iguana feeds with the fish on rocky
pastures off the Galapagos Islands. It is the only marine-going lizard in
the world and makes full use of the plentiful green and red seaweed
covering the rocks. On land, food is nowhere near as plentiful.

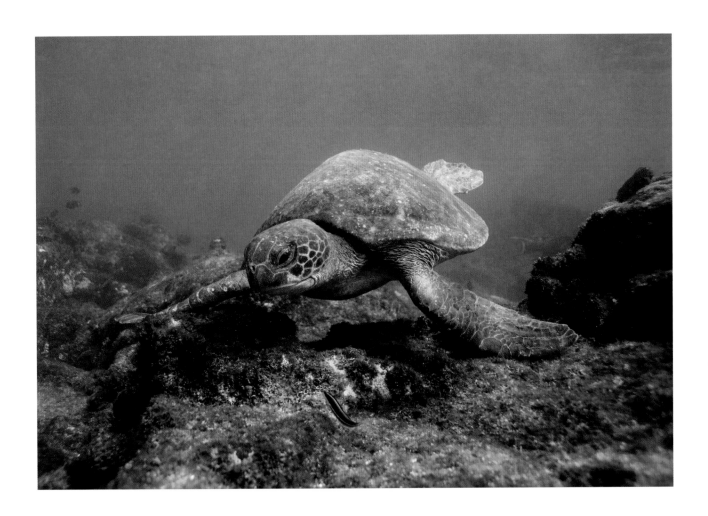

GRAZING TURTLE A Pacific green turtle grazes on Galapagos seaweed. Unlike other marine turtles, adult green turtles eat mainly sea grasses and algae, which means they remain close to shore. Their droppings help fertilize their pastures, and sea-grass beds are kept healthy by grazing.

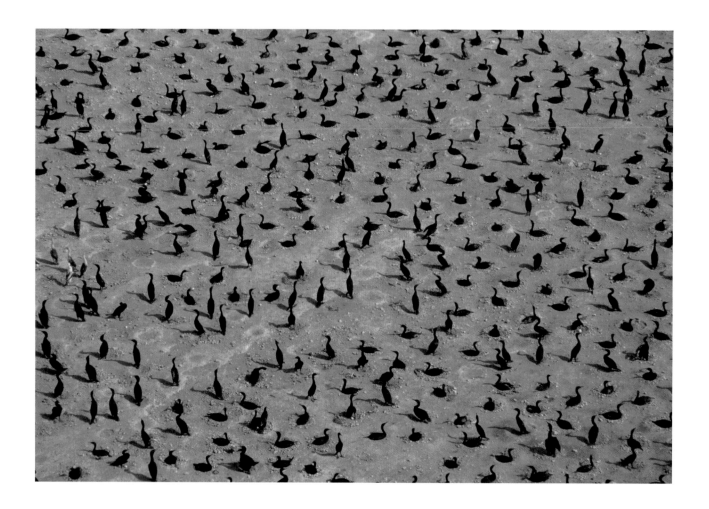

BEAK TO BEAK An aerial view of a Socotra cormorant colony revealing
a densely packed island neighbourhood of regularly spaced nests, each
one a beak's length apart. Islands in the rich sea of the Arabian Gulf
attract huge numbers of breeding Socotra cormorants every year.

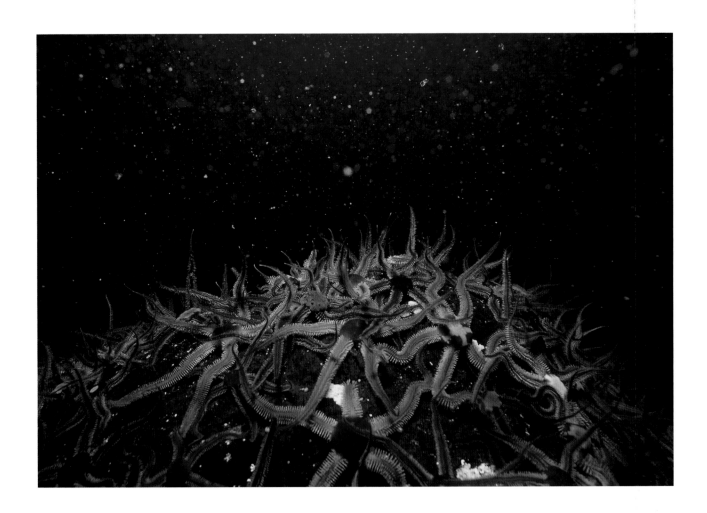

**ABOVE** ARM TO ARM Hundreds of common brittlestars cover a rocky outcrop off Scotland. Their arms reach out to catch the slowly sinking organic matter in these rich waters. Rocky areas are hugely important as they give marine plants and animals somewhere to gain a foothold.

**OVERLEAF** COLOUR-CODED COURTSHIP Spectacular ripples of colour pulsate along a male common cuttlefish as it woos a female off Cornwall. These highly visual cephalopods flash many messages, including those of courtship, in rhythmic patterns over the skin.

245

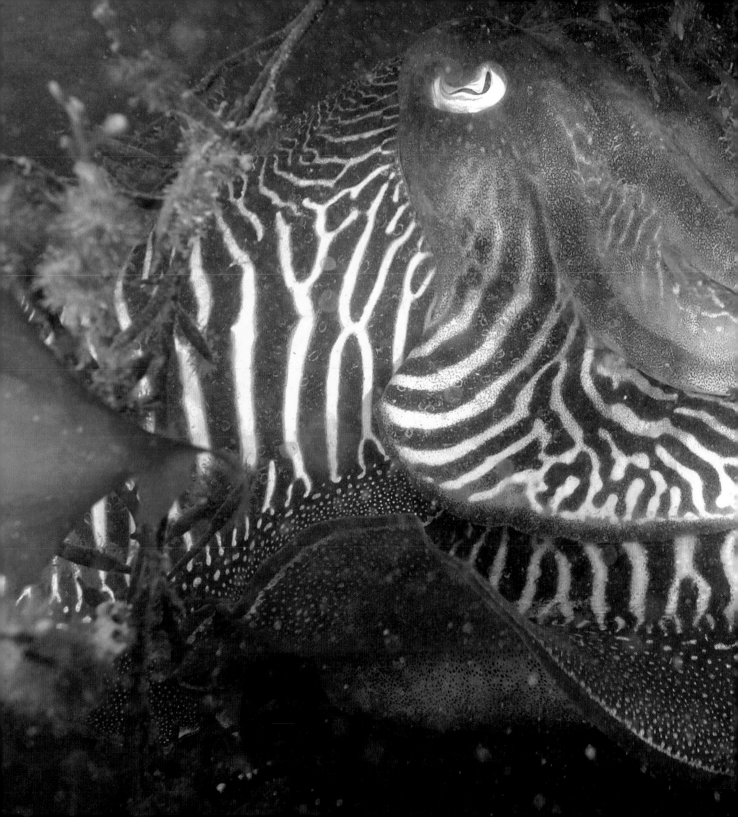

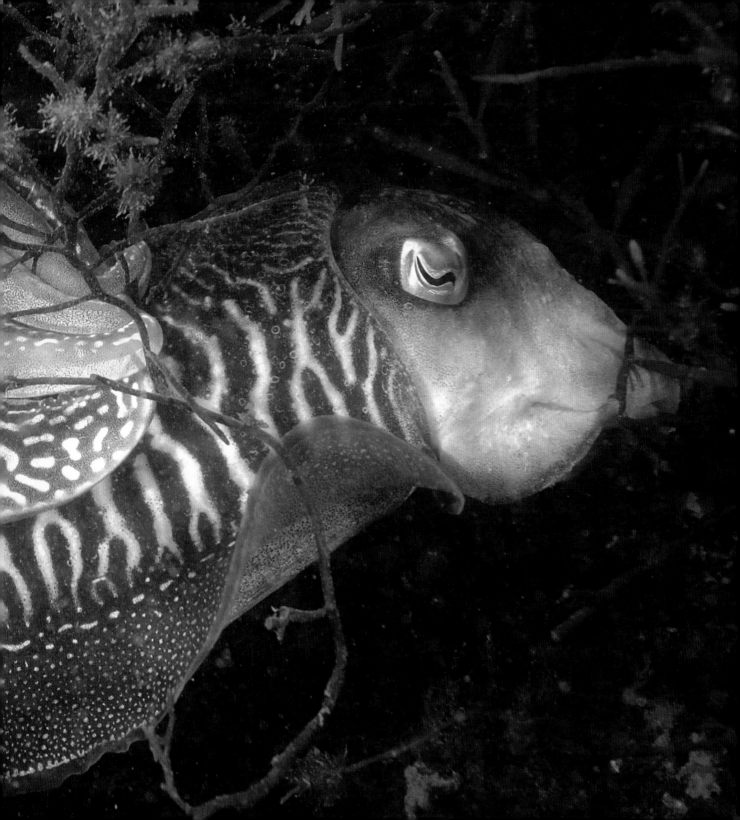

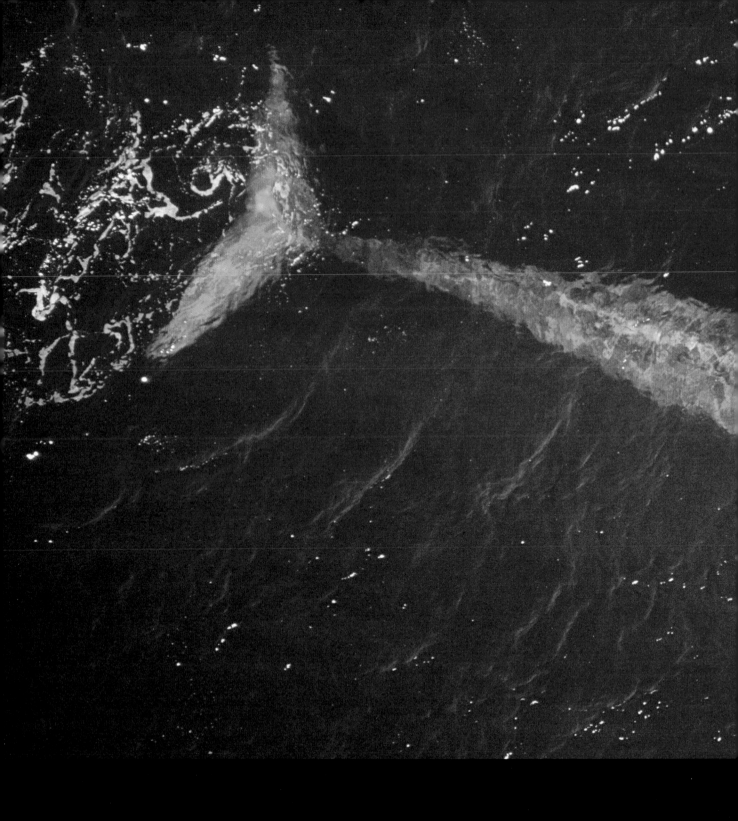

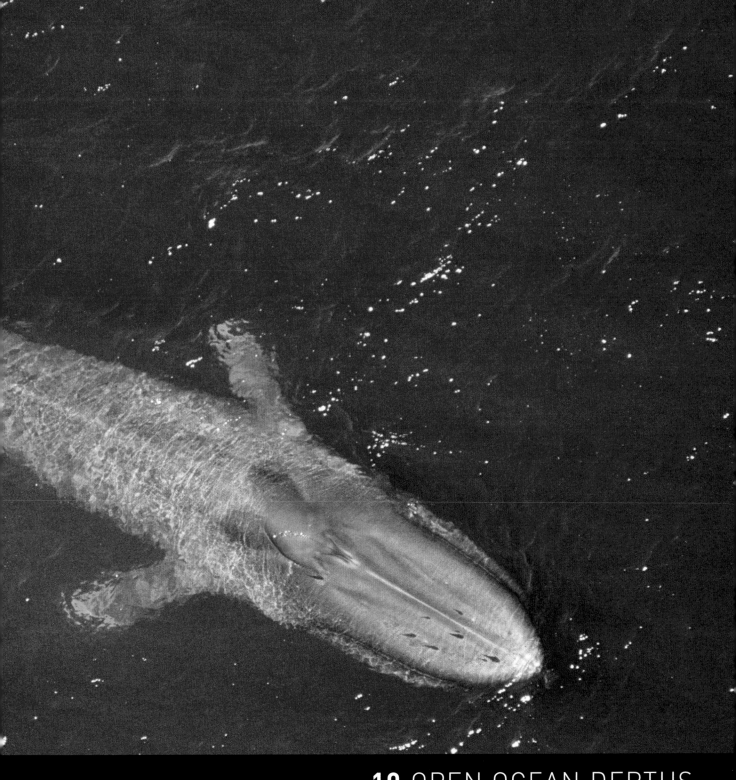

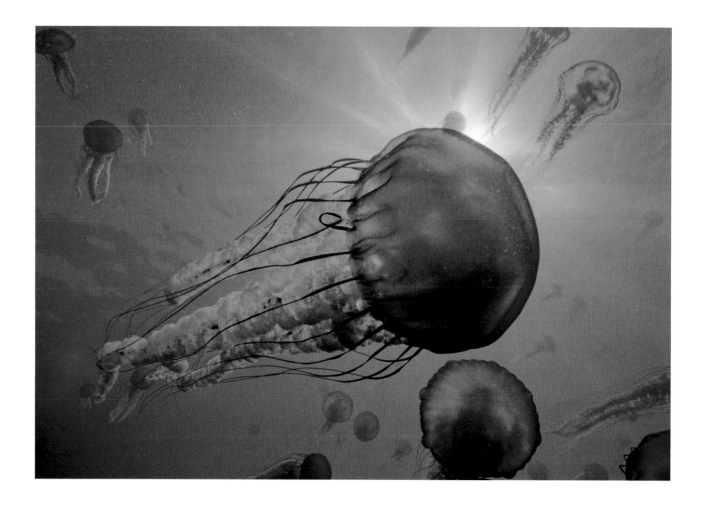

THE DRIFTERS A swarm of sea-nettle jellyfish, dragging behind them
long tentacles covered in stinging cells fatal to small fish. For open-ocean
animals, life is spent wandering the vast expanse in search of food,
swimming if they can, but in this case, going with the flow.

250

THE DEEP AND OPEN OCEAN COVERS MORE THAN 60 PER CENT OF THE PLANET AND IS THE REGULATOR OF OUR CLIMATE. IT IS ALSO THE LEAST KNOWN HABITAT ON EARTH.

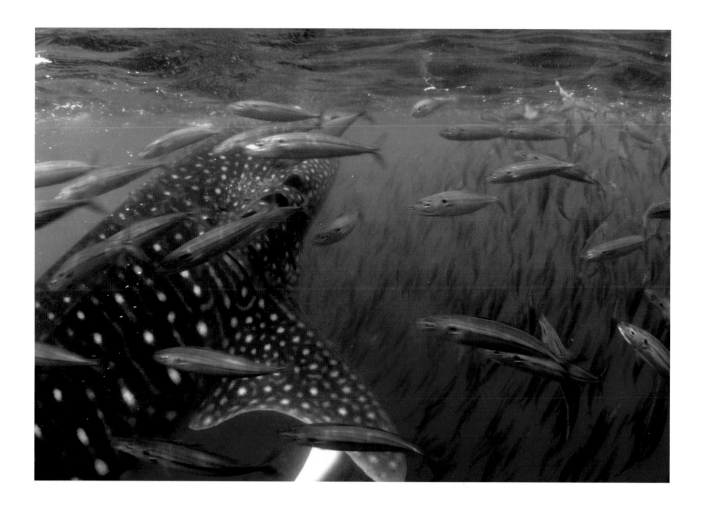

**ABOVE** THE BIGGEST FISH IN THE SEA A whale shark feasting on plankton. Off Venezuela, *Planet Earth* filmed tiny bait fish swarming around a whale shark, sheltering from tuna. Suddenly, the massive shark took a great gulp of fish – surprising behaviour for a plankton-feeder.

**RIGHT** THE BIGGEST BONY FISH A sunfish skulls slowly along in the open ocean. Sunfish are weak swimmers and often drift with the currents. Reaching 3.5 metres (11 feet) or more and weighing up to at least 1410kg (3109 pounds), they feed on jellies and other plankton.

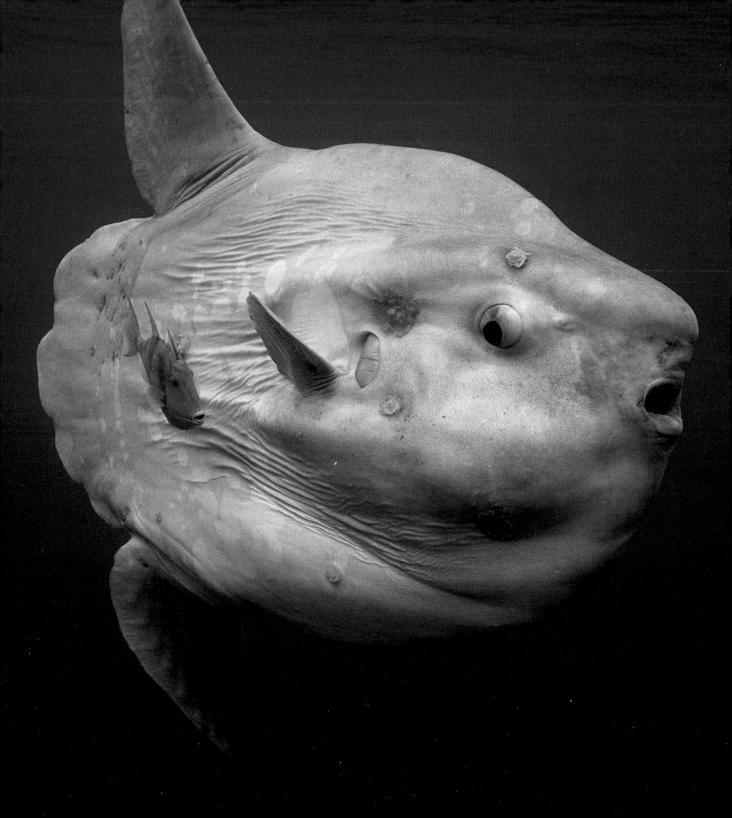

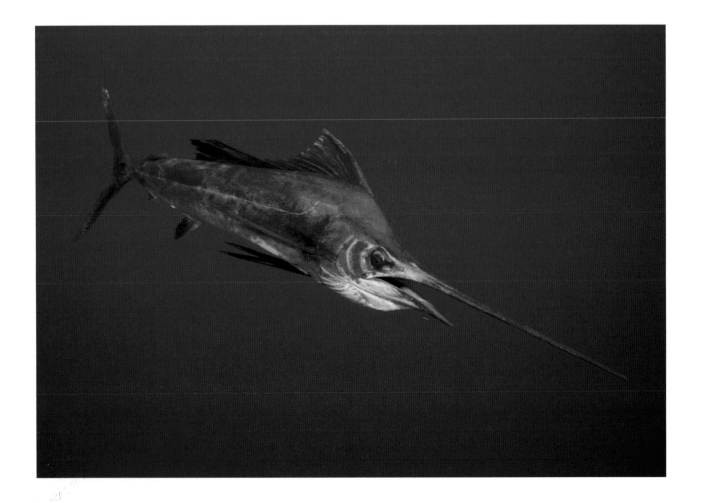

**ABOVE** THE FASTEST IN THE SEA A sailfish with its 'sail' slightly raised – the sprint record-holder at up to 110kph (68mph). *Planet Earth* filmed nearly 100 sailfish attacking a shoal of bait fish, constantly raising their dorsal fins and flashing blue to dark black to confuse their prey.

**RIGHT** GREAT WANDERER A huge manta ray filter-feeding plankton from the surface. There are few underwater experiences that can compare to a chance meeting with a wandering manta ray, silently cruising the open ocean currents on its massive wingspan.

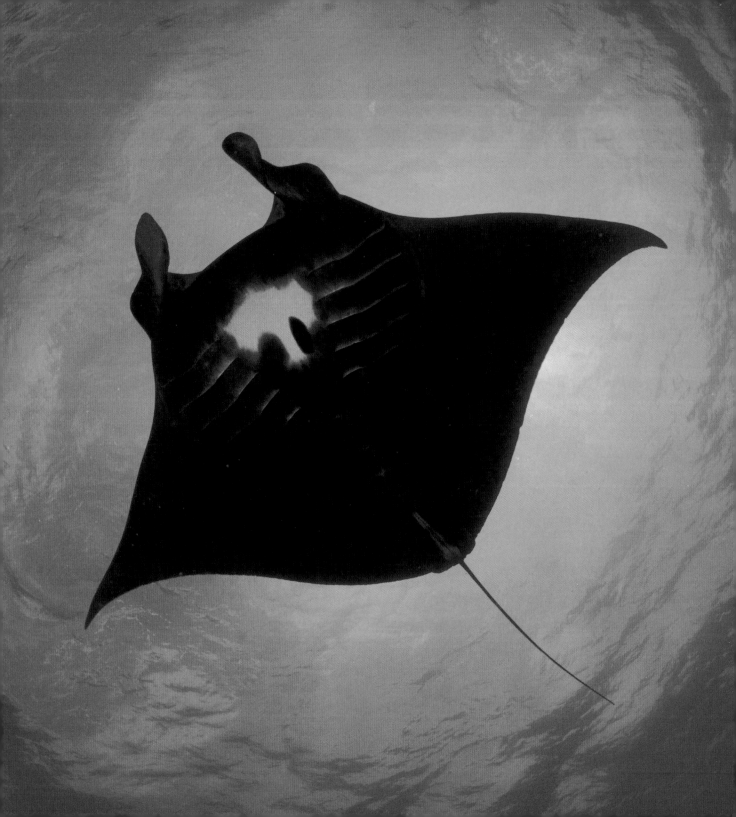

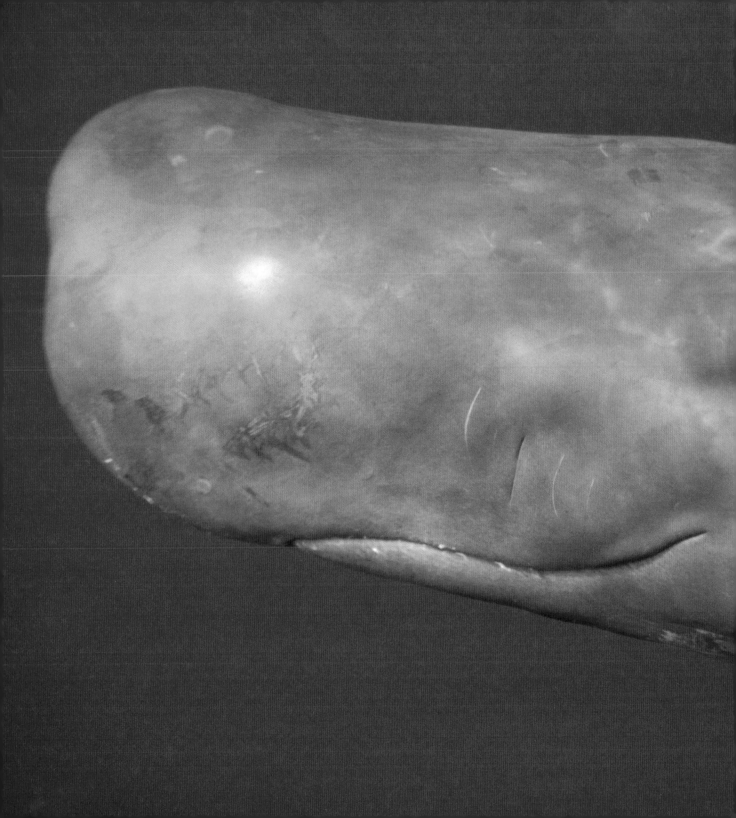

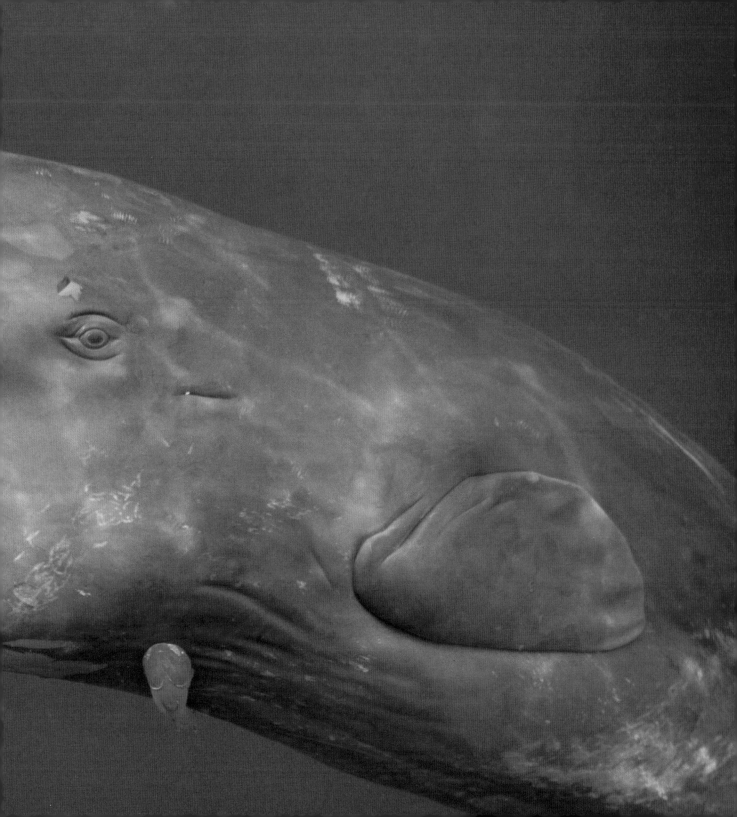

'Maybe the only true wildernesses are those at the bottom of the deep seas. We don't know what's going on there. We don't know what's living there. We don't know how the system works there.'

NEVILLE ASH, HEAD OF ECOSYSTEM

ASSESSMENT FOR UNEP-WCMC

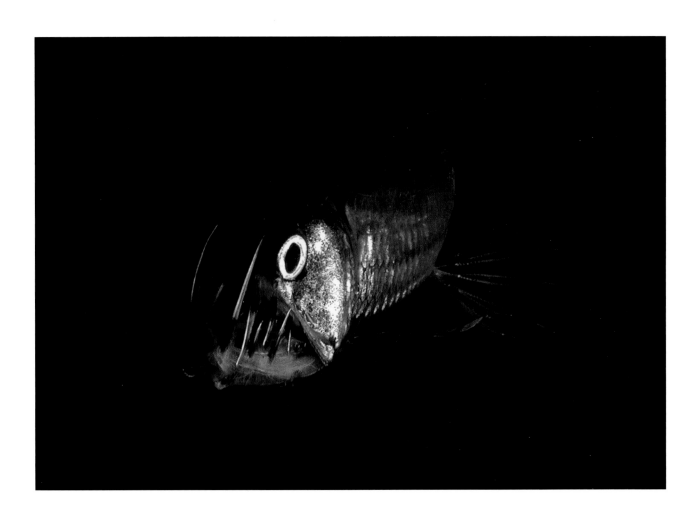

PREVIOUS SPREAD THE GREAT DIVER A huge sperm whale – probably the deepest-diving whale species. Diving sperm whales routinely reach depths of 3000 metres (9840 feet) or more in their hunt for deep-water squid and fish that live at such depths.

ABOVE FANG TRAP A Pacific viperfish, with a mouthful of fangs so long that they must be held outside its mouth. In the deep ocean, meals come along rarely, and so predators such as this have developed massive teeth to deal with prey of all sizes and make sure there is no escape.

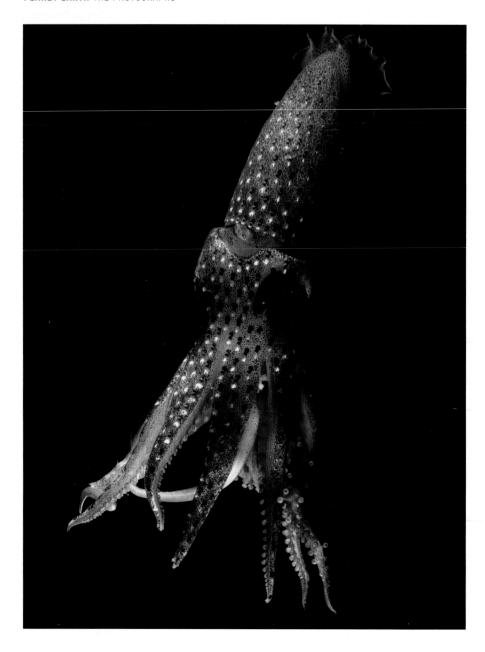

ABOVE THE FLASHER A jewel squid from the deep-ocean twilight zone, where little daylight penetrates. Large eyes help it spot prey, and the jewels covering its body are photophores that can be turned off to hide it from prey and predators, including sperm whales.

RIGHT FIREWORKS OF DEATH A deep-sea display is created by thousands of deadly bioluminescent sting cells suspended by a siphonophore as a lure for prey. This predator – a gelatinous colony of polyps that can be many feet long – drifts along in the ocean.

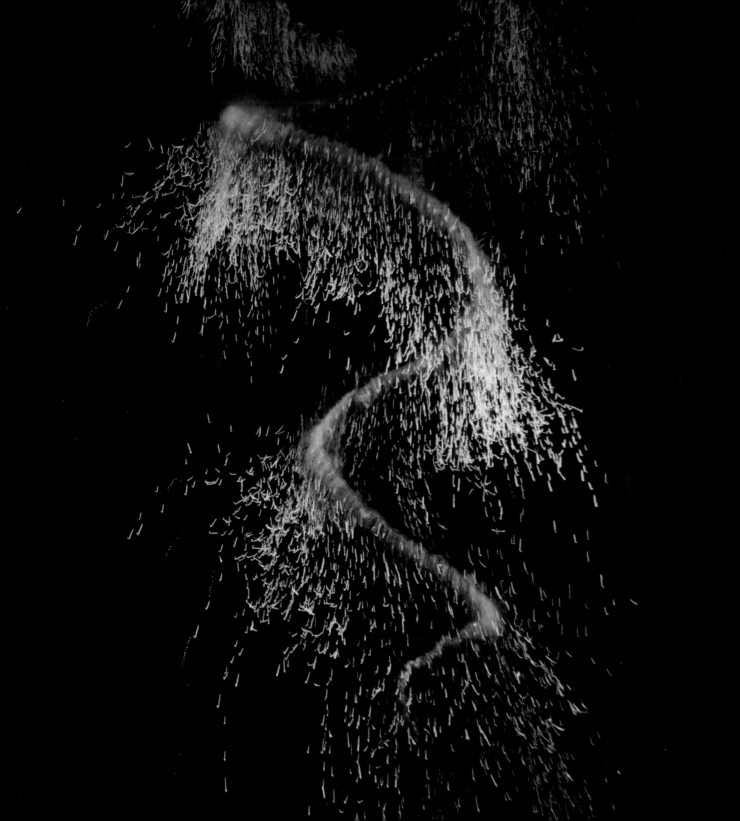

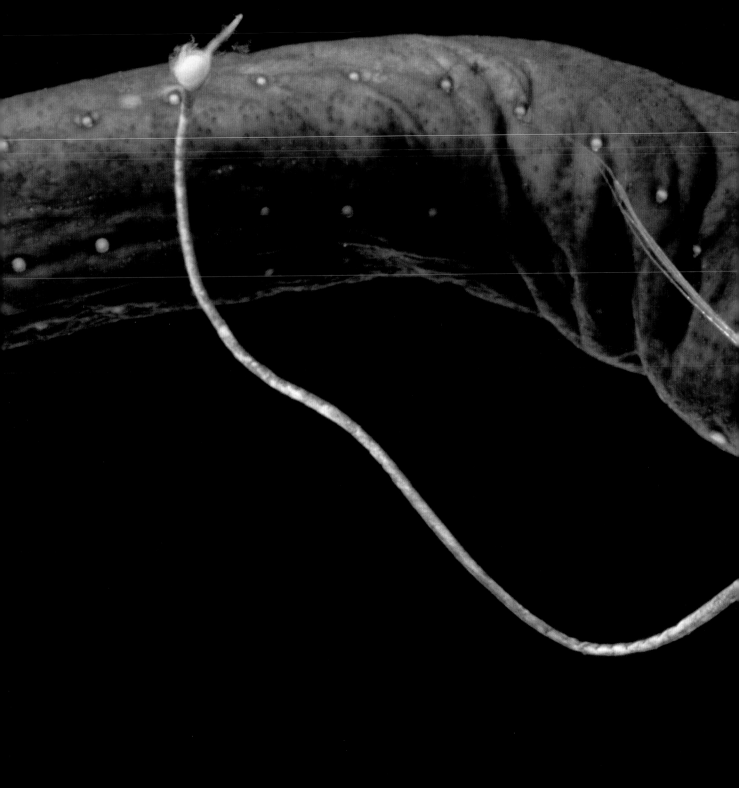

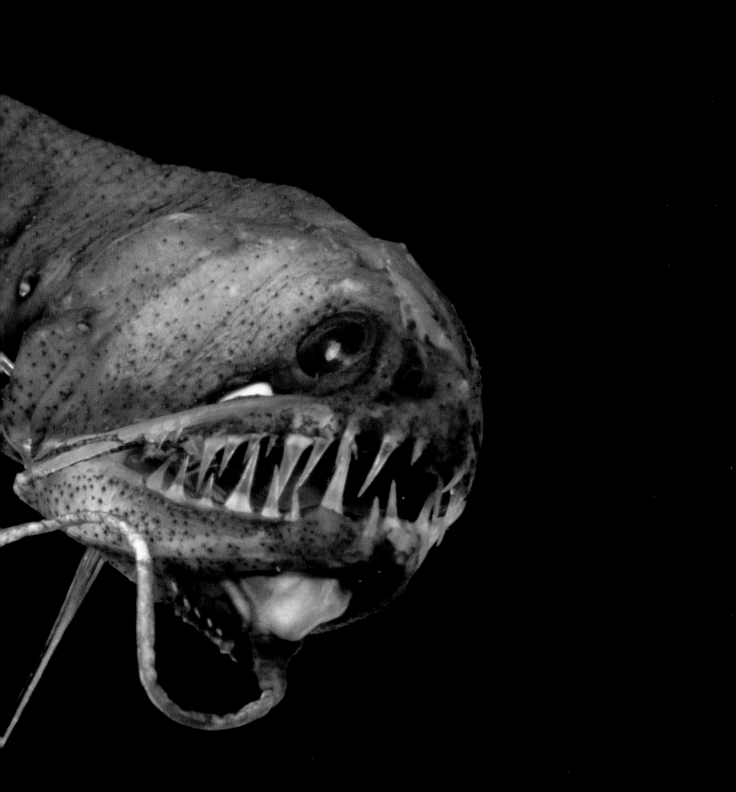

'Odd-looking deep-sea creatures like the dumbo octopus are part of ecosystems that need to function well if we are to be able to harvest the products that we need or benefit from the services the seas supply.'

JEFF MCNEELY, CHIEF SCIENTIST, IUCN —

THE WORLD CONSERVATION UNION

**PREVIOUS SPREAD** DEEP-SEA DECEPTION A scaleless black dragonfish looking huge but in reality only 24cm (9 inches). It has a glowing tip at the end of the whip attached to its lower jaw to lure in prey. The jaw is highly expandable to cope with almost any eventuality.

**RIGHT** SLOW MOVER An umbrella octopus hovering above the seafloor. It swims slowly by flapping its ear-like fins – energy conservation being vital in a place where food is hard to come by. In the dark of the depths, its red colour would appear black – camouflage against predators and prey.

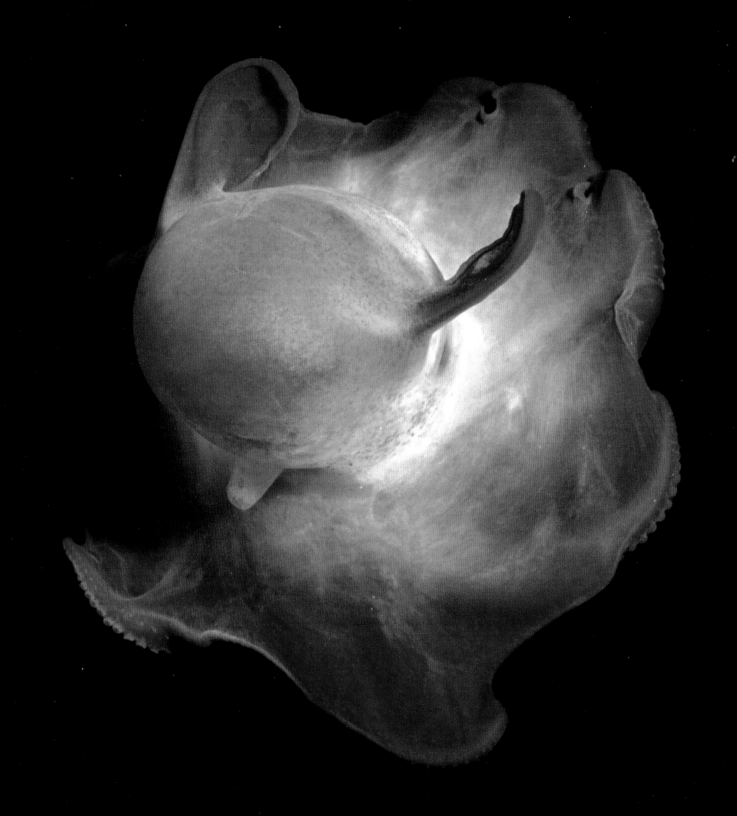

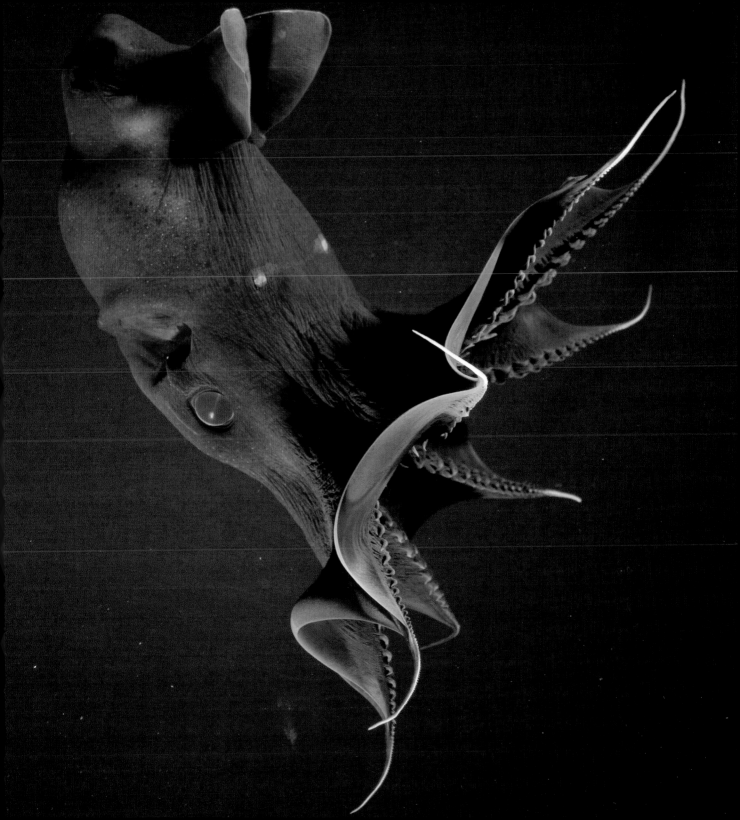

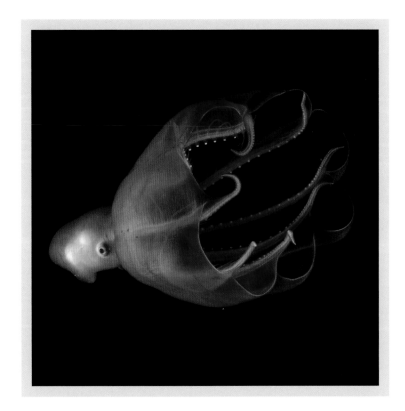

**LEFT** FLASHING SQUID A vampire squid, named after the fleshy fang-like projections under its mantle. *Planet Earth* used highly sensitive cameras to film its displays of bioluminescence. The tips of its tentacles flash and a light appears behind its eye, possibly to confuse predators.

**ABOVE** RED DEVIL A glowing sucker octopus makes a swift getaway from the submersible vehicle following it. Like most deep-sea octopuses, the thin flaps of skin between its arms act like a parachute, helping to keep it suspended in midwater, so saving energy when not hunting.

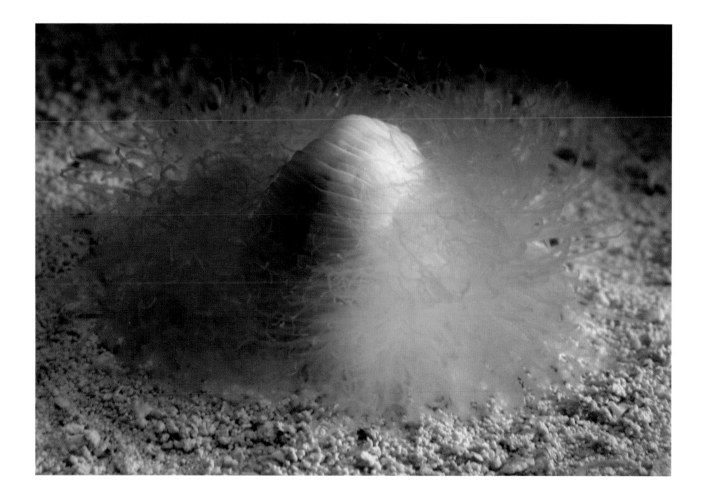

STICKY STRATEGY A polychaete worm with a tutu of thousands of
sticky tentacles to which food particles adhere. Most deep-sea worms live
permanently within the sediment, but this one swims from place to place
by twisting and turning its body.

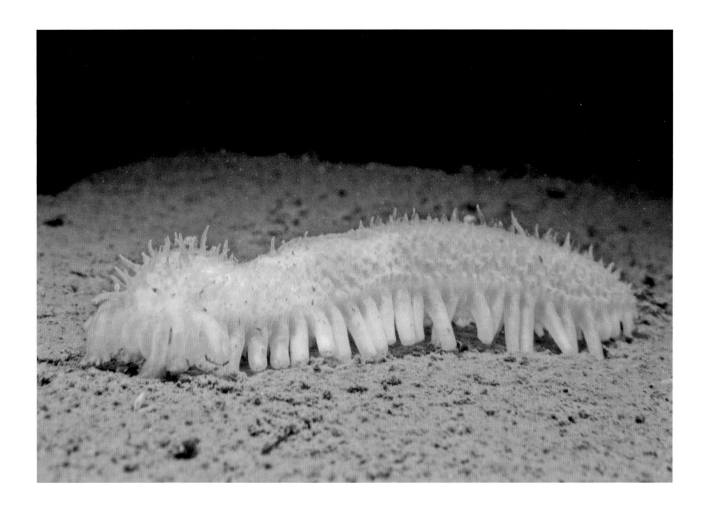

SEABED VACUUM A sea cucumber using its multiple legs to forage over the seabed, hoovering up sediment to extract the organic content. If disturbed, it glows bioluminescent blue-green. Sea cucumbers may make up 95 per cent of the biomass on the deep-ocean floor.

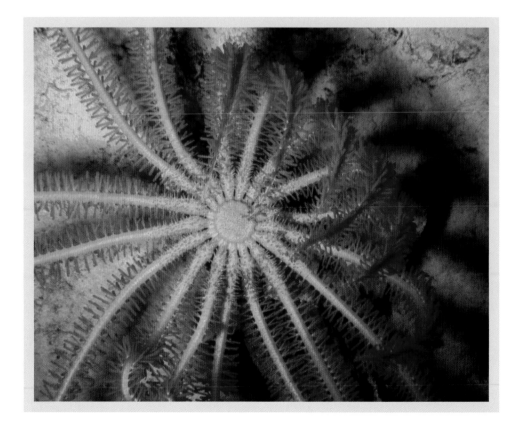

**ABOVE** SEASTAR OF MANY ARMS The deepsea brisingid seastar, a filter feeder, which extends its long, flexible arms up into the current to capture passing food. Its arms are covered with large pedicellaria (pinchers), all the better to grab things with.

**RIGHT** SEA LILIES OF THE DEEP Atlantic stalked crinoids, or sea lilies, in company with brittlestars. Attached by their stalks to a hard seabed, they wave their crown of feeding arms around to stop unwanted items settling on them. If threatened, they can break off and crawl away.

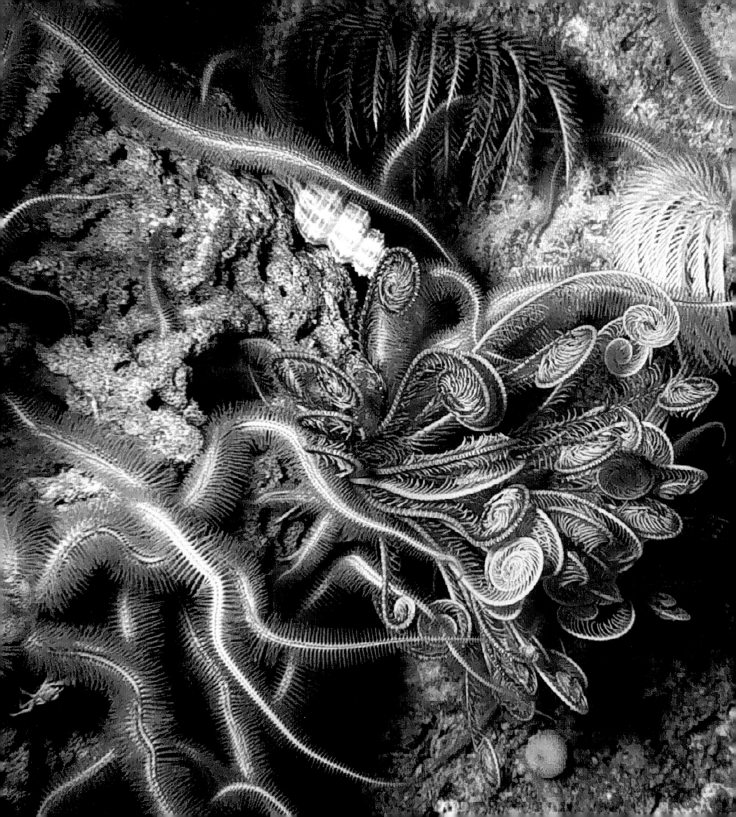

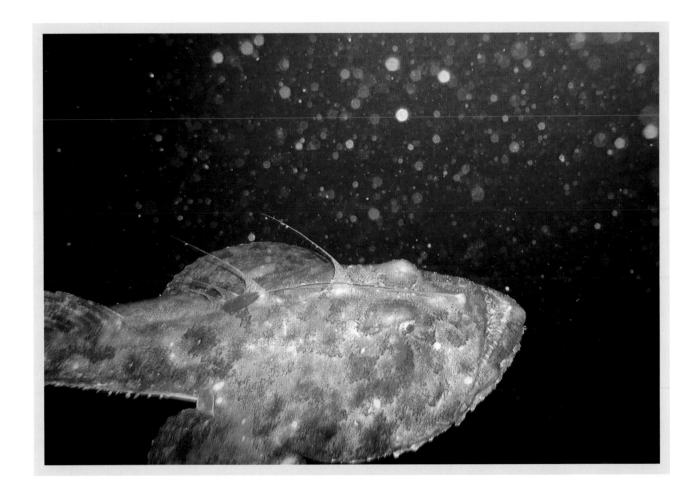

**ABOVE** ANGLER ON THE MOVE A deep-sea anglerfish takes off, illuminated by a submersible, its fishing lure folded back over its head. When lurking on the seafloor, its huge mouth enables it to grab anything that is attracted by the bioluminescent wriggling end of its lure.

**RIGHT** SLOW-GROWING GIANTS Giant file clams with sea anemones from a deep Norwegian fjord. In cold, deep water, animals tend to be slow growing and long lived. Many, though, like these clams, also tend to grow far larger than their shallow-water relatives.

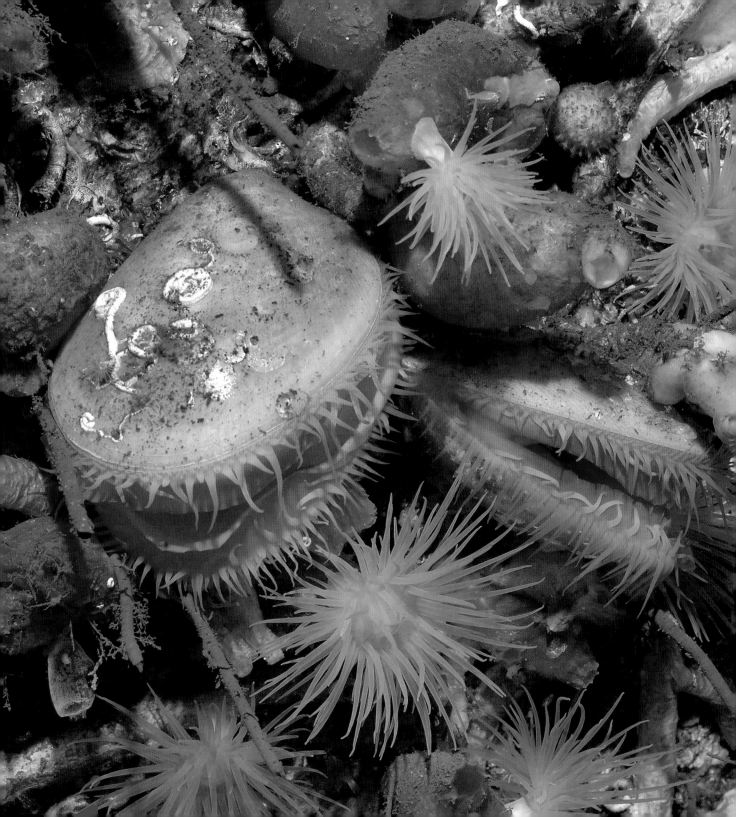

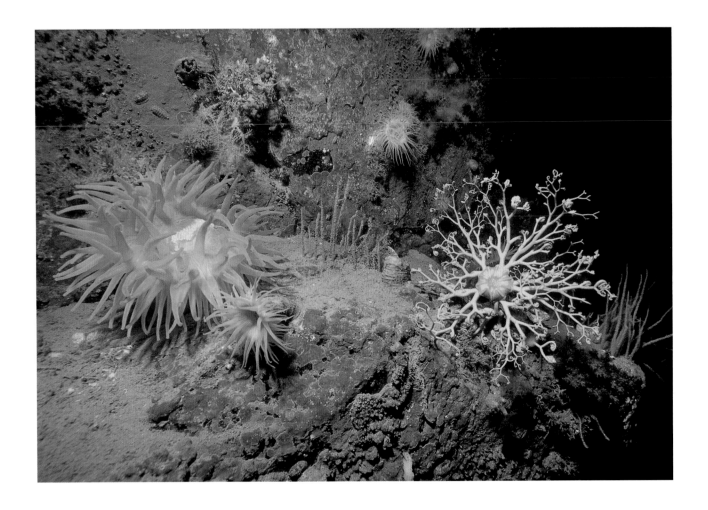

OASIS A rocky outcrop off Svalbard projecting into strong, food-bearing currents has turned into a little oasis of deep-sea life. Here sea anemones, a gorgon's head, or basket star, and red cold-water soft corals (in the background) benefit from such a prime position.

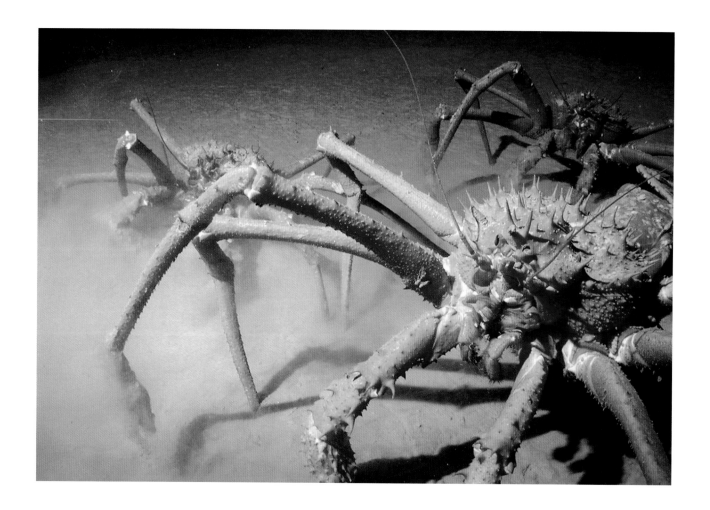

CRABS ON THE HUNT Giant Neolithodes spider crabs in the Gulf of
Mexico, which can grow up to a metre (more than 3 feet) across.
Using a specially designed deep-sea time-lapse camera, *Planet Earth*
filmed a frenzy of these scavengers squabbling over the carcass of a tuna.

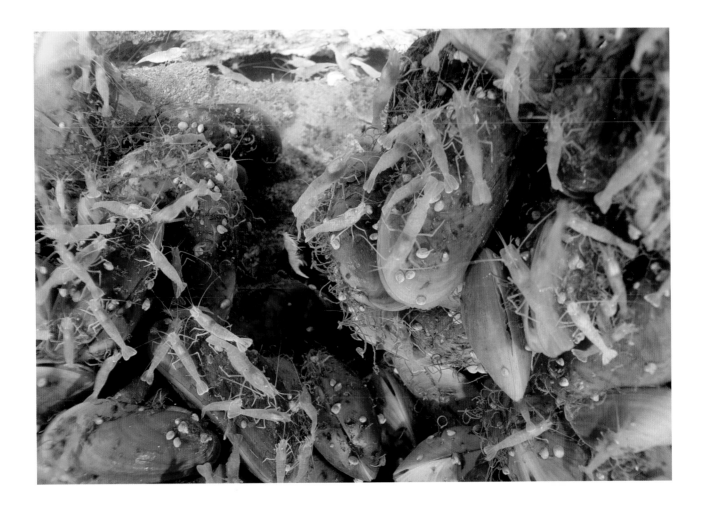

**ABOVE** HOT PINK SHRIMPS A colony of blind shrimps, mussels and limpets gathered at the base of a deep-sea hydrothermal vent. All of these animals rely on specialized bacteria that can fix energy from the hydrogen sulphide gases that pour out of the volcanic vents.

**RIGHT** ICE GREEN SPONGE A 12cm (5-inch) deep-sea sponge, photographed beneath fast sea ice in Antarctica. This year-round covering of ice protects the seafloor from the scouring effects of icebergs, allowing rich benthic life to flourish undisturbed.

'About 1.8 million species have been described, but we don't really know how many there are. Some scientists say 10 million, some say 15, some say 100. It could even be more than 100 million if we start looking at the bacteria in the oceans, on the ocean floor, in the soil.'

JEFF MCNEELY, CHIEF SCIENTIST, IUCN —

THE WORLD CONSERVATION UNION

RIGHT PALM WORMS A colony of palm worms cluster around hydrothermal vents on the Mid-Atlantic Ridge. Here, chemicals in the hot water are used by bacteria that form the basis of an extraordinary food chain – more than 600 species have been discovered at such vents.

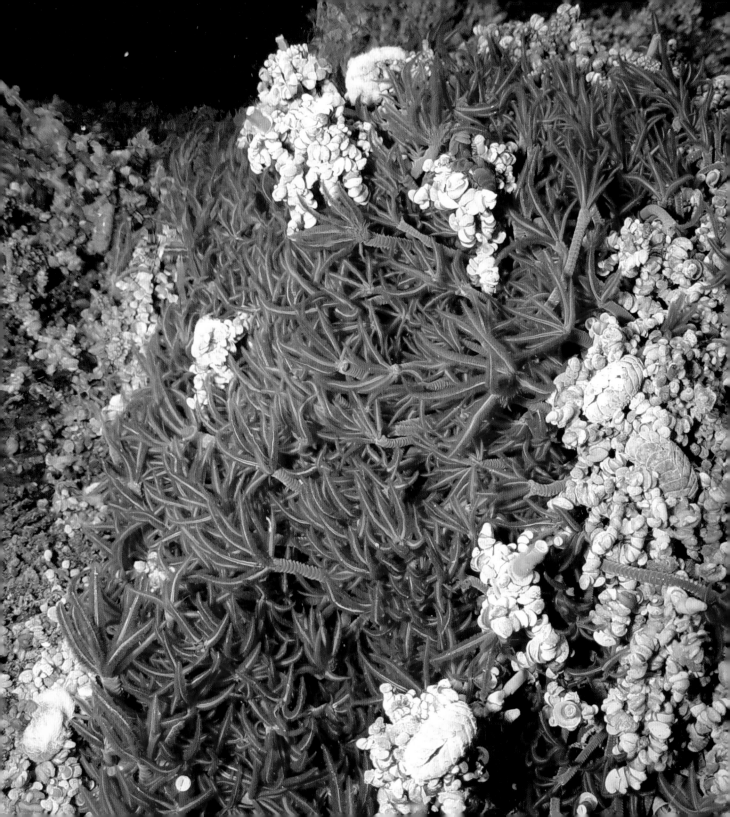

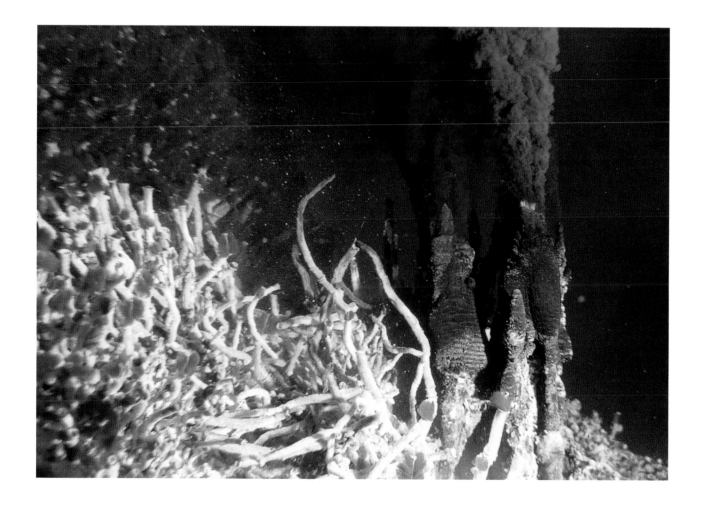

ROARING BLACK SMOKERS At hot vents 2202 metres (7224 feet)
down off the west coast of Canada, hydrothermal chimneys belch
super-heated, toxin-laden water. To film black smokers for *Planet Earth*
required two submersibles, one with the cameras and one with the lights.

'How do you live hundreds of feet under water in an undersea volcano, in toxic gases and flowing sulphur at great temperatures? Life has invented a way of doing that, just as it invented birds that can fly almost above the level that human beings can survive without oxygen. These intricate solutions to 'how do you exist on the planet' are wonderful things.' RICHARD MABEY

## PICTURE CREDITS

1 François Savigny/naturepl.com; 2 Martyn Colbeck; 4-5 Ben Osborne/BBC Planet Earth; 6-7 **top, left to right**: NASA–BDH/BBC Planet Earth, Sue Flood/The Image Bank/Getty Images, Heather Angel/Natural Visions, Jorma Luhta/naturepl.com; 6-7 **middle, left to right:** Ben Osborne/BBC Planet Earth, Tim Fitzharris, Colin Monteath/photolibrary.com, Gavin Newman/Alamy; 6-7 **bottom, left to right:** Kevin Schafer, Christian Ziegler, Jurgen Freund/naturepl.com, V. Tunnicliffe (Univ. Victoria); 9 Flip Nicklin/Minden Pictures/FLPA; 10 Ben Osborne/BBC Planet Earth; 12-13 BBC-NHU; 14-15 Michael S. Nolan/SeaPics.com; 16-17 Jan Vermeer; 18 Andy Rouse; 21 Tony Martin/photolibrary.com; 22 Fred Olivier; 23 Fred Olivier; 24 John Giustina/Getty Images; 26-7 Paul Nicklen/National Geographic Image Collection; 28 Fred Olivier; 29 Tim Voorheis/SplashdownDirect.com; 30 Norbert Wu/Minden Pictures/FLPA; 31 Norbert Wu/Minden Pictures/FLPA; 32 Erin Falcone; 33 Ian McCarthy; 34 Jan Vermeer; 35 Thorsten Milse; 37 Heather Angel/Natural Visions; 38-9 Nikita Ovsyanikov; 40 Paul Nicklen/National Geographic Image Collection; 42 Jan Vermeer; 43 Paul Nicklen/National Geographic Image Collection; 44 Flip Nicklin/Minden Pictures/FLPA; 45 Sue Flood ; 46-7 Jorma Luhta/naturepl.com; 48 Jorma Luhta/naturepl.com; 49 Paul Nicklen/National Geographic Image Collection; 51 Jim Brandenburg/ Minden Pictures; 52 Staffan Widstrand; 53 Pete Cairns/naturepl.com; 54 John Goodrich/WCS; 56 Toshiji Fukuda; 57 AFLO/naturepl.com; 58 Xi Zhinong/naturepl.com; 59 Christian Ziegler; 61 Jack Dykinga/naturepl.com; 62 Frans Lanting; 63 Kevin Schafer/Photographer's Choice/Getty Images; 64 Jim Brandenburg/Minden Pictures/FLPA; 65 Kevin Schafer/Photographer's Choice/Getty Images; 66-7 Art Wolfe; 68 BBC-NHU; 69 BBC-NHU; 70 Warwick Sloss; 71 Warwick Sloss/naturepl.com; 72-3 Richard du Toit; 75 Ben Osborne/BBC Planet Earth; 76 Ben Osborne/BBC Planet Earth; 77 Ben Osborne/BBC Planet Earth; 78 Ben Osborne/BBC Planet Earth; 79 Ben Osborne/BBC Planet Earth; 80-1 Anup Shah/naturepl.com; 82 Suzi Eszterhas; 83 Suzi Eszterhas; 84-5 Suzi Eszterhas; 86 Tony Heald/naturepl.com; 88-9 Ingo Arndt; 90 Chris Hendrickson; 91 Jeff Turner/naturepl.com; 92-3 Michio Hoshino/Minden Pictures/FLPA; 94 George Chan; 96-7 Xi Zhinong/naturepl.com; 98 Milo Burcham; 99 Xi Zhinong; 100-1 M. & P. Fogden/fogdenphotos.com; 102 Tony Heald/naturepl.com; 104 Martyn Colbeck; 105 Tony Heald/naturepl.com; 106-7 Grant MacDowell/naturepl.com; 109 Dan Rees/naturepl.com; 110 Jack Dykinga/naturepl.com; 111 Tim Fitzharris; 112-13 Tim Fitzharris; 114 Jack Dykinga/naturepl.com; 115 Jack Dykinga/naturepl.com; 116-7 Tim Fitzharris; 119 Jack Dykinga/naturepl.com; 120 Barrie Britton/naturepl.com; 121 Rhonda Klevansky/naturepl.com; 122 Huw Cordey; 123 Henry M. Mix, Nature Conservation International; 124-5 Ingo Arndt; 126 Konrad Wothe; 127 Jeff Turner; 129 Sumio Harada/Minden Pictures; 130-1 Martyn Colbeck; 132 Anup Shah/naturepl.com; 133 Ingo Arndt/naturepl.com; 134-5 Chadden Hunter; 136 Raghu Chundawat; 137 Jeff Wilson; 138 Martyn Colbeck; 140-1 Colin Monteath/photolibrary.com; 142 N. Shigeta/The Yomiuri Shimbun; 144 BBC-NHU; 145 Igor Shpilenok; 146-7 Tim Laman/National Geographic/Getty Images; 149 Stephen Alvarez/National Geographic/Getty Images; 150 M. & P. Fogden/fogdenphotos.com; 151 Kenneth Ingham;

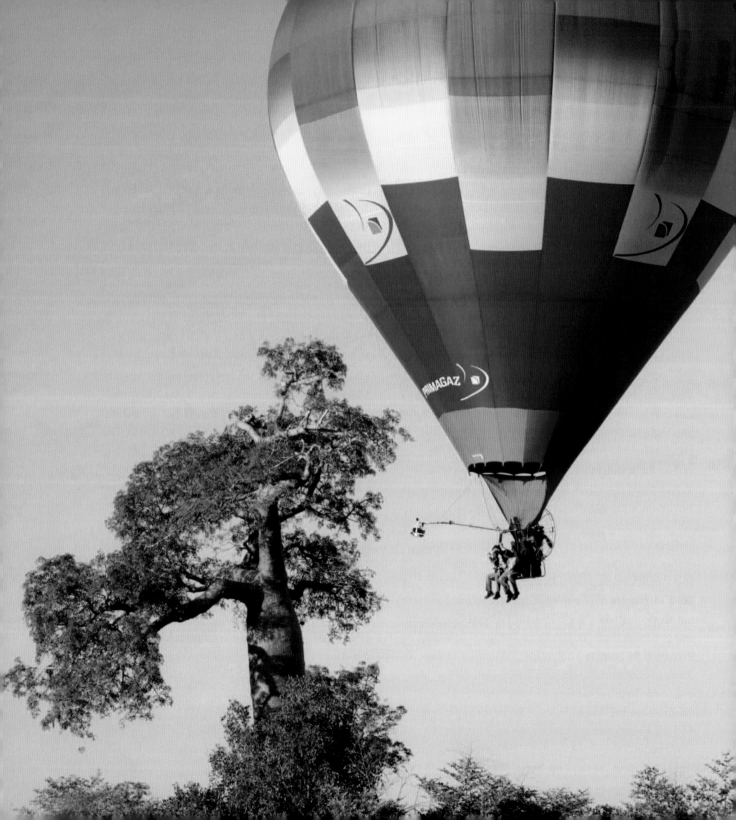

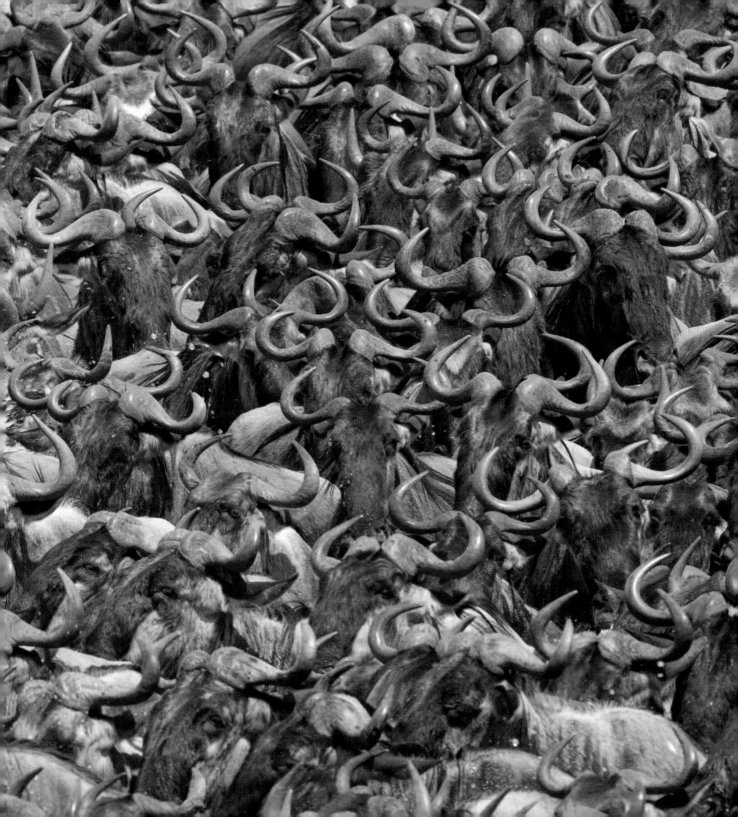

10 9 8 7 6 5 4 3 2

Published in 2007 by BBC Books, an imprint of Ebury Publishing.
A Random House Group Company

The Random House Group Limited Reg. No. 954009
Addresses for companies within the Random House Group can be found at
www.randomhouse.co.uk
A CIP catalogue record for this book is available from the British Library.

ISBN 978 1 846 07346 5

The Random House Group Limited makes every effort to ensure that the papers used in
our books are made from trees that have been legally sourced from well-managed and
credibly certified forests. Our paper procurement policy can be found at
www.randomhouse.co.uk

Commissioning editor: Shirley Patton
Project editor: Rosamund Kidman Cox
Designer: Two Associates
Picture researcher: Laura Barwick
Production controller: David Brimble

Colour separations by GRB Editrice Ltd, London
Printed and bound in Italy by Graphicom

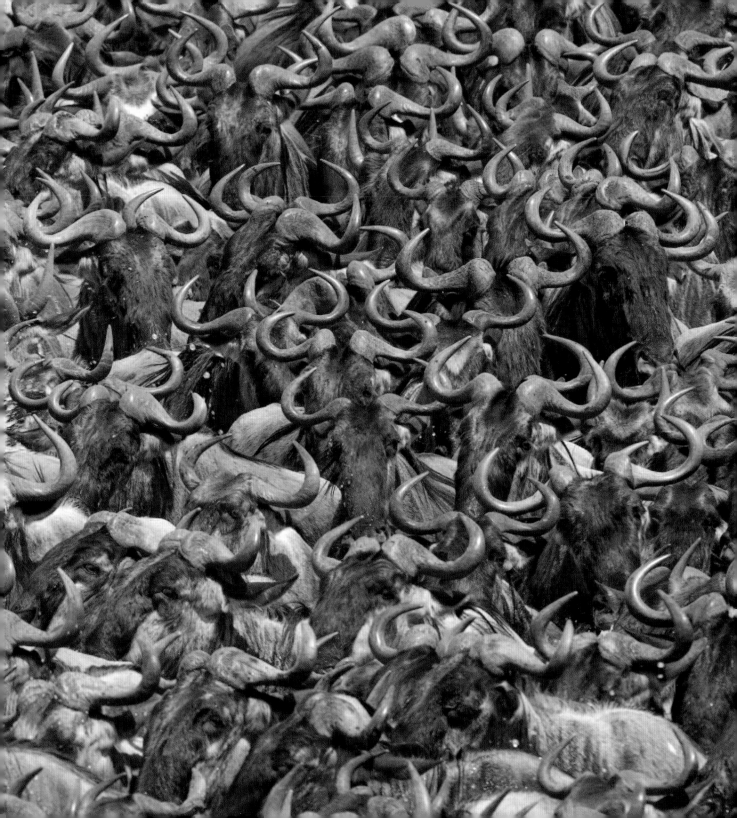

10 9 8 7 6 5 4 3 2

Published in 2007 by BBC Books, an imprint of Ebury Publishing.
A Random House Group Company

The Random House Group Limited Reg. No. 954009
Addresses for companies within the Random House Group can be found at
www.randomhouse.co.uk
A CIP catalogue record for this book is available from the British Library.

ISBN 978 1 846 07346 5

The Random House Group Limited makes every effort to ensure that the papers used in
our books are made from trees that have been legally sourced from well-managed and
credibly certified forests. Our paper procurement policy can be found at
www.randomhouse.co.uk

Commissioning editor: Shirley Patton
Project editor: Rosamund Kidman Cox
Designer: Two Associates
Picture researcher: Laura Barwick
Production controller: David Brimble

Colour separations by GRB Editrice Ltd, London
Printed and bound in Italy by Graphicom

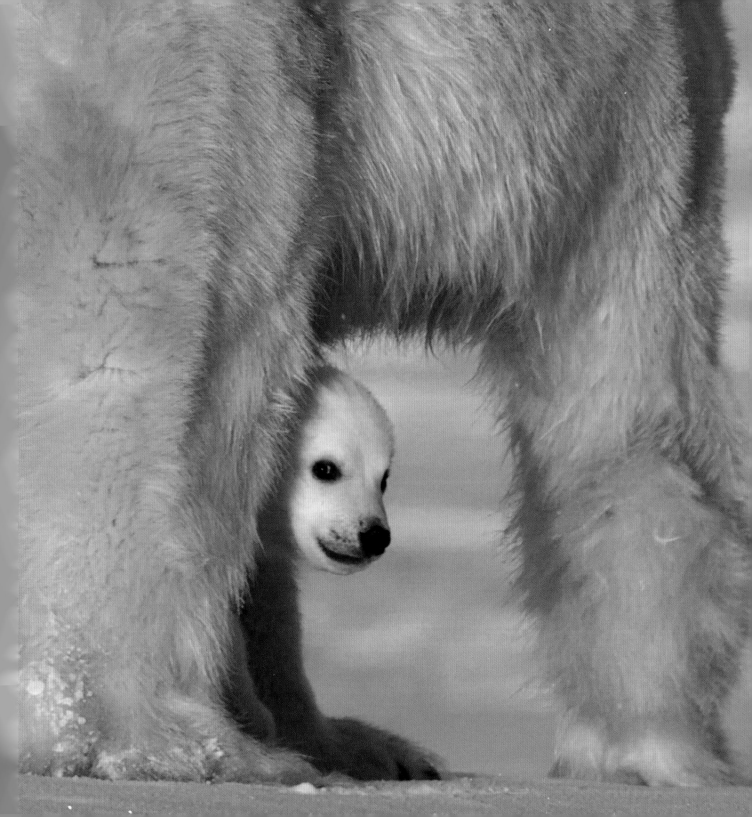

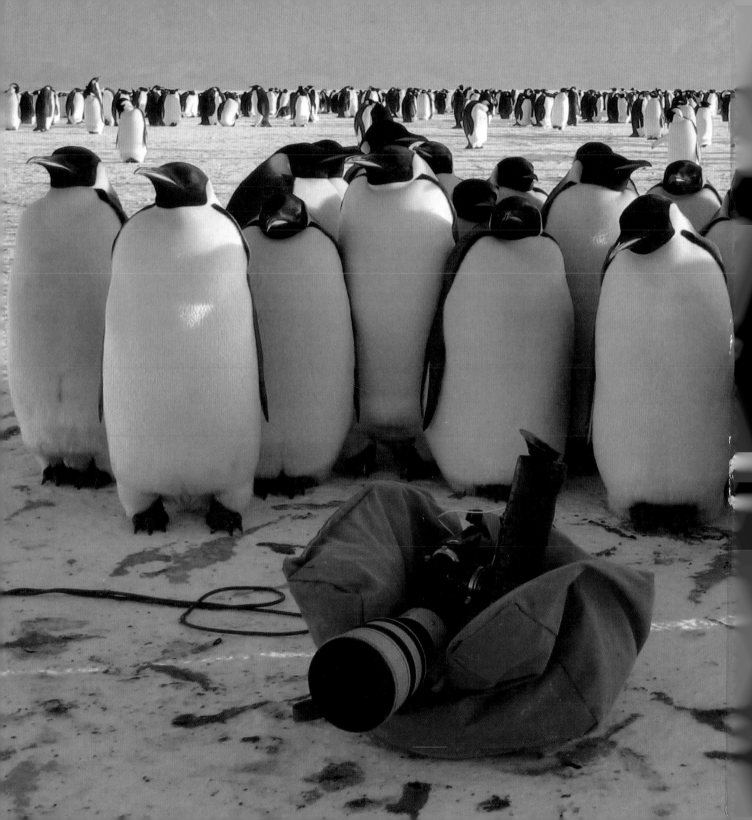